Princess MONONOKE

The Art and Making of Japan's Most Popular Film of All Time

HYPERION

New York

Princess Mononoke
Copyright © 1997 Nibariki Co., Ltd., Tokuma Shoten Co., Ltd., Nippon Television
Network Corporation, Dentsu Inc. and Studio Ghibli.

Princess Mononoke : The Art and Making of Japan's Most Popular Film of All Time
Copyright ©1999 Studio Ghibli
Translated from the Japanese by Mark Schilling

First printed in Japan by Studio Ghibli, a division of Tokuma Shoten Co., Ltd.
Copyright © 1997 Studio Ghibli
(except all drawings and image boards © 1997 Nibariki Co., Ltd.)

ISBN: 0-7868-6609-8

10 9 8 7 6 5 4 3 2 1

Introduction by Mark Schilling

Hayao Miyazaki is often called the Walt Disney of Japan. Although some say his animated films are as different from those of the Disney studio as sushi is from steak, there are reasons for the comparison. Starting their careers with little more than talent and ambition, Miyazaki and Disney both built hugely successful animation studios and created characters that have since become indelibly identified with their names; Miyazaki's Totoro, the big, cushiony cross between an owl and a cat that starred in the 1988 film *My Neighbor Totoro,* and of course Disney's Mickey Mouse.

Both Disney and Miyazaki made quality their trademark early on. At a time when most Japanese animated features were cheaply and quickly made, Miyazaki and long-time associate Isao Takahata decided to go in the opposite direction. Studio Ghibli, the studio they founded in 1985 with the backing of publisher Tokuma Shoten, was from the beginning dedicated to making feature films at the highest levels of animation art. Yes, Miyazaki and Takahata wanted to appeal to the widest possible audience, but they were also both auteurs who put their stylistic stamp on and wove their personal concerns into every film they made.

Studio Ghibli—the name comes from an Arabic word for a hot, strong wind in the Sahara of Northern Africa—was essentially betting the company with each and every release and Miyazaki did not expect it to survive long. But even in the early years, when they were winning their box office bets by thin margins, Miyazaki and Takahata never cut corners or otherwise compromised their original vision.

With its fifth feature film, the 1989 *Kiki's Delivery Service (Majo no Takkyubin)* Studio Ghibli began to enjoy Disney-like megasuccess. This film about a young witch's initiation into adulthood became the highest-earning Japanese movie of the year. By 1998, the films of Studio Ghibli had become dependable regulars in the upper ranks of the annual top-ten box office charts. Miyazaki and Studio Ghibli had become known even by the large majority of Japanese who seldom or never went to the movies.

It was Studio Ghibli's 1997 release *Princess Mononoke (Mononoke Hime)* that finally became the highest-grossing film ever released in Japan, foreign or domestic. Directed by Miyazaki, this eco-fable set in sixteenth-century Japan quickly outdistanced the previous record holder, *E.T. the Extra-Terrestrial,* at the Japanese box office following its July 12 opening. By the end of its first run in March, after an incredible eight months in theaters, *Princess Mononoke* had grossed more than $150 million in a country with one-half the U.S. population and less than one-tenth the number of screens. No film released in Japan in the past decade has even approached this total (with the exception only of the box office behemoth *Titanic).*

Like James Cameron's disaster epic, *Princess Mononoke* defied industry logic—earning nearly twice as much as original projections—while becoming a widely discussed social phenomenon. It had been thought that a serious film, a non-Hollywood Japanese production and one that was set so far back in the history of Japan, could never become a major box office success. Yet *Princess Mononoke* went on to become the movie event of the year, if not the decade.

Accounting for nearly one-tenth of all ticket sales for 1997, attracting more than one-tenth of the population to the theaters, *Princess Mononoke* almost single-handedly lifted the Japanese film industry from the box office doldrums in which it had languished for more than three decades. It also scooped major domestic film awards, including Best Picture at the 1998 Japan Academy Awards, was screened at major overseas films festivals, including the 1998 Berlin Film Festival, and was Japan's nominee for the 1998 Foreign Film Academy Award.

Princess Mononoke represented both a culmination and departure for Miyazaki. The origins of the story about a girl raised by a wolf who fights with forest gods against human invaders lay deep in his artistic past, while its themes and motifs have reappeared again and again in his work.

Miyazaki made his first sketches of the Princess Mononoke character, which Studio Ghibli later published in book form in 1980, but his early versions of the story bore no relation to the final version.

In his 1984 film *Nausicaa of the Valley of the Wind (Kaze no Tani no Nausicaa)*, whose young heroine battles to survive in a poisoned future world, he made the first full-length treatment of the humans-versus-nature theme that was later to resurface in *Princess Mononoke*. Miyazaki also dwelt on this theme at length in a *Nausicaa of the Valley of the Wind* comic that he wrote from 1982 to 1994, for a total of fifty-nine episodes.

Nausicaa became, over the years, a critical and cult favorite both in Japan and abroad and was instrumental in launching the Japanimation boom overseas. Meanwhile, Miyazaki never gave up his dream of a film based on the Princess Mononoke character. Finally in 1994, after a decade and a half of gestation, he decided to make *Princess Mononoke* Studio Ghibli's tenth film.

Once again, the story would feature a young girl saving nature and setting a disordered world right. This time, however, the setting would not be the near future but the distant past or, more specifically, the Muromachi period (1392–1573), when Japan was undergoing the prolonged social upheaval and political unrest that gave birth to many traditional arts and institutions, from the tea ceremony to the military dictatorship of the Edo period.

Princess Mononoke was Miyazaki's first period drama, but he had no intention of adhering to genre conventions. Instead of samurai, geisha, and other standard period drama figures, he cast his central characters from outcast groups and oppressed minorities who had rarely, if ever, appeared in Japanese films. He also freely mixed periods and added elements that may have had their origins in Japanese history and mythology but were ultimately products of his fertile imagination.

Princess Mononoke or, as she is more commonly called in the film, San, is one such product, though she has her antecedents in Rudyard Kipling's *Kim* and François Truffaut's *The Wild Child*. With her painted face and *domen* mask, she seems to be a relic from the prehistoric past, a thousand years or more before the film's actual period.

Another central character, Ashitaka, belongs to the Emishi. In the film, however, a tribe of Emishi still live in a remote northern Honshu forest. Ashitaka's Yakkuru, though resembling a species of native elk, is a Miyazaki-conceived cousin to the unicorn.

The Tatara clan of ironworkers commanded by Lady Eboshi are of the film's period, but they include former prostitutes, lepers, and others who have been pushed to the fringes of Japanese society and been forced to live in its wild places. Also, they are not based on any historical model.

The forest gods that they battle, including the lifeforce Deer God, do not belong to the usual pantheon, which was a creation of the Emishi's Yamato conquerors, but are presented by Miyazaki as "lost" gods living amidst the last remnants of untouched nature, whose human worshippers have long since vanished, replaced by human destroyers and predators.

Miyazaki's intent, however, is not to create a realistic portrait of medieval Japan, but to portray the conflict between the ancient land of primeval forests and animistic gods and the then-emerging modern industrial civilization, which was a product of Japan's contact with the outside world. He has, however, rejected the usual good-versus-evil dichotomies of popular entertainment.

Ashitaka, the film's would-be peacemaker, becomes a cause of the contentiousness, a target of the bitterness. When he rescues San from Lady Eboshi's Tatara fortress and is dying from a Tatara musket ball, he is set upon by a wolf and nearly stabbed to death by an enraged San. When, at Deer God Pond, the boars learn that the wolves and the Deer God have saved Ashitaka's life, they rage at their allies for aiding a human and are only narrowly averted from attacking them. When Ashitaka is recovering from his wound at Moro's cave, Moro (the wolf god), tells him he can end his pain by jumping into the chasm below. San and the forest gods are not stainless heroes. Their long, losing conflict with humans has made them bitter and unforgiving toward their enemies, divided and contentious within their own ranks.

Also, though the film's ostensible villains—Lady Eboshi and her Tatara clan—may cut trees and pollute streams, they are also outsiders trying to survive in a hostile and chaotic world. Their palisades protect them, their muskets defend them, while their iron forge mill brings them a measure of prosperity and gives them a feeling of security and solidarity. They are, Miyazaki seems to be saying,

basically good people trying to get by, just as their descendants tried to get by in the similarly chaotic period after World War II and ended up building the world's second-largest economy, while wreaking destruction on the environment.

If there are any true villains in the film, they are Jiko Bo and his Karagasaren minions, who hunt the Deer God, ostensibly at the behest of the emperor, in the belief that its head will give them eternal life. Plotters and schemers who will stop at nothing to accomplish their ends, they seem to stand for all the dark, corrupt forces that brought Japan to ruin in a later era through their overarching ambition and heedless egotism, again in the emperor's name. But Miyazaki's only punishment for Jiko Bo is the revelation, at the end, that his headhunt is an act of self-destructive and self-delusive hubris. The Deer God can't die, Ashitaka reminds us, because he is life itself. Defeated, Jiko Bo throws up his hands, laughs, and accepts the obvious, though he can hardly be called repentant.

The ending, with the ravaged hillsides around the Tatara-ba bursting into green life, leaves us on an ambiguous note. The Tatara will try to live in harmony with the newly rejuvenated forest, but Jiko Bo and his companions, we feel, still have more tricks up their sleeves and the samurai marauders of Asano are still waiting to pounce. The film's conclusion, in short, is consistent with what has gone before—the battle has not necessarily ended.

To make *Princess Mononoke*, Studio Ghibli spent ¥2.35 billion ($19.6 million), more than twice the budget of any previous Ghibli film and more than that of any Japanese animated film to date. Some of this money went for the hardware, software, and staff needed to incorporate nearly fifteen minutes of computer graphics into key scenes, again a record for a Ghibli production. The studio's previous films had all been very much hand-crafted—long a point of pride for Miyazaki and his staff. But by the time *Princess Mononoke* went into production, technological advances made computer graphics a highly useful tool for its efficiency at creating certain effects. Also, Ghibli animators used a total of 144,000 cels, approximately 80,000 of which were key animation cels, the most of any Ghibli film.

The result is movement with far more fluidity and realism than that of the typical Japanimation film. The camerawork for the thrilling leaps, slashing sword fights, and thundering gallops is also dynamic in a way that only animation can achieve, while the computer-generated imagery conveys the immediacy and presence of live-action film. Perhaps Miyazaki owes something of a debt to the classic Kurosawa films of the past. *Princess Mononoke* is, as Miyazaki said it would be from the beginning of production, "an action movie."

But all in all Miyazaki's animation is less about sheer movement than the evocation of atmosphere and the delineation of emotion in all shades and nuances. In *Princess Mononoke* the forest is not just another painted backdrop but a living presence whose age, mystery, and deep, still beauty awes and heals. A place like this, we feel, must have once existed but only Miyazaki could have imagined it with such astonishing rightness. Like the best period drama directors, he impresses as having a vital connection with the past, but in *Princess Mononoke* he is less concerned with recreating a historical moment than returning to the wellsprings of native myth and belief. We better understand San's devotion to her forest and its gods—a devotion as strongly rooted and ancient in origin as Shinto itself—because we can directly experience what she loves and fears to lose.

The scenes set at the Tatara-ba conjure a similar feeling of imaginative reality. We forget that we are watching an animated movie and can almost touch the night dampness on the wooden palisades, feel the heat from the furnace, and smell the smoke rising from the mill. The extraordinary attention to detail, with the grain and heft of every log carefully rendered, does not end in mere picturesqueness, however. Miyazaki uses it to express both the newness and rawness of life in the Tatara-ba—it could be a frontier fort in a James Fenimore Cooper novel—and the iron firmness of the will behind its construction.

This kind of obsessive concern with mood and atmosphere is not unique to Miyazaki. Other Japanese animators such as Katsuhiro Otomo and Mamoru Oshii share it, but only Miyazaki and his Studio Ghibli colleagues are as adept at bringing the natural world, in all its manifestations, to pure, vibrant life.

Character design is yet another area in which Miyazaki has set *Princess Mononoke* apart from most other animation, in both Japan and the West. In depicting the forest gods he has resisted the usual animation ploy of drawing anything with four legs as rounder, softer, cuter than life. Moro is a wolfish wolf, Okkotonushi, a boarish boar, but with a strangeness and grandeur that are archaic, larger than life. Also, though they talk to each other and the humans around them, as have uncounted legions of animated animals from Mickey Mouse on down, they seem to be communicating through a form of telepathy, resulting in an almost hypnotic persuasiveness.

Because Miyazaki's name is mentioned so often and in so many contexts, one may be left with the impression that *Princess Mononoke* is the creation of one mind, with Miyazaki's Studio Ghibli staff merely doing his bidding. That is not true and, in a film with the complexity of *Princess Mononoke,* would have been impossible in any case. Even so, Miyazaki regarded the job of director as not only overseeing, but participating in every aspect of production, from scripting to promotion.

He checked every one of the film's 144,000 cels and took a pencil to nearly 80,000—a brutal workload that would have taxed the energy of a much younger man. Miyazaki, fifty-six years old at the time of the film's completion and with more than three decades in the animation trenches, finished his three-year immersion in the biggest project of his career with his health and sanity intact, but determined to never direct again.

Born in Tokyo in 1941, Miyazaki was the second of four brothers. His father was the director of an aircraft parts company that made rudders for the Zero fighter plane, while his mother spent much of Miyazaki's youth in a sickbed, battling spinal tuberculosis. A voracious reader who took a keen interest in current affairs, she often expressed her disdain of the intellectuals who had rapidly changed from rabid nationalists to fervent democrats after Japan's defeat in the war. Miyazaki later said that he inherited his questioning and skeptical cast of mind from her.

At Gakushuin University, an elite private college with close ties to Japan's imperial family, Miyazaki majored in political science and economics and was strongly influenced by Marxist thought. He was also a member of a children's literature study circle, where he nursed his ambition to become an animator.

After graduating in 1963, Miyazaki joined Toei Animation, then as today the largest animation studio in Asia, where he worked as an in-betweener—the lowest rung on the animation ladder. This was an unusual choice of occupation for a Gakushuin graduate, but Miyazaki was a diligent and talented animator who soon attracted the attention of his seniors. One was Isao Takahata, who first worked together with Miyazaki as a director on the 1964 TV series *Wolf Boy Ken (Okami Shonen Ken)*. Miyazaki and Takahata also worked together as activists in the company union. (Today Studio Ghibli is one of the few animation houses in Japan to pay its staff a living wage and offer them health care and other benefits.)

In 1965, Miyazaki joined Takahata and animation director Yasuo Otsuka in making a full-length feature titled *The Little Norse Prince Valiant (Taiyo no Oji Horus no Daiboken)*. Eager to make a film able to compete with the TV cartoons that were killing off the market for animated features, Takahata and Otsuka opened their creative brainstorming sessions to all members of their team, regardless of company rank or experience. Miyazaki jumped at the chance. Bombarding his superiors with ideas, he played a key role in developing the film's style and story line.

This film about villagers banding together to protect their homes and families against an evil witch won critical and popular acclaim following its release in the summer of 1968. It marked the emergence of a style in commercial Japanese animation that equaled or surpassed any in the world at that time.

In 1971, Miyazaki and Takahata left Toei and joined a new animation production company, A-Pro. Together they made *The Adventure of Panda and Friends (Panda Kopanda)*, a 1972 feature that may have exploited the panda boom of the early 1970s, but realistically portrayed the inner world of its young heroine. In 1973, Miyazaki and Takahata left A-Pro to join Zuiyo Pictures, where they made *Heidi (Alps no Shojo Haiji)*, the first Japanese TV cartoon series based on sketches drawn by animators at a foreign location, in this case Switzerland. Its unhurried, intimately detailed portrayal of life in a nineteenth-century Alpine village made *Heidi* a fondly remembered hit.

But though these projects may have enhanced his industry prestige, Miyazaki was also responsible for *The Castle of Cagliostro (Lupin III Cagliostro no Shiro)*, a 1979 feature about a debonair but wacky thief that was about as socially redeeming as a James Bond movie. It became a box office success.

The film that first brought Miyazaki to international attention was the 1984 *Nausicaa of the Valley of the Wind (Kaze no Tani no Nausicaa),* an eco-fable about a young girl's struggle to survive in a poisoned world inhabited by warring tribes and giant mutant insects. Miyazaki scripted and directed the film based on the comic he drew and Takanata served as producer.

In *Nausicaa,* Miyazaki created an intricately imagined near-future, while commenting on the topical issue of ecological disaster caused by commercial greed. Representing a bold advance over the simplistic space operas that were then the sci-fi animation mainstream, *Nausicaa* won a slew of awards and accolades, including the Grand Prize at the Second Japanese Anime Festival and a commendation from the World Wildlife Fund.

Miyazaki's follow-up to *Nausicaa* was the 1986 *Laputa: Castle In the Sky (Tenku no Shiro Laputa)*, a fantastic adventure tale inspired by *Gulliver's Travels* about the search for the lost flying island of Laputa. As in *Nausicaa,* a spunky princess was the heroine and the story contained a respect-for-nature subtext, but the action element was more central, and the plotting less labyrinthine. In order to produce *Laputa,* Miyazaki and Takahata had launched their new animation studio, Studio Ghibli, in 1985.

In the 1988 *My Neighbor Totoro (Tonari no Totoro),* an original story which he wrote and directed, Miyazaki abandoned the SF genre to spin a leisurely paced, loosely plotted fantasy about the encounter of two young sisters with magical forest spirits. Two of the most memorable are an enormous owlish/catish creature called Totoro and the Cat Bus, a twelve-legged, bus-size cat that comes complete with doors, windows, furry seats, and headlight eyes.

The setting is a paradisical countryside in midsummer, the time, the nostalgic past. Dad is an infinitely patient and understanding, if slightly woolly-headed archaeology professor, who has come to this country retreat to write a book, while Mom lies several kilometers away in a hospital sickbed (echoes of Miyazaki's own youth), recovering from an undefined illness.

Though not quite the box office success of *Nausicaa, Totoro* also acquired the status of an animation classic. If anything, it has become even more popular over the years in Japan, with adults and children alike. In a poll by public broadcaster NHK that asked respondents to rate their all-time favorite films, *Totoro* came in second among domestic movies, after Akira Kurosawa's *The Seven Samurai.*

Takahata's 1988 film *Grave of the Fireflies (Hotaru no Haka),* which told the story of a boy caring for his younger sister in the chaos of wartime Japan, was released with *Totoro* as a double feature. The two films could not have been more different. *Grave of the Fireflies* wrenched tears from nearly everyone who saw it, and is possibly the most beautifully moving animated film ever made. It is also one whose subject has rarely been treated by any Japanese filmmaker. Its co-release with *Totoro* speaks more of the tremendous economic pressures facing animated filmmakers at the time than anything else, and the simultaneous production of two films is something Ghibli has not since attempted and probably never will.

The 1989 *Kiki's Delivery Service (Majo no Takkyubin)* launched Studio Ghibli on an unbroken string of box office hits. The story of a young witch on a quest to complete her apprenticeship in witchcraft, *Kiki* is a fairly typical coming-of-age story, but the flying scenes in particular are stunningly realized (Miyazaki is an aviation buff). The port city that Kiki decides to call home is a charmingly eccentric blend of styles and periods, with 1930s automobiles in the street and electronic ovens in the houses. More mass-audience friendly than *Nausicaa* and more visually dynamic than *Totoro, Majo* became the biggest domestic box office hit of 1989.

Ghibli's follow-up film, the 1991 *Only Yesterday (Omoide Poroporo),* was executive produced by Miyazaki but scripted and directed by Takahata. Although the two men had developed a distinctive Ghibli house style over the years, Takahata's films were definitely different from Miyazaki's, with their greater stress on realism of character and story, and their stronger tug on the heartstrings. *Omoide* is

about the voyage to self-discovery of a twenty-seven-year-old Tokyo office worker named Taeko who visits relatives in the countryside and, on the way, travels mentally back to her tenth year. Why, she wonders, is the little girl of 1966 so important to the woman of 1982? Like the girl about to become a woman, Taeko is on the cusp of change. Tired of her humdrum existence, she longs for something new. Then, at the farm of relatives of her sister's husband, where she had often spent her summers, she finds herself attracted to a chipperly earnest young farmer. The film continues to function on two levels; a sensitively developed inner dialogue with the past, and a conventional love story in the present. The scenes depicting the natural beauties of country life, drawn to the last verdant branch, bud, and leaf, helped mark the film unmistakably as a Ghibli creation, and it went on to become yet another box office hit.

The studio scored an even bigger success with the 1992 *Porco Rosso (Kurenai no Buta)*. Scripted and directed by Miyazaki, this film is about an ace pilot named Marco whose visage has been changed by a mysterious (and completely unexplained) spell to resemble a pig who battles air pirates over the Adriatic Sea in the days after World War I. The bright red biplane he flies is named *Porco Rosso*.

The film has all the Miyazaki trademarks, including breathtaking flying sequences and a feisty young heroine who works as an aircraft designer. The story, in which Marco duels a pirate leader while carrying a torch for a sultry chanteuse, is sub-Hemingway, but the animation is among Miyazaki's exuberantly lovely best. *Porco Rosso* became the Japanese animation industry's biggest hit (remaining so until the release of *Princess Mononoke*) and topped the year's box office chart.

In 1994, Takahata returned with *Pom Poko (Heisei Tanuki Gassen Ponpoko)*, a fable about a clan of *tanuki* (Japanese badger dogs) who battle developers to save their idyllic forest homes in Tama Hills, just outside of Tokyo. Favorites of traditional story and legend, these overfed cousins to the raccoon are known for changing their form to baffle pursuers and trick intruders. Takahata's tanuki transform into everything from iron pots to Tokyo businessmen while calling on a wild and wonderful assortment of monsters and goblins to aid them in their struggle against human invaders.

In 1995, Studio Ghibli released *Whisper of the Heart (Mimi wo Sumaseba)*, a simple love story about a fourteen-year-old girl who wants to be a writer and a fifteen-year-old boy who wants to go to Italy to become a violin maker. Though Yoshifumi Kondo directed, Miyazaki wrote the script and contributed an incandescently gorgeous flying sequence. While working on *Mimi*, however, he was already involved in the production of his next film, *Princess Mononoke*.

Takahata is directing Studio Ghibli's eleventh film *My Neighbors the Yamadas*, about which he has said little other than it will take the family as its theme. Set for release in 1999, it will cost nearly ¥1.6 billion (13.3 million) to make and be fully digital. Meanwhile, Miyazaki is contemplating his next project, which may well become Ghibli's first of the twenty-first century.

What will become of Studio Ghibli when he and Takahata lay down their pens for the last time? A clear successor is not yet in sight and Miyazaki has expressed his doubts that one can be found. Studio Ghibli films are less the products of a formula than of the creations of two individual talents, the studio less a dream factory consecrated to mammon than an animation atelier dedicated to excellence. But whether or not the studio survives, the films, which have proven that animation can entertain a mass audience while expressing a personal vision and tell an absorbing story while representing real emotions, are likely to endure.

Mark Schilling is a well-known critic of Japanese films and writer on Japanese popular culture. He has been reviewing Japanese films for "The Japan Times" since 1989 and reporting on the Japanese film indusry for "Screen International" magazine since 1990. He also frequently contributes articles on animation and other aspects of Japanese popular culture to publications both in Japan and abroad, including the Japan edition of "Premiere," "The Asian Wall Street Journal," "The Japan Quarterly," "Winds" and "Kinema Jumpo." In 1997 he published "The Encyclopedia of Japanese Popular Culture," an indispensable guide to the modern Japanese pop culture of the last fifty years. A resident of Japan since 1975, Schilling lives in a suburb of Tokyo with his wife, Yuko, and his two children, Ray and Lisa.

THE ART OF
Princess
MONONOKE

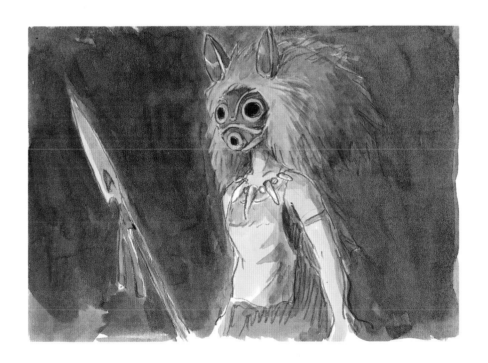

もののけ姫

人は、かつて、森の神を殺した

人面と獣の身体、樹木の角を持つ森の神・シシ神を
人はなぜ、殺さねばならなかったのか——

この時代、人間がふえ、多くの原生林が拓かれたとはいえ、
まだ人を寄せつけぬ太古の森が、あちこちに残っていた
それぞれの森は、猪や山犬など
巨大で賢かった獣たちが必死になって守っていた

そして、聖域を侵す人間たちを襲い
荒ぶる神々と恐れられていた
その獣たちを従えていたのが、シシ神である

荒ぶる神々ともっとも激しく戦っていたのは
タタラ者と呼ばれる製鉄集団だった

女の身でタタラ集団を率いるエボシ御前
彼女は己が信念で、森を切り拓いていた
その配下で、御前を敬い慕う、ゴンザにオトキと甲六
シシ神をねらう正体不明の坊主・ジゴ坊
乙事主、ナゴの神、モロなど森を守る神獣たち
それに森の精霊・コダマたち……

少女サンは人間の子でありながら
山犬モロに育てられた「もののけ姫」だった
サンは、森を侵す人間を激しく憎んでいた

そして、人間と荒ぶる神々の最後の大決戦に
巻き込まれる少年アシタカ

彼は、死の呪いをかけられたがゆえに
穢れを浄める方法を探しに、旅に出た少年だった

少年と少女は惨劇の中で出会い、
しだいに心を通わせていく
ふたりが憎悪と殺戮の果てに
見い出した希望とは、何だったのか

少年と少女の愛を横糸に
シシ神をめぐる人間たちの戦いを縦糸に
波乱万丈の一大叙事詩が、展開されていく……

Princess MONONOKE

There was a time, long, long ago
When people killed the Great God of the Forest.

Human face. Body of a stag.
Horns atop his head like the trunks of massive trees.
For what reason did the humans take his life?

The human population was large.
Much of the ancient forests had been cut.
Here and there, stands of the old forest remained
Defying the humans' attempt to penetrate it.

Great wise beasts, wolves, boars and others
Desperately guarded the last sanctuaries.
They were feared as rampaging gods.
They revered the Great God of the Forest.

A clan called Tatara were makers of iron,
And it was the Tatara who fought battle after savage battle
With the raging gods of the forest.

Their leader was a woman, the Lady Eboshi,
Determined to clear and open the forest.
And to those that served her
Gonza, who would follow her through the gates of hell,
Otoki and Kohroku.

And the mysterious priest, Jiko, who is sworn
To capture the head of the Great God of the Forest.

The old woman, the Oracle, the far-seeing and wise
Lived in a village remote and hidden from time.

Nago, Moro and Okkotonushi, fierce-eyed and terrible
Rampaging gods who guarded the forest.
And the tiny woodland spirits, the Kodama.

The girl San was born a human
But she was raised by Moro the wolf
To be the Princess Mononoke, the defender of the forest.
She loathed the humans who invaded their land.

The youth Ashitaka, delivered by fate
Into the midst of the last desperate battle
Between the humans and the rampaging gods,
On a journey to cleanse from his body a scar
And escape its slow curse of death.

Ashitaka and San,
Met in the midst of the carnage and chaos of battle.
What hope could there be for feelings of love
Born of a place steeped in hatred and killing?

In the weaving of this epic tapestry,
Which current will prevail?
The battle between forest and human
Or the love between warrior and princess?

Princess Mononoke

The quivering string of a fully drawn bow
Your heart astir in the moonlight
Your beautiful face seen from the side
Unforgiving as the edge
Of a just-sharpened sword

Those who know your true heart
Hidden in grief and anger
Only the spirits
Only the spirits of the forest

The Legend of Ashitaka

A legend is a wind that moves unseen
As if passing through a sea of grass.

In rough mountain lodges where life is harsh
The villagers' voices yet whisper a story
Of the youth Ashitaka from the borderlands,
A story not written in history books.

Ashitaka the gallant, Ashitaka the brave
Who never once thought to turn from his fate.
Ashitaka who loved the people. Ashitaka who loved the forest.
Ashitaka who saw with eyes clear and bright.

Again and again to their children
The villagers tell this tale.
Again and again they tell them,
Children, live like Ashitaka.

The Lost People

Deep in the forest, when this island was young,
Far to the east, where the beech and oak grow,
There lived a proud people, called the Emishi.
The men rode red elk, the horned steed of legend,
And shot jade-tipped arrows,
And coursed o'er hills and meadows.

The women wore their hair combed straight
And adorned their bodies with jewels
Beautiful, and elegant, and strong.
The people revered the gods of the forest
Listened ever closely to the forest's still breathing,
And offered to the forest their songs.

And suddenly, like a surging tidal wave
The people of the Western Emperor came.
The forest people fought with courage
They fought, but they fought in vain.

Victory at times they tasted in battle
Pushing the enemy back to the lowlands
Pillaging storehouses, taking rich prizes.
But defeat at times they also suffered
Carrying their wounded
To hide away deep in the mountains.

Year after year
They struggled
But could not stay the western tide
And finally
Left their lands
Forever
Swallowed by the mists
And forgotten.

Perhaps there will come a time
When the strength of the Western Emperor fades
And his tiger-generals retract their claws
And perhaps the children of the lost people will return
To the land that was once theirs
Astride the great red elk as in days of old
Revering the forest
Seeing things clearly as they are
Passing over the land as the wind.

The blood of the lost people
Flows in us
Oppressed, forgotten, and despised
Yet their story still survives.

The Demon God

The rampaging demon god has come from the west,
His body a writhing mass of foul black snakes.
He comes from darkness and goes to darkness
Burning whatever he touches.

This most ancient god of the mountains by man has been shot
A giant wild boar driven from his forest
Driven mad by his broken bones, his rotting flesh, and his painful wounds
Runs and runs over mountains, across valleys
Wrapped in an alchemy of doom
Fueled by his gathering rage
Until at last he has become a demon god
A living curse of hate and revenge.

Fate itself has collapsed into the form of an animate being
And all living things tremble before its rage,
Cannot approach it
Cannot stop it
Daring not even to breathe
Waiting for it to pass.

Behold the wretched ancient god.
If you can, help his spirit find peace
If you can, help his spirit find rest
This giant god of another time.

Moro the Wolf God

Do not look into her eyes
Awakening her great despair
For she will rip you to shreds
And devour your still-beating heart.

Bristles of silver hair and a forked tail
A mirror to another world
A fragment of a nature that no longer exists
Ancient forest gods that once were, but are no longer.

Nothing left but despair for what has gone
And regret for what cannot be changed.
Gentleness is her true nature
But people have taught her to hate.

Lady Eboshi

Your heart of steel so fearless.
Your will so fierce.
So kind are you to the weak,
Yet merciless to your enemies.

Your neck so white,
Your arms so slender,
Your strength so great!

Your chosen path you follow, without doubt or hesitation.
Earning your followers' adoration.

Far off into the distance you stare.
Is what you see with those eyes the future?
Or do they gaze on some past hell?

Kodama

You appeared in the dim light of the forest
Or so I thought
For no sooner had my ears taken in
Your rattling queer laugh
Than I glimpsed you again
Now closer
Walking by my feet.

Or have you really been smiling there all the while
Out in the darkness beyond?

If I beckon, you turn bashful and run away.
If I pretend not to notice, you cling to my knees.
Little children
Your forest is a place of wonders.

Yakkuru

Great noble animal
Last remnant of a dying breed
Your legs do not fear steep slopes
You run like a bird in flight.

My old, dear friend
You loyal, simple being.
Your fur is soft and smooth
Your glance is warm and watchful.
Let us run together to the ends of the earth!

The Forest of the Deer God

A forest existing since the birth of time
Deep and dark
Filled with a radiant spirit
Full of creatures that have long since vanished from the world
A forest where the Deer God dwells.

Strange animal.
Body of a deer. Face of a man.
Horns like the tangled branches of a tree.
A terrible and beautiful god
Who dies together with the old moon
And is reborn again with the new.
A god who remembers when the forest was born
And who still has the heart of a child.

A god who brings both life and death.

At the touch of the Deer God's hoof
Grass grows, trees revive
Wounded animals regain their strength.

At the touch of the Deer God's breath
Grass withers, trees rot
And Life ends without fail.

The forest where the Deer God dwells
Is a world where a radiance beckons
And humans are not welcome.

The poems translated from the Japanese on pages twelve to nineteen were written by Hayao Miyazaki to communicate his vision of the film to Jo Hisaishi, who composed the music for The Princess Mononoke.

The Battle Between the Rampaging Forest Gods and Human Beings

This film has few of the samurai, feudal lords, and peasants that usually appear in Japanese period dramas. And the ones who do appear are in the smallest of small roles. The main heroes of this film are the rampaging forest gods of the mountains and the people who rarely show their faces on the stage of history. Among them are the members of the Tatara clan of ironworkers, the artisans, laborers, smiths, ore diggers, charcoal makers, and drivers with their horses and oxen. They carry arms and have what might be called their own workers associations and craftsman guilds.

The rampaging forest gods who oppose the humans take the shape of wolves, boars, and bears. The Deer God on which the story pivots is an imaginary creature with a human face, the body of an animal, and wooden horns. The boy protagonist is a descendant of the Emishi tribe, who were defeated by the Yamato rulers of Japan and disappeared in ancient times. The girl resembles a type of clay figure found in the Jomon period, the pre-agricultural era in Japan, which lasted until about 8 A.D.

The principal settings of the story are the deep forests of the gods, which humans are not allowed to penetrate, and the ironworks of the Tatara clan, which resembles a fortress. The castles, towns, and rice-growing villages that are the usual settings of period dramas are nothing more than distant backdrops. Instead, we have tried to re-create the atmosphere of Japan in a time of thick forests, few people, and no dams, when nature still existed in an untouched state, with distant mountains and lonely valleys, pure, rushing streams, narrow roads unpaved with stones, and a profusion of birds, animals, and insects.

We used these settings to escape the conventions, preconceptions, and prejudices of the ordinary period drama and depict our characters more freely. Recent studies in history, anthropology, and archaeology tell us that Japan has a far richer and more diverse history than is commonly portrayed. The poverty of imagination in our period dramas is largely due to the influence of clichéd movie plots.

The Japan of the Muromachi era (1392-1573), when this story takes place, was a world in which chaos and change were the norm. Continuing from the turbulent Nambokucho era (1336-1392), when two imperial courts were warring for supremacy, it was a time of daring action, blatant banditry, new art forms, and rebellion against the established order. It was a period that gave rise to the Japan of today. It was different from both the Sengoku era (1482-1558), when professional armies conducted organized wars, and the Kamakura era (1185-1382), when the strong-willed samurai of the period fought each other for domination.

It was a more fluid period, when there were no distinctions between peasants and samurai, when women were bolder and freer, as we can see in the *shokuninzukushie*—pictures that depicted women of the time working at all the various crafts. In that era, the borders of life and death were more clear-cut. People lived, loved, hated, worked, and died without the ambiguity we find everywhere today.

Here lies, I believe, the meaning of making such a film as we enter the chaotic times of the twenty-first century. We are not trying to solve global problems with this film. There can be no happy ending to the war between the rampaging forest gods and humanity. But even in the midst of hatred and slaughter, there is still much to live for. Wonderful encounters and beautiful things still exist.

We depict hatred in this film, but only to show that there are more important things. We depict a curse, but only to show the joy of deliverance. Most important of all, we show how a boy and a girl come to understand each other and how the girl opens her heart to the boy. At the end, the girl says to the boy, "I love you, Ashitaka, but I cannot forgive human beings." The boy smiles and says, "That's all right. Let's live together in peace."

This scene exemplifies the kind of movie we have tried to make.

Hayao Miyazaki

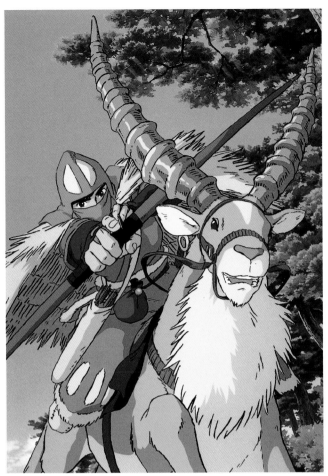

Cel drawing for the first film poster.

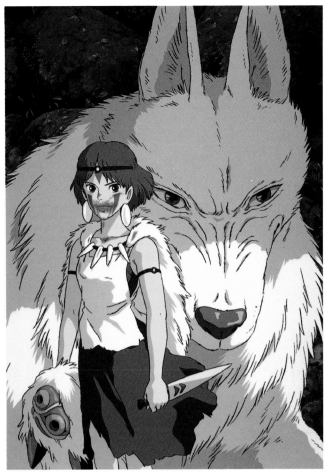

Cel drawing for the second film poster.

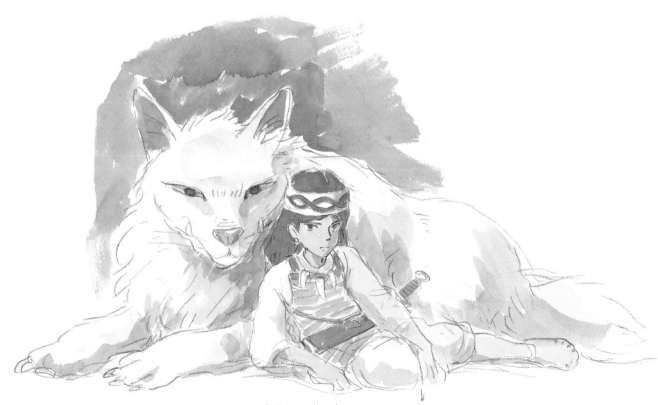

Early image board.

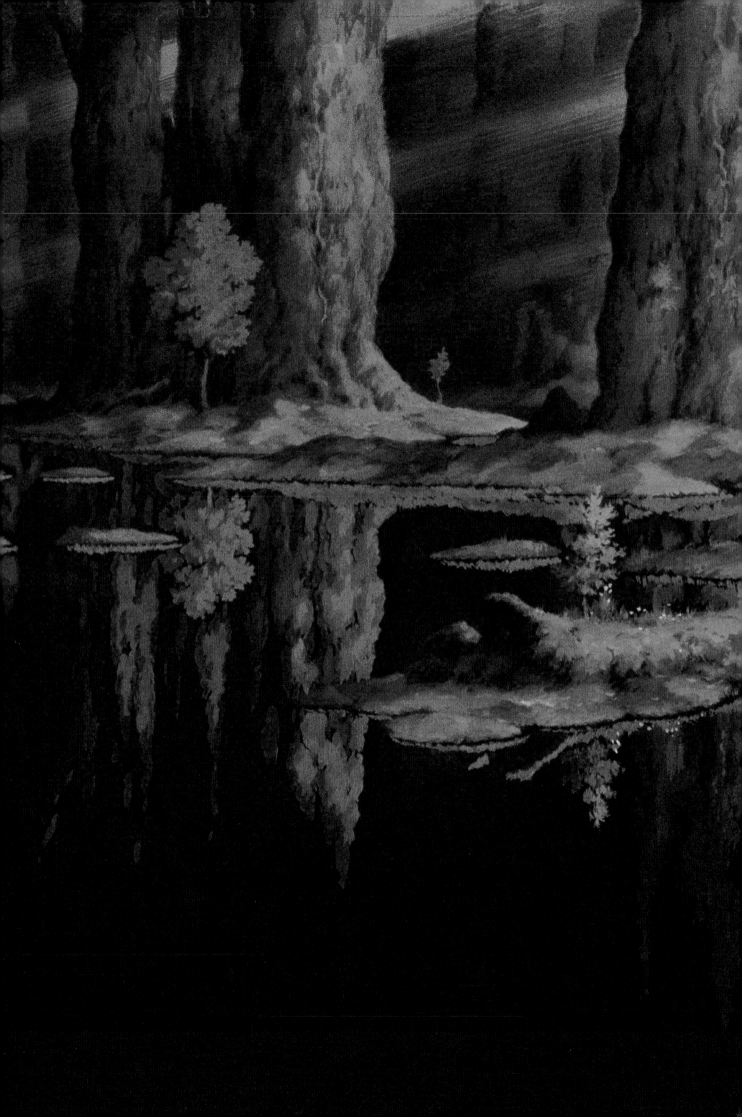

THE ART OF Princess MONONOKE

Contents

About This Book

This book is a collection of image concept art, background drawings, and cel drawings that tell the story of _Princess Mononoke,_ an animated film conceived, scripted, and directed by Hayao Miyazaki. The concept art is by Hayao Miyazaki, while the background art was drawn by five artists, Jisan Yamamoto, Naoya Tanaka, Yoji Takee, Satoshi Kuroda, and Kazuo Oga. The book also contains storyboards and continuity drawings by Hayao Miyazaki and character sketches by animation director Masashi Ando. Studio Ghibli did not image process some of the cel drawings that appear in the book and thus they differ from those used in the film.

(Outside cover, image art) The forest of the Deer God. _(Inside cover, cel drawing of the characters only)_ San, together with the boar gods, is about to join battle with human beings led by Lady Eboshi. _(Back inside cover and page 1, storyboards)_ Scenes not used in the film, _(pages 4–7, background drawing)_ Green mountains in the mist that appear in the opening scenes. _(Pages 8–11, background drawing)_ Virgin stand of beech trees from the opening scenes. _(Pages 14–15, art board)_ The forest of the Deer God.

The Curse of the Demon God

The Demon God suddenly attacks an Emishi village hidden in the far reaches of the North Country. The youth Ashitaka, a descendant of his tribe's chieftains, shoots and kills the Demon God with his arrows to protect his village. For having touched the Demon God, Ashitaka is cursed, and bears an ill-omened red and black scar on his right arm. To rid himself of the curse, Ashitaka journeys to the West Country.

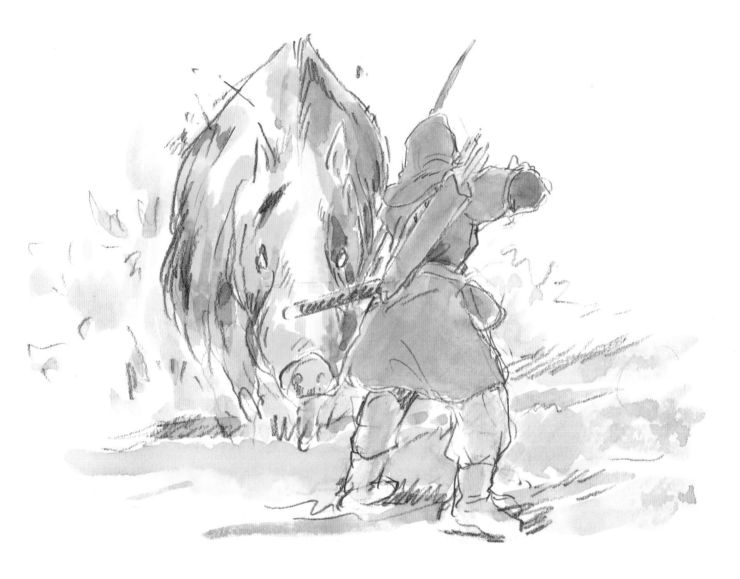

(*Storyboard*) Ashitaka shoots an arrow at the Demon God, who is charging toward the Emishi village.

Mountain Village in the North Country

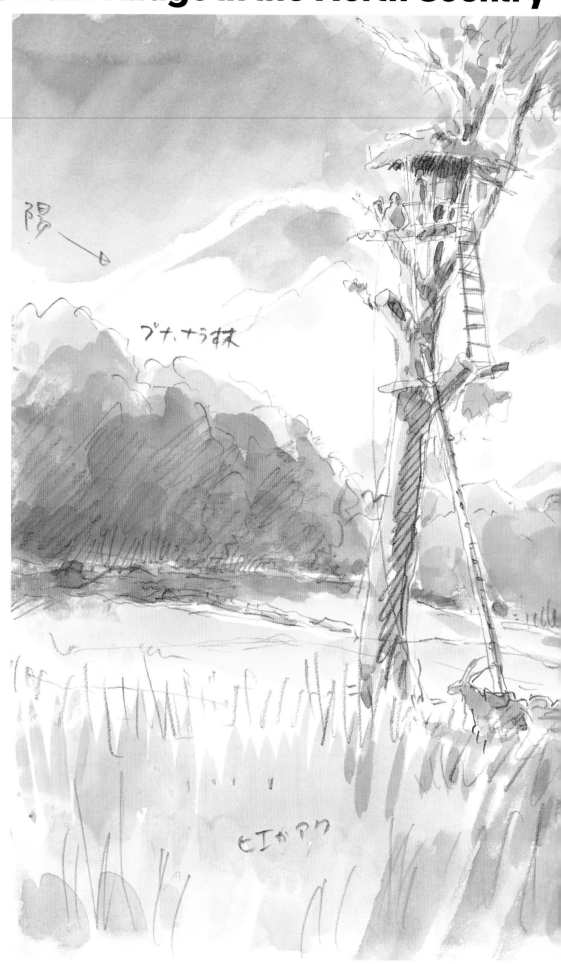

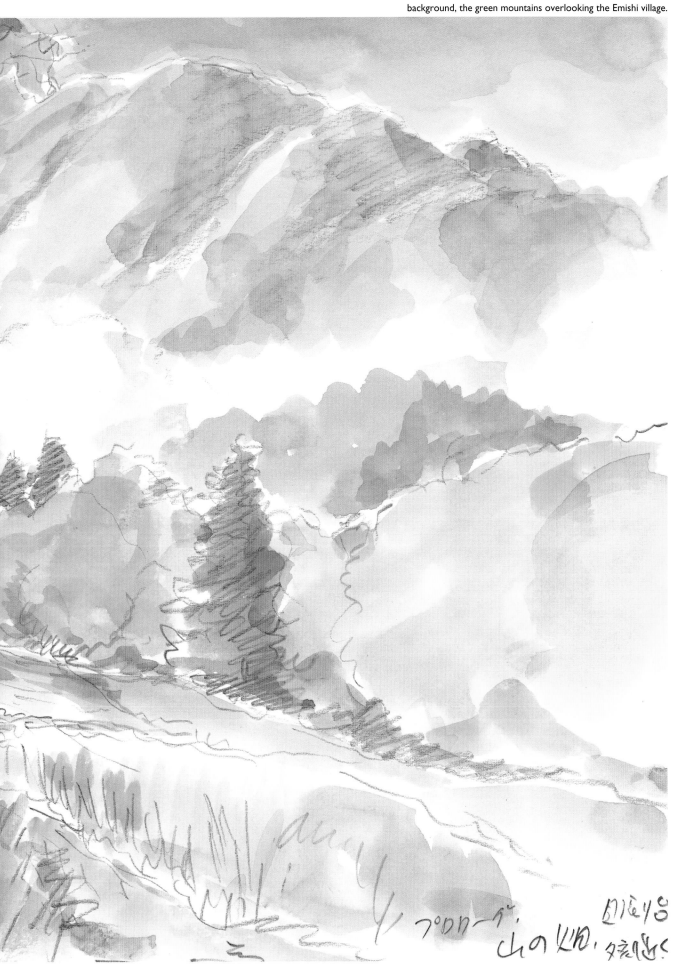

(Image board) In the foreground are mountain fields and, in the background, the green mountains overlooking the Emishi village.

プロローグ・
山の火田、夕方近く

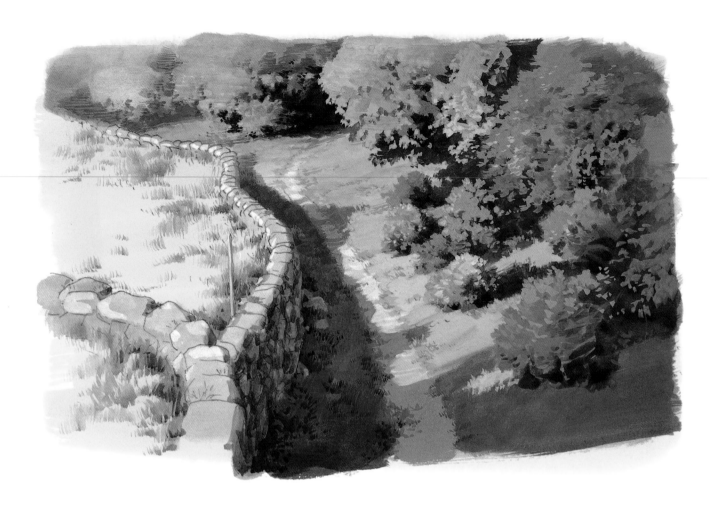

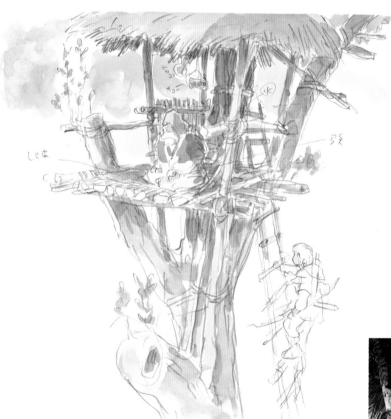

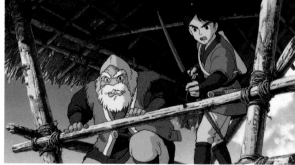

(Upper left, art board) Slope near the village, bounded by a stone fence. *(Middle left, image board)* Observation tower. *(Lower left, cel drawing)* Grandfather and Ashitaka intently watch the Demon God. *(Right, background drawing)* A road between stone walls, leading to the observation tower.

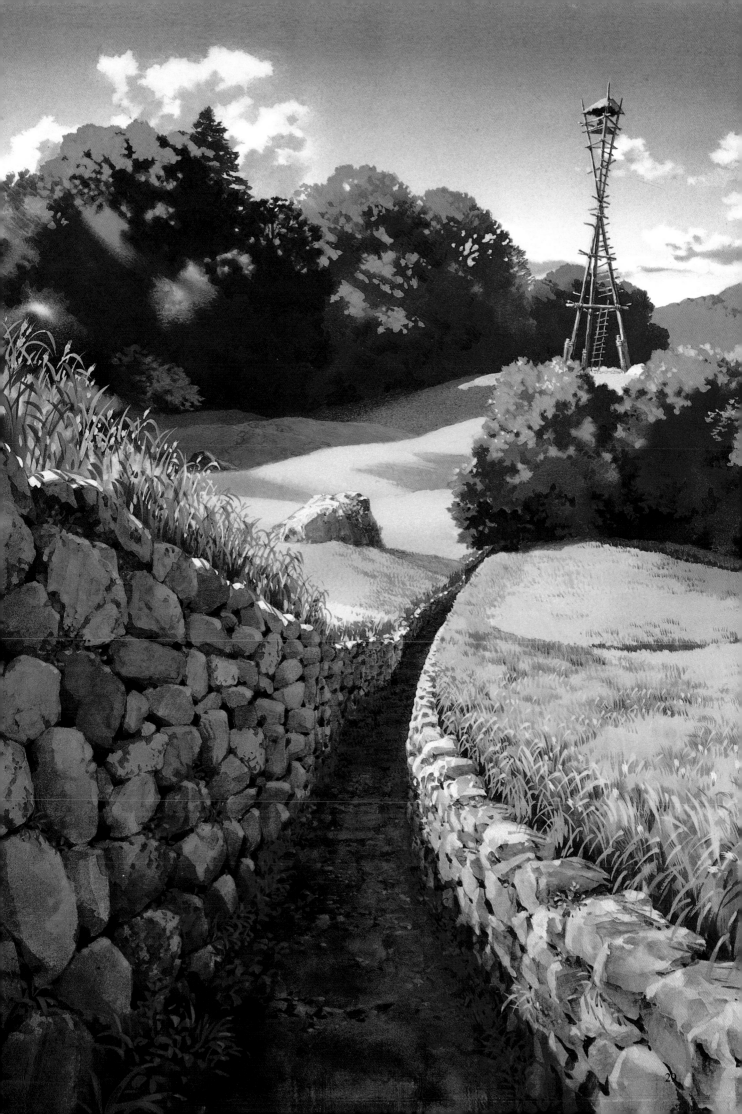

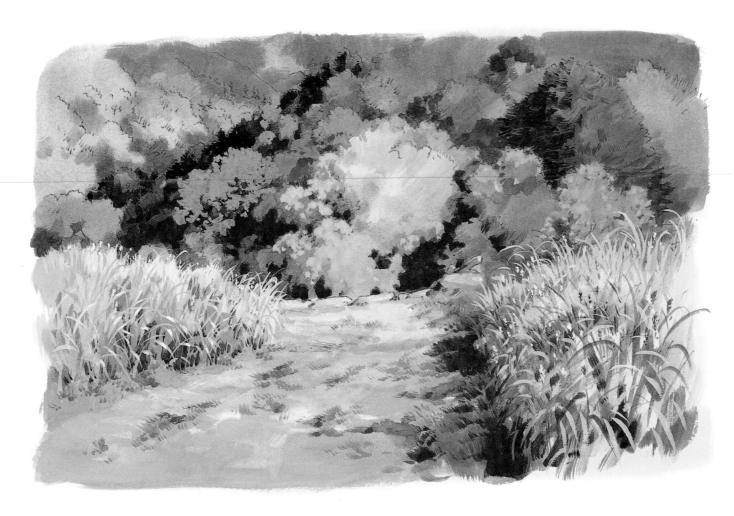

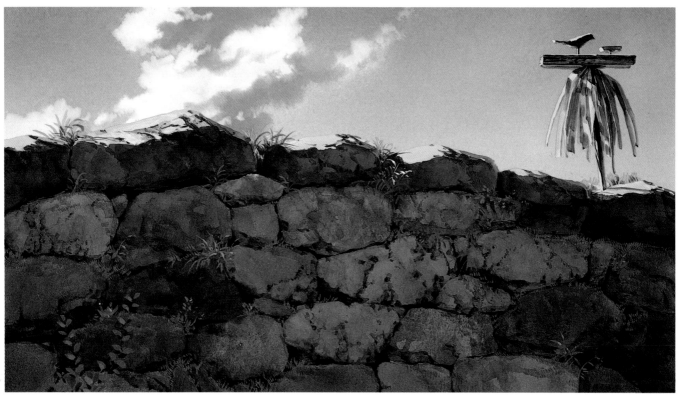

(Upper, art board) A field of foxtail millet and Deccan grass near the village.
(Lower, background drawing) An old moss-covered stone wall.

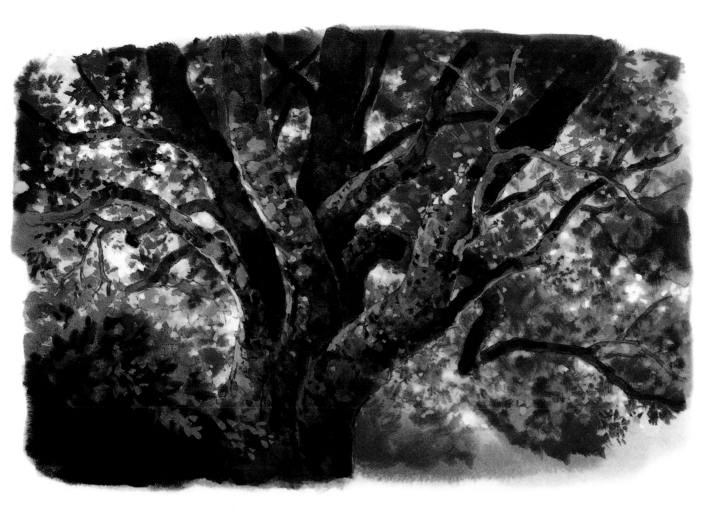

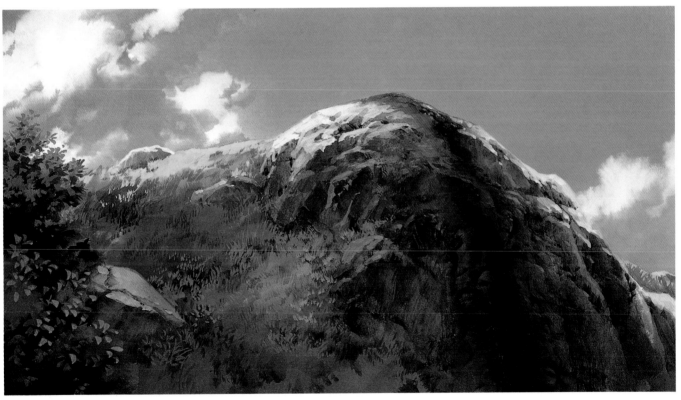

(Top, art board) A grove at the base of the valley, below the observation tower.

(Bottom, background drawing) A rocky outcrop burned a reddish brown by the Demon God.

The Attack of the Demon God

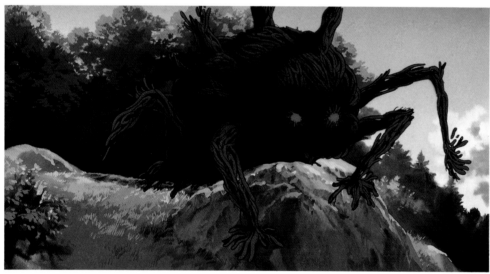

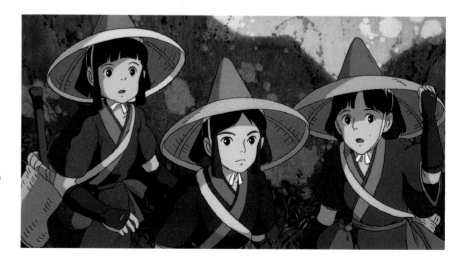

(*Top, CG [computer graphics] image*) The Demon God emerging from the depths of the forest and breaking through a stone wall. (*Middle, cel drawing*) The Demon God moving its black, snakelike feelers and scorching the grass by the stone outcropping. (*Bottom, cel drawing*) Three Emishi girls sense that something is amiss. The girl in the middle is Kaya.

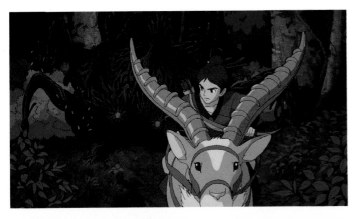

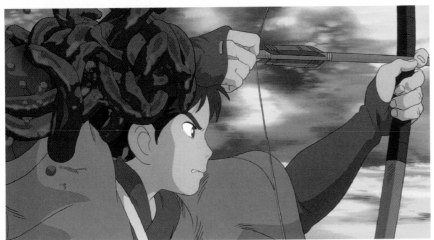

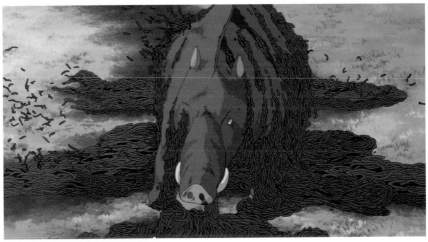

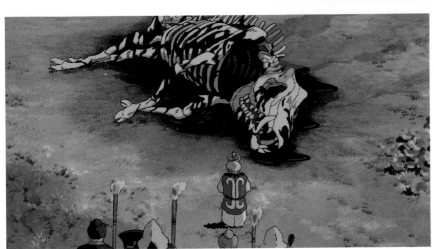

(Upper left, cel drawing) Ashitaka being pursued by the Demon God. (Upper right, CG image) The Demon God extending its feelers and spraying clouds of rage. (Left middle, CG image) With his right arm entangled in the Demon God's tendrils, Ashitaka shoots an arrow. (Right middle, CG image) Tendrils fallen from the Demon God, who has been struck in the temple by an arrow. He is revealed as the dying Nago, a boar god. (Bottom, cel drawing) As the Emishi villagers look on, the body of the dead giant Nago becomes a pile of white bones.

(Storyboard) The Demon God, transformed into a mass of rage.

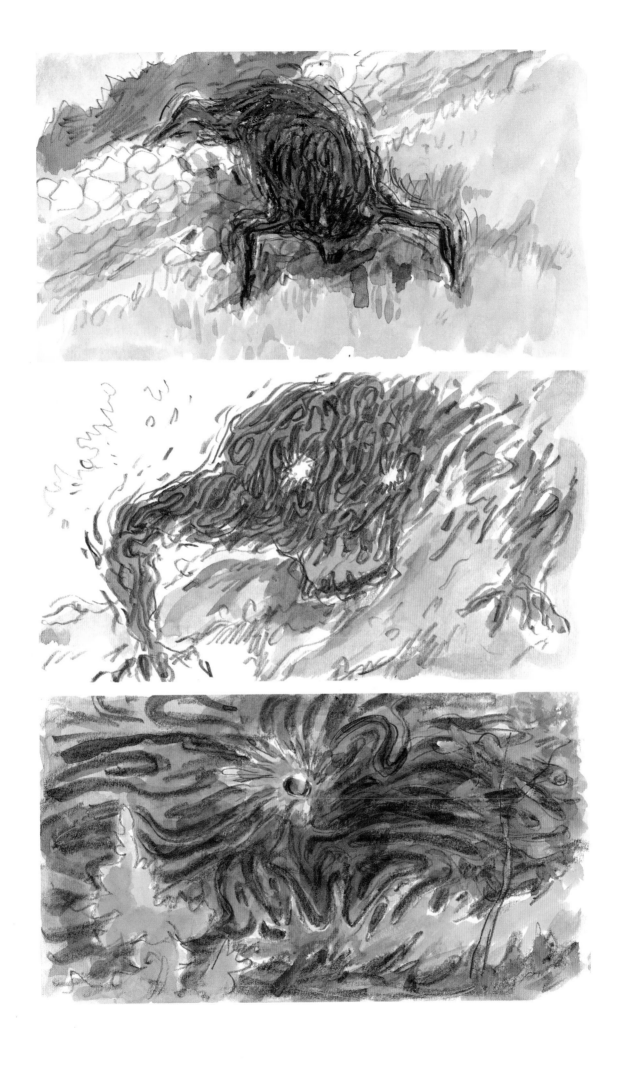

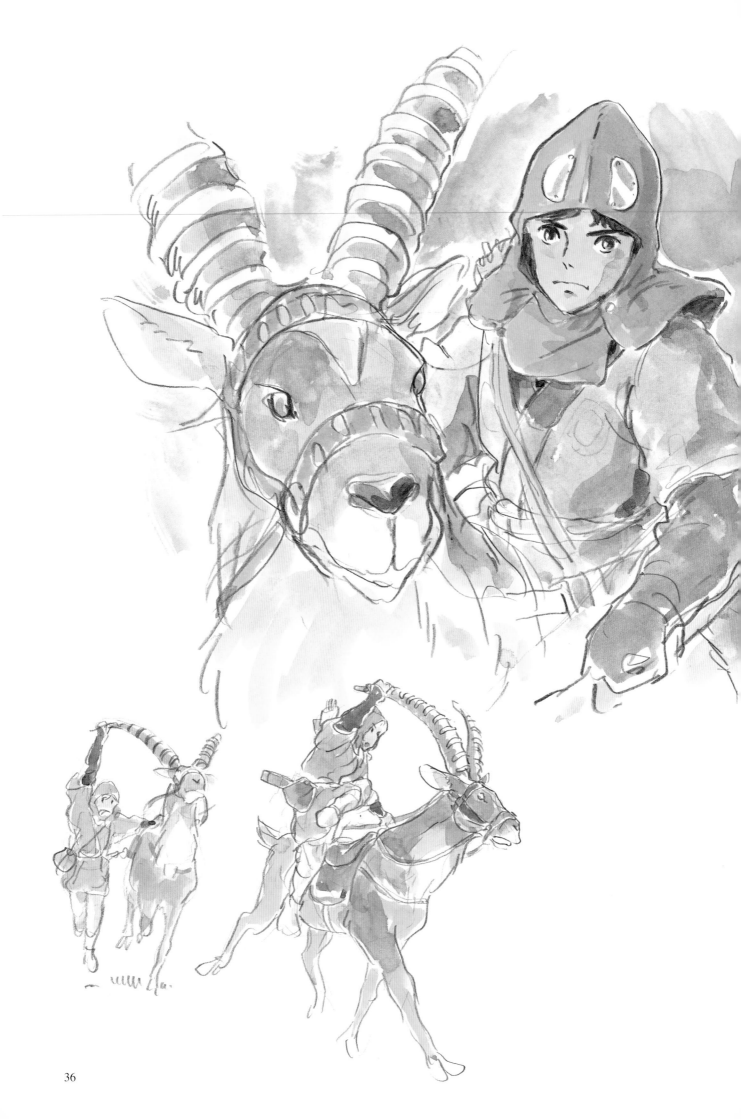

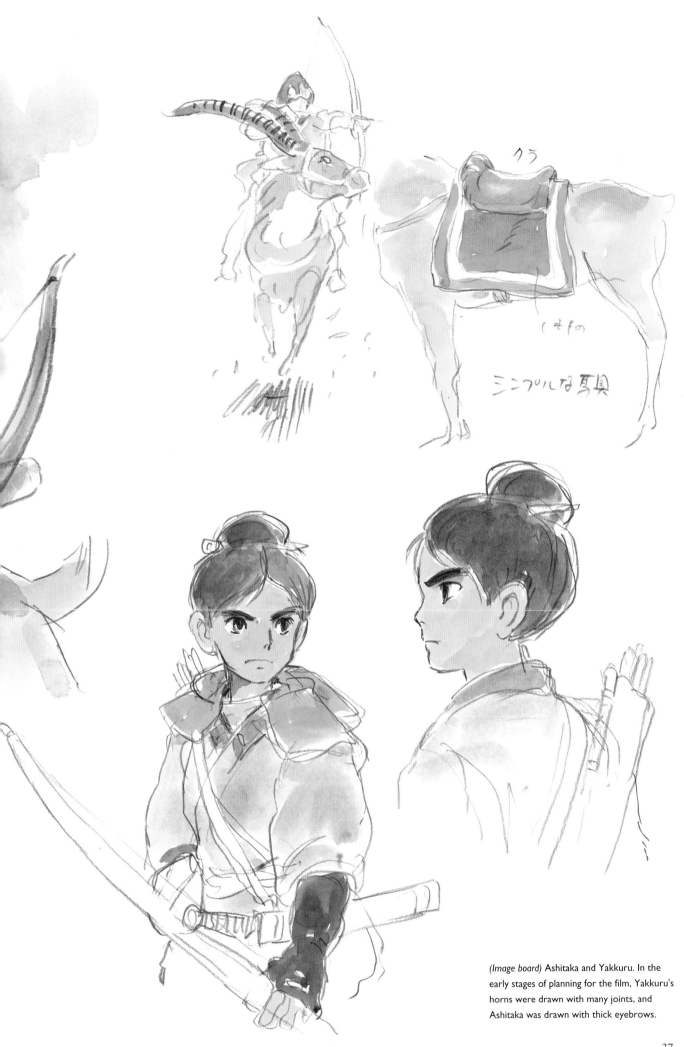

(Image board) Ashitaka and Yakkuru. In the early stages of planning for the film, Yakkuru's horns were drawn with many joints, and Ashitaka was drawn with thick eyebrows.

(Image board) Ashitaka and Yakkuru. Many variations of this character were drawn, including Ashitaka wearing a straw rain cloak and with his hair chopped short.

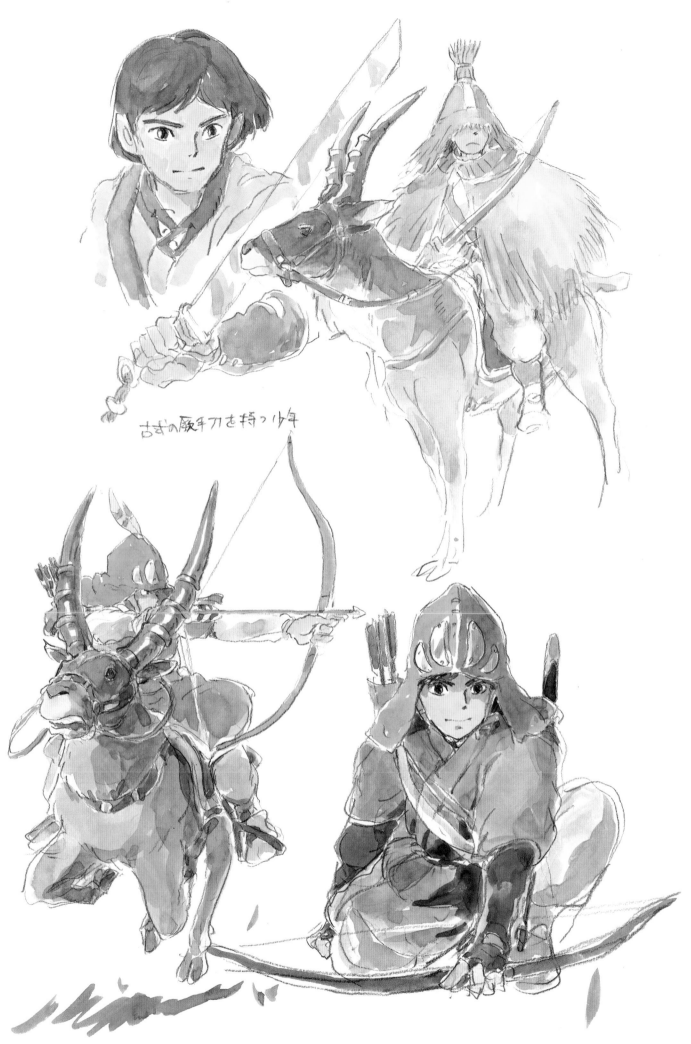

古式の厩手刀を持つ少年

The Emishi Village

(Top, background drawing) A bird's-eye view of the Emishi village. *(Lower left, art board)* The interior of the Emishi village meeting hall. *(Lower right, art board)* The gate of the Emishi village, from which Ashitaka departs on his journey.

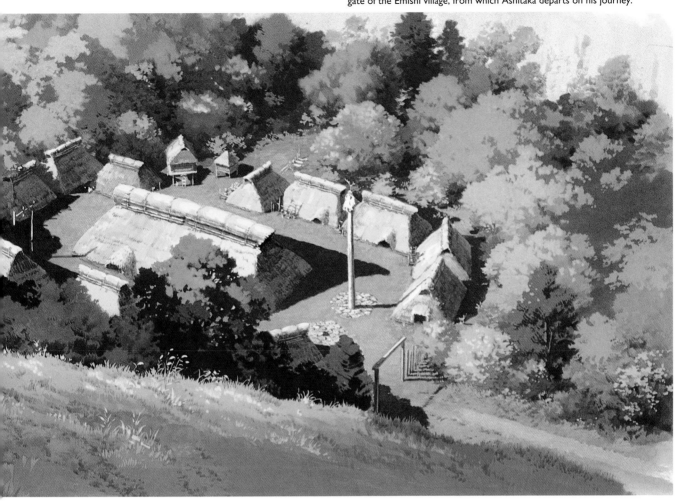

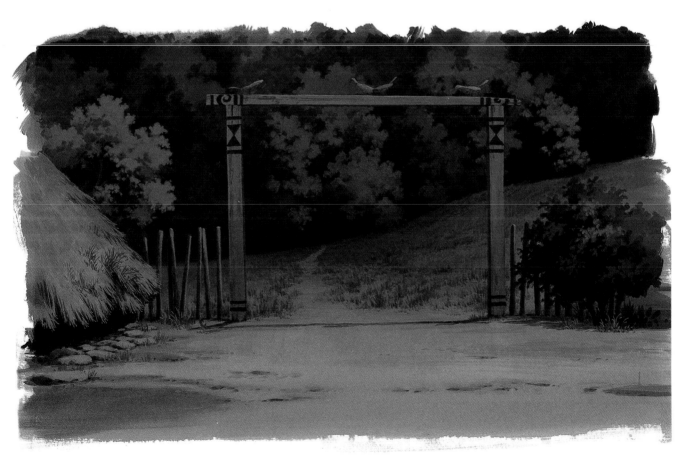

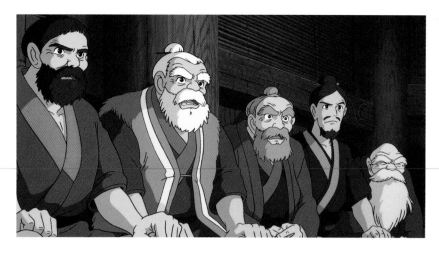

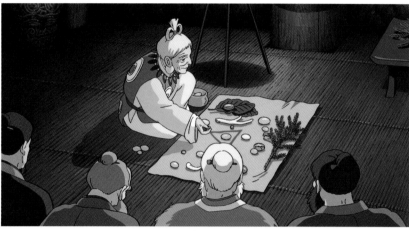

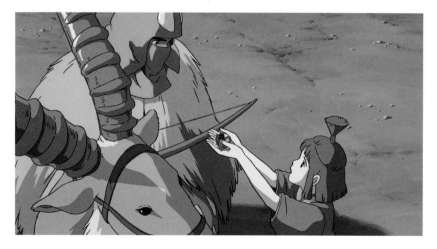

(Upper left, cel drawing) The men of Emishi village assembled in the meeting hall involuntarily gasp when they see the scar on Ashitaka's right arm. Grandfather is sitting second from the left. *(Middle left, cel drawing)* The Oracle tells the fortune of Ashitaka, who has been cursed by the Demon God. She says that, according to her divination, Ashitaka must journey to the West Country. *(Lower left, cel drawing)* Ashitaka is about to leave on his journey to free himself from the curse of death. Kaya, a village girl who loves Ashitaka, gives him a small knife as a good luck token. *(Right page, upper left corner, image board)* The Emishi village. *(Right page, upper right corner, image board)* The Oracle sitting on a verandah and *(below)* the Oracle with a village man. *(Right page, lower left and right, image board)* Grandfather.

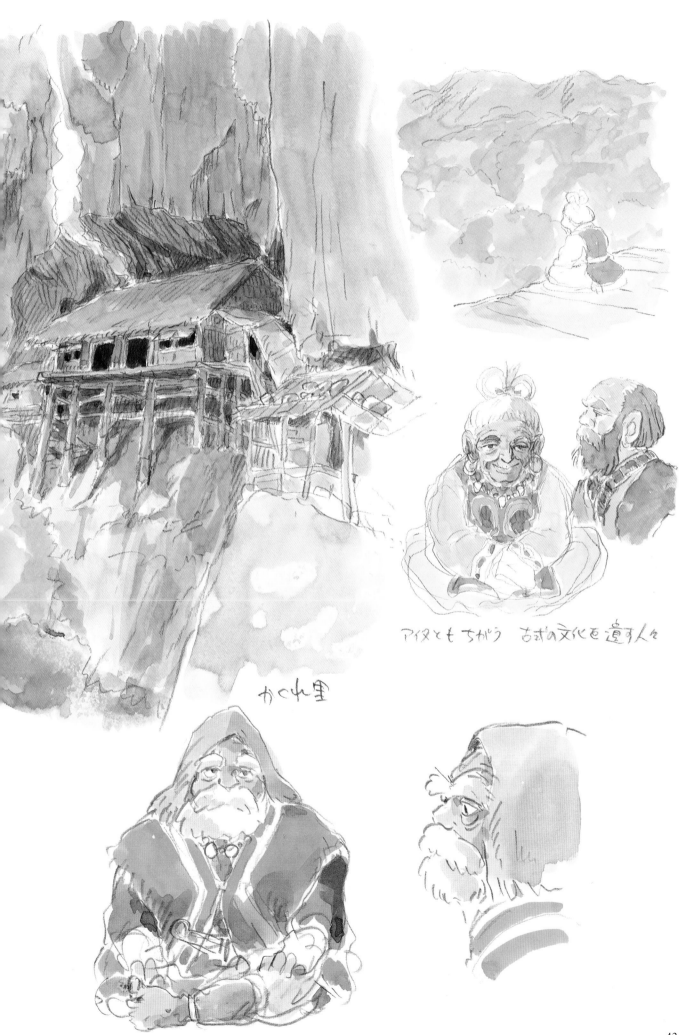

アイヌとも ちがう 古来の文化を 遺す人々

かくれ里

43

Ashitaka Sets Out On His Journey

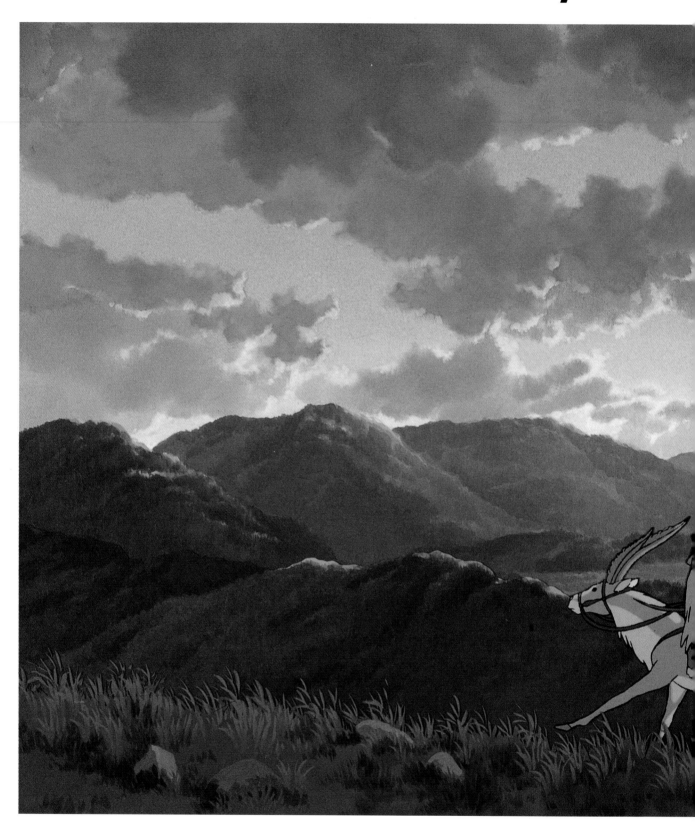

(Cel drawing) Ashitaka and Yakkuru gallop along a mountain ridge
toward the West Country in the fading light of dusk.

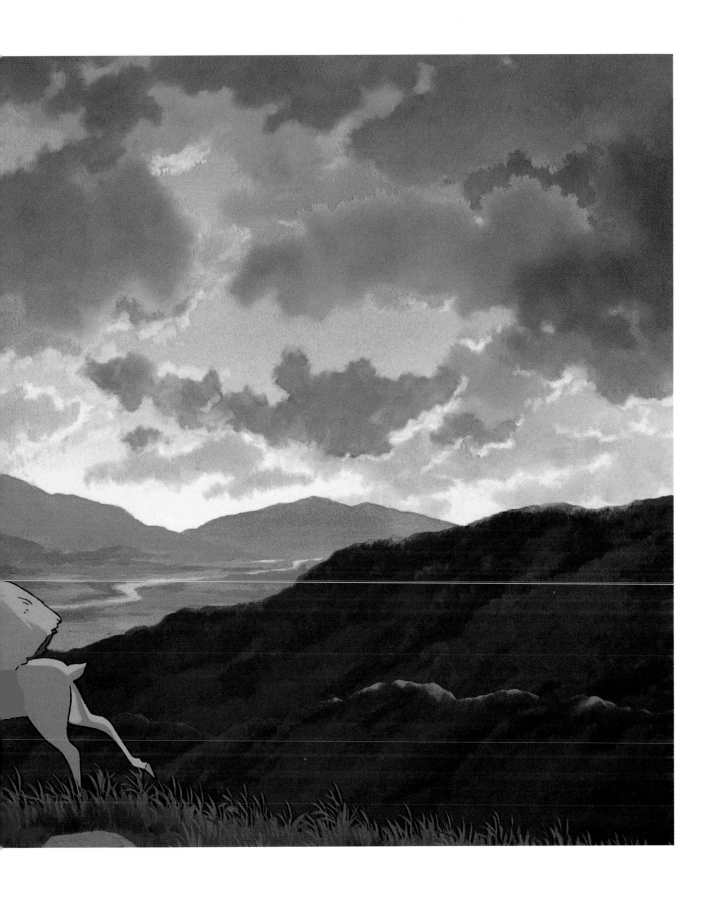

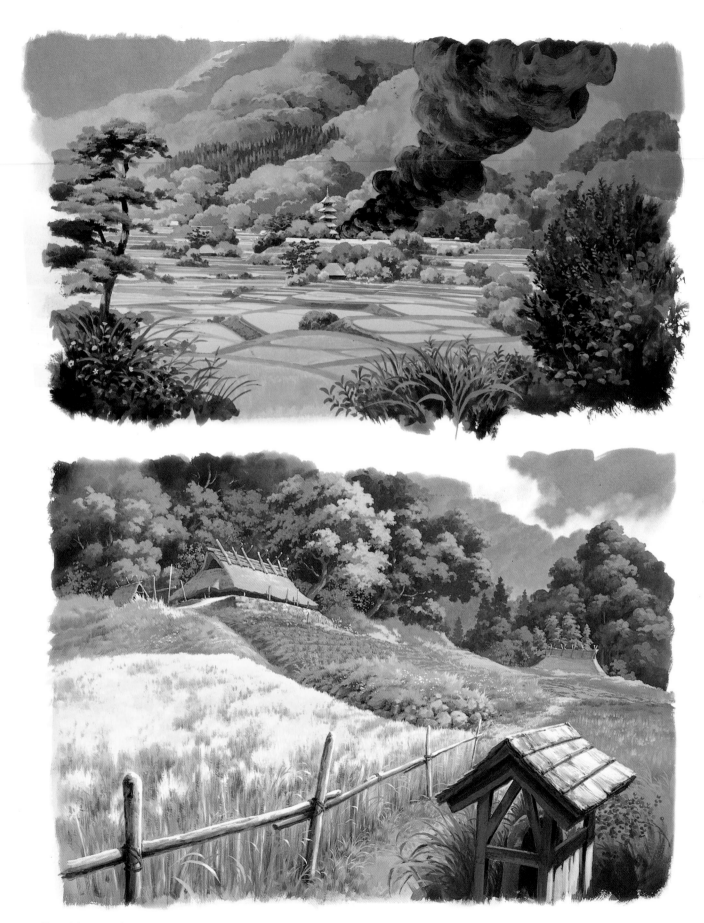

(Upper left, art board) An alluvial plain spreading out before high mountains and wetlands in the distance. In the foreground can be seen hills and rice paddies and, in the background, a burning temple. *(Lower left, art board)* A view of a mountain village, with straw-thatched houses scattered about. *(Right, art board)* A panoramic view of an alluvial plain. A single column of smoke rises from a farming village surrounded by low hills.

46

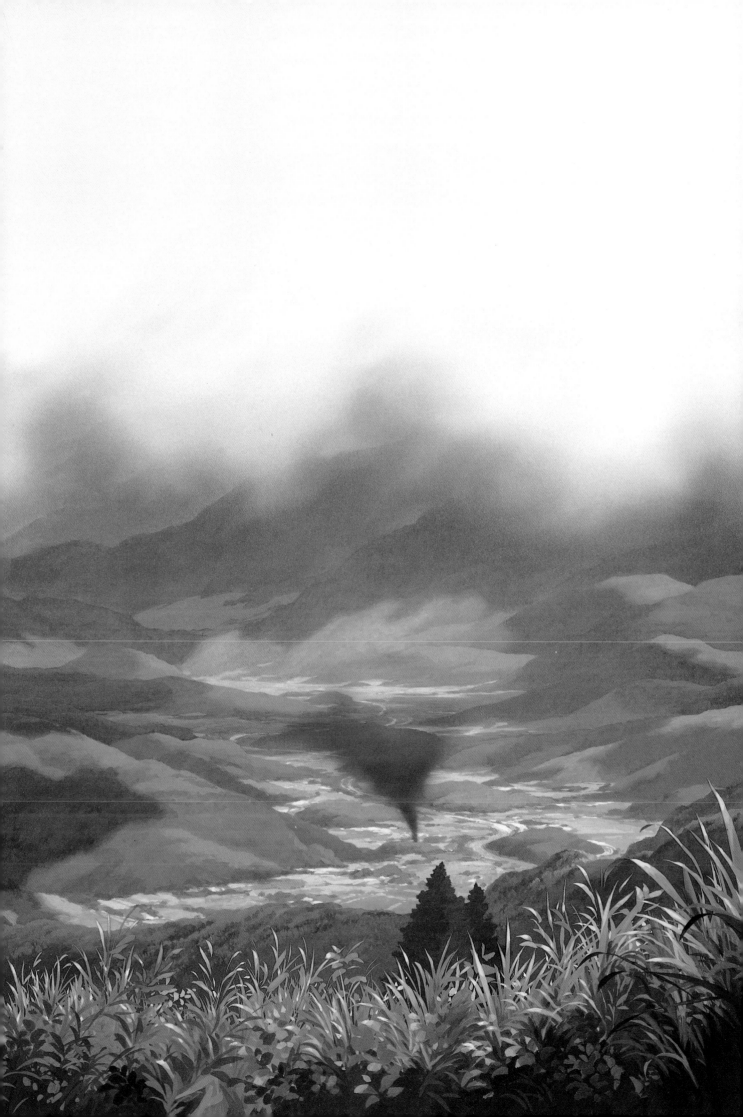

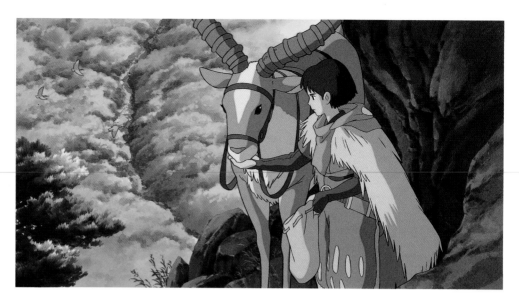

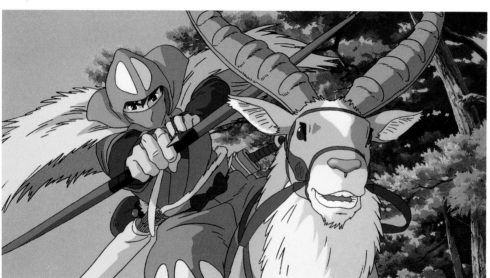

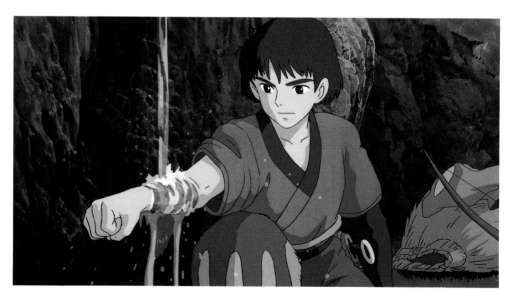

(Upper left, cel drawing) Ashitaka feeds Yakkuru on a rock ledge overlooking an alluvial plane. Below, scarlet ibises soar over a river. *(Middle left, cel drawing)* Passing by a farming village, Ashitaka becomes involved in a fight with a band of marauding samurai. As he shoots arrows at his persistent pursuers from the galloping Yakkuru, pain shoots through his right arm. *(Bottom left, cel drawing)* After escaping to a grove of Japanese cedar trees, he soothes his hurting arm by thrusting it under a stream of cold water falling from a rock above. *(Right, background drawing)* Even at midday, the cedar grove is wrapped in gloom and darkness.

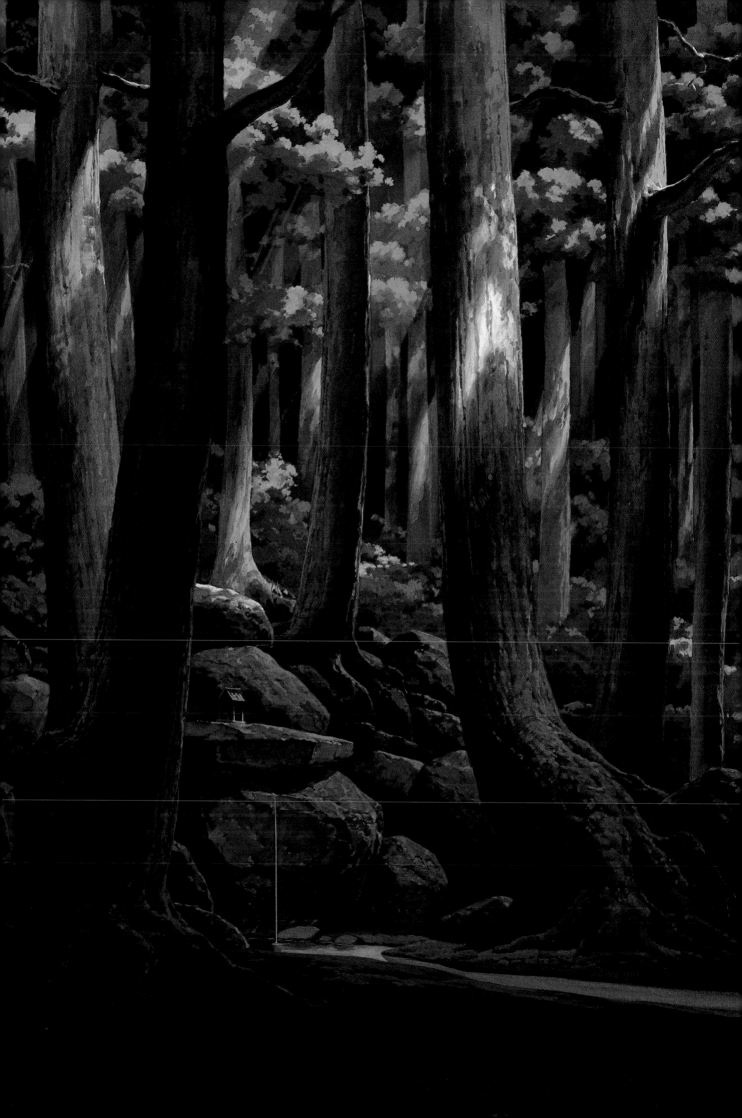

In a Strange Town

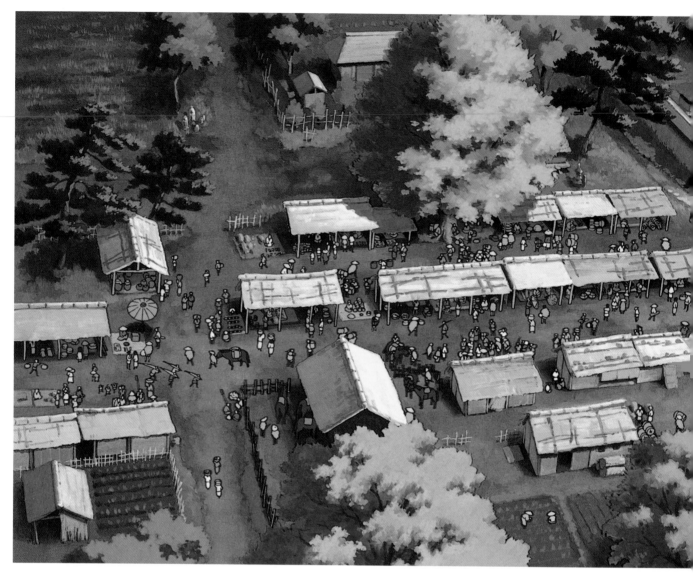

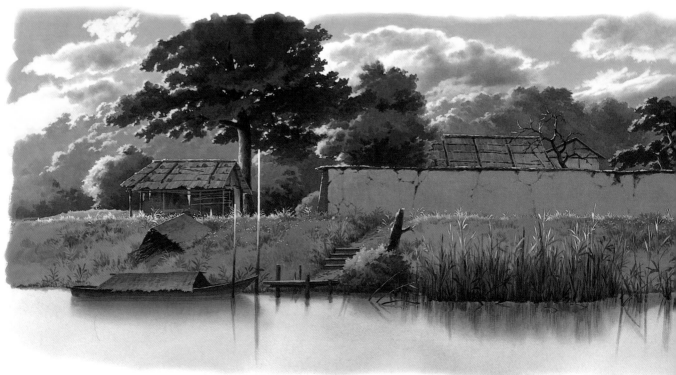

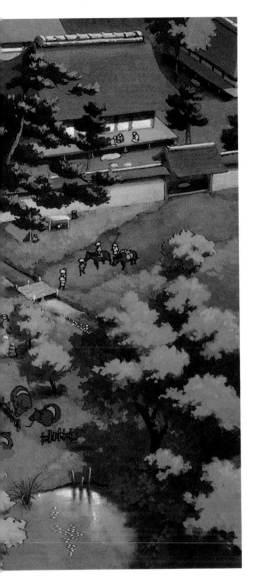

(Top left, cel drawing) Ashitaka comes to town to buy food. A lively market, with street stalls lining the sides of road, is open for business. (Bottom left, background drawing) A river embankment in the town. (Upper right, cel drawing) Ashitaka comes to buy rice at a stall. A throng of passers-by gather around Yakkuru and Ashitaka and gaze at them curiously. (Lower right, background drawing) Stalls in the marketplace, built simply with wooden poles and joined together at the eaves.

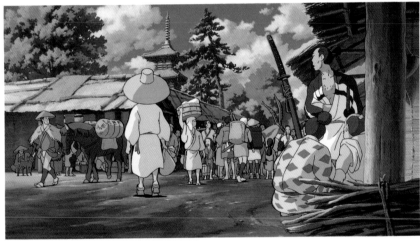

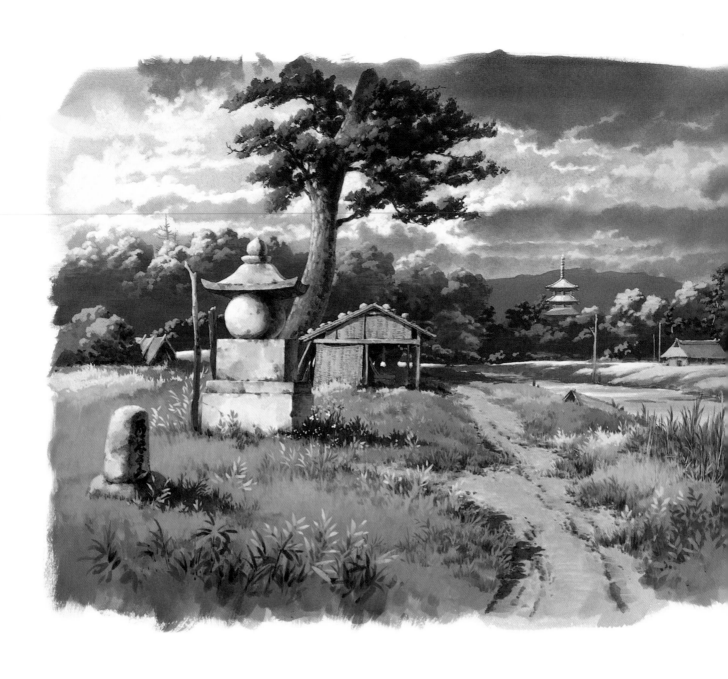

(Upper left, art board) A country road at the edge of town on which Ashitaka travels together with Jiko Bo, a mysterious priest he met at the market. *(Bottom left, background)* The lonely, desolate place where Ashitaka and Jiko Bo camp for the night, where only a humble stone lantern stands guard. *(Upper right, cel drawing)* After spotting Yakkuru at the market, Jiko Bo has become interested in Ashitaka and is about to approach him. *(Middle right, cel drawing)* Jiko Bo and Ashitaka camp under a large tree that has fallen into a muddy stream. Jiko Bo tells Ashitaka about the forest of the Deer God. *(Lower right, character sketch)* Jiko Bo is actually a member of a mysterious organization called the Shishoren *(the Master Sect)*. He wants the head of the Deer God, believing that it has the power of eternal life.

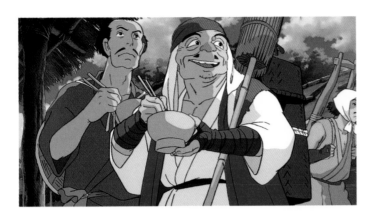

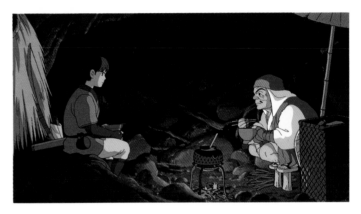

Driving Oxen in the Rain

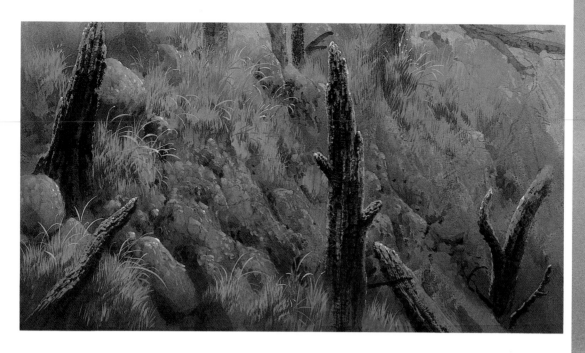

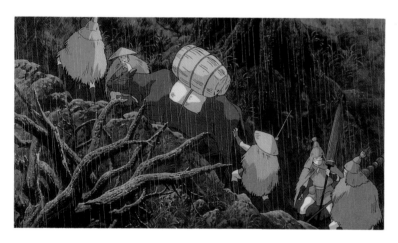

(Upper left, art board) The side of a mountain on the way to the ironworks of the Tatara clan of ironmakers. On the slope, which has been burnt to a reddish brown, are smashed rocks and numberless blackened tree stumps standing like gravestones. *(Lower left, cel drawing)* A procession of ox herders and straw-hatted musketeers on a mountain trail in the rain. *(Right, art board)* A narrow trail carved from the side of a mountain over which the fleeing ox train is attacked by Moro the wolf god.

54

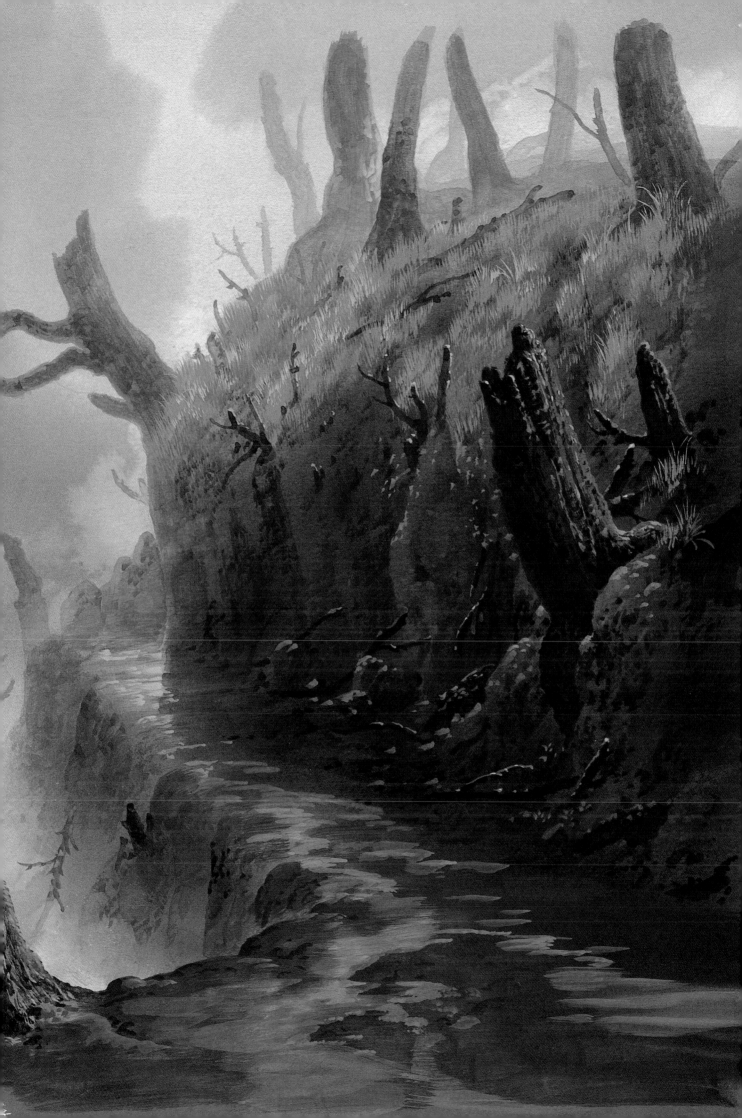

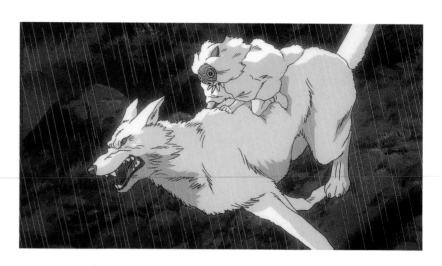

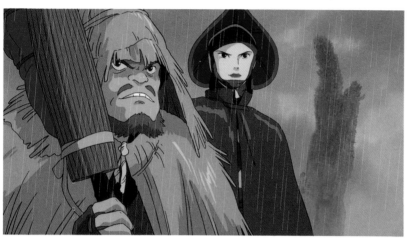

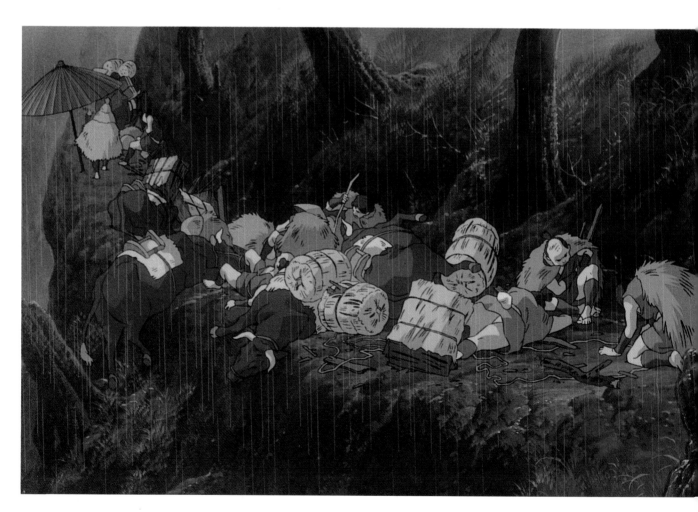

(Upper left, cel drawing) Riding on the back of Moro, San--the Princess Mononoke—attacks the ox train. *(Middle left, cel drawing)* Lady Eboshi, who is the leader of the ox train, and her loyal lieutenant, Gonza, who is the captain of the ox herders and musketeers. *(Upper right, background drawing)* The battlefield on which the ox train receives the charge of Moro. *(Bottom, cel drawing)* The terrible aftermath of Moro's attack. Writhing oxen, fallen and stunned men. Streams of blood and loads of supplies scattered on the rocks.

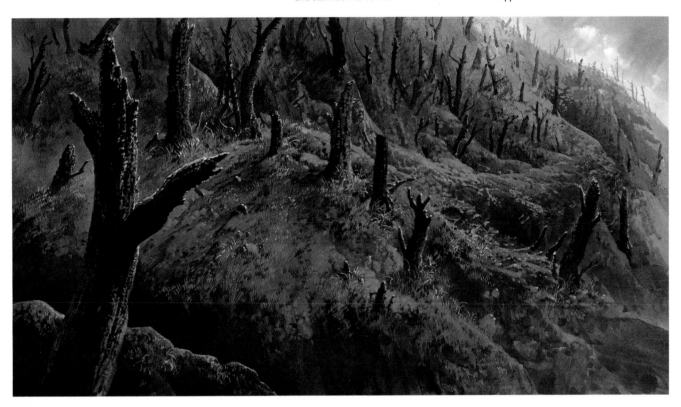

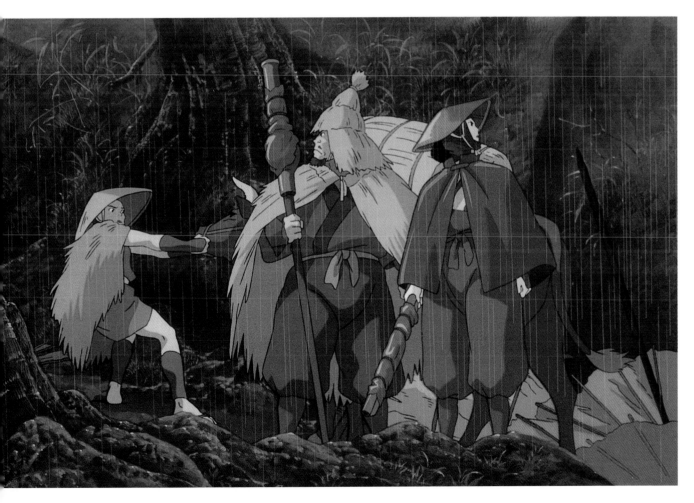

An Encounter with San

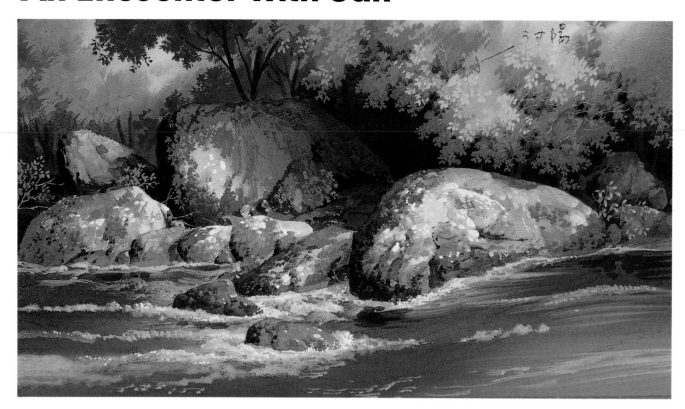

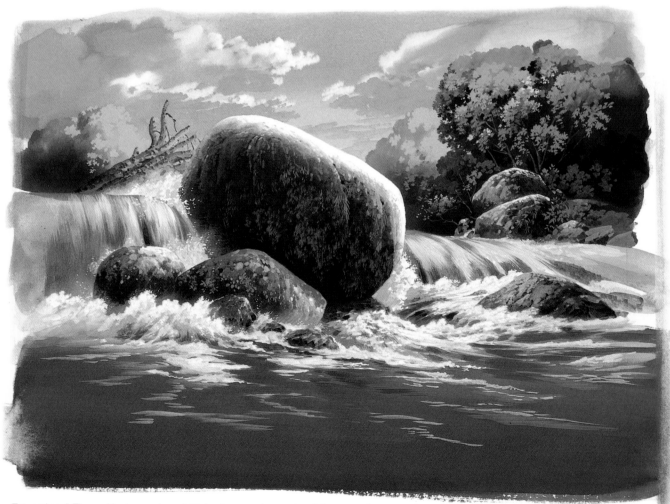

(Top, art board) The muddy stream where Ashitaka discovers the remains of the men and oxen who were attacked by Moro the wolf god. *(Bottom, art board)* A muddy stream showing the effects of a heavy rain. Driftwood and rocks, both large and small, block the stream.

58

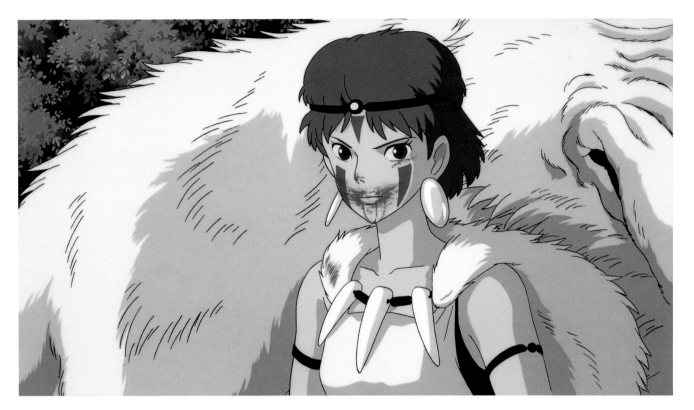

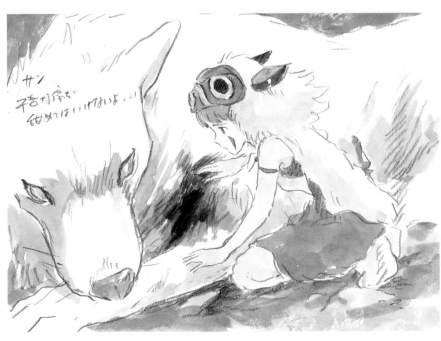

(Top, cel drawing) San sucks poisoned blood from Moro, the giant wolf god who was wounded by the bullet of an ox herder. Ashitaka is stunned by this sight. This is the first encounter between Ashitaka and San and Moro. (Middle, cel drawing) Ashitaka calls to San and Moro, but there is no reply. (Bottom, storyboard) San tries to soothe Moro's wound (this scene was not included in the film).

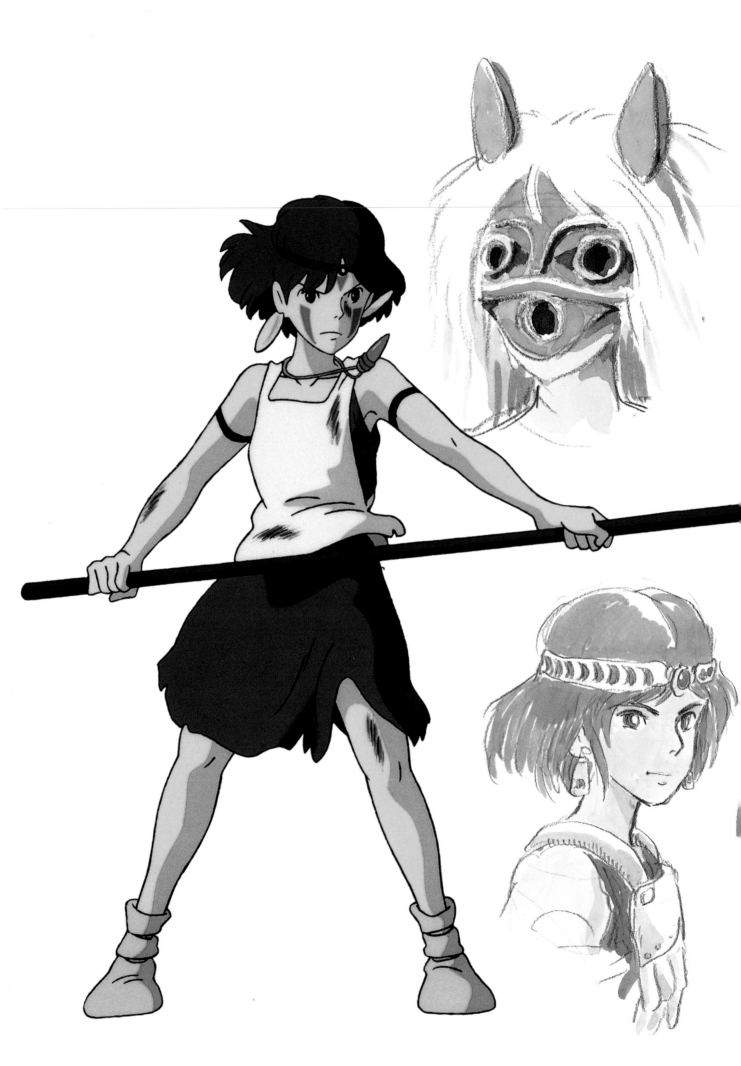

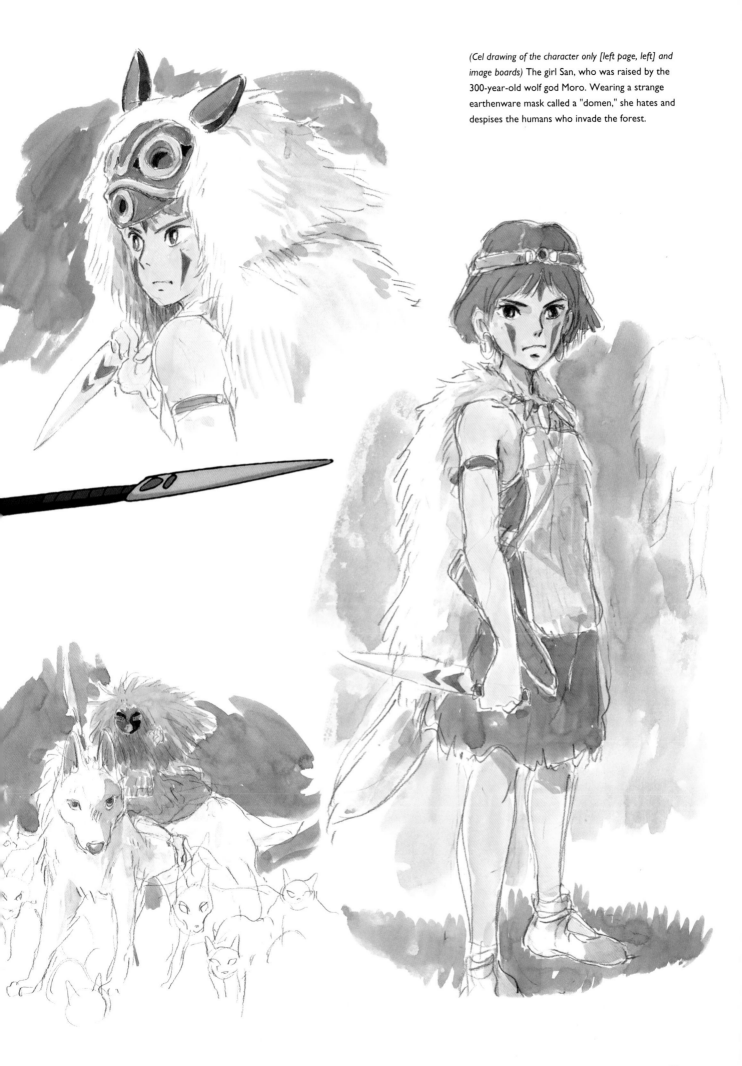

(Cel drawing of the character only [left page, left] and image boards) The girl San, who was raised by the 300-year-old wolf god Moro. Wearing a strange earthenware mask called a "domen," she hates and despises the humans who invade the forest.

Through the Moss-covered Forest

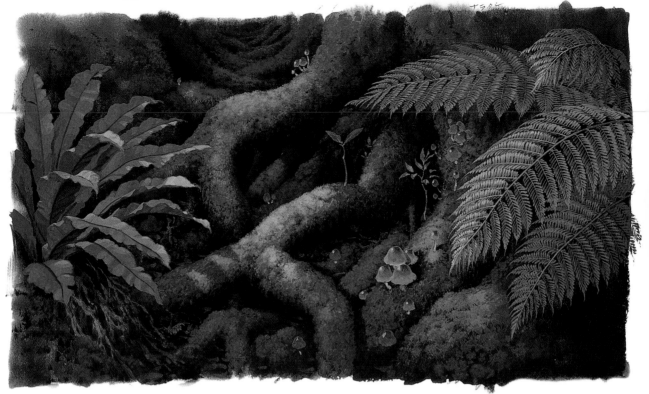

(Top left, art board) The depths of the forest, where Ashitaka, who has rescued Kohroku, an ox herder, first encounters the Kodama, the spirits of the forest. (Middle left, character sketches) Character sketches of Kohroku the ox herder. (Bottom left, cel drawing) Ashitaka and Kohroku catch sight of the Kodama. A trembling Kohroku tells Ashitaka that the Kodama summon the Deer God. (Right, background drawing) The dark and gloomy forest where the Kodama dwell—a virgin stand of deciduous trees.

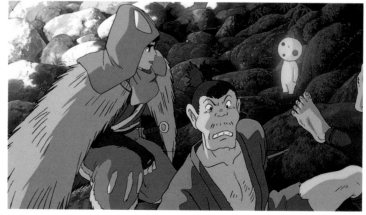

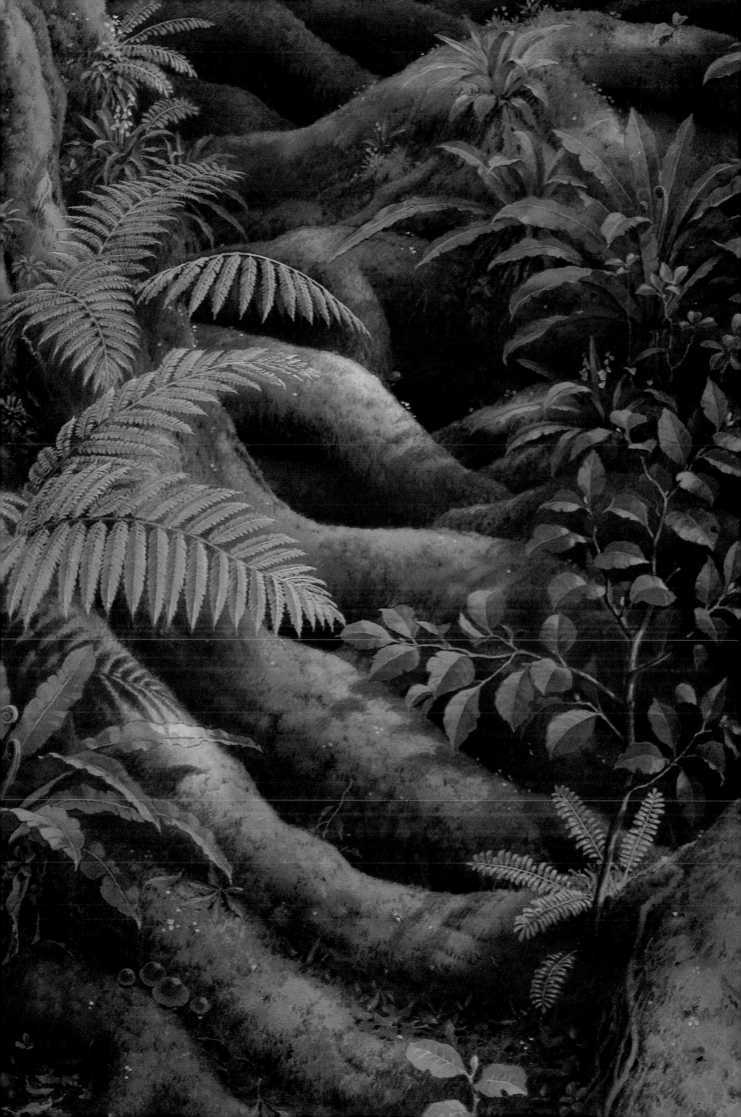

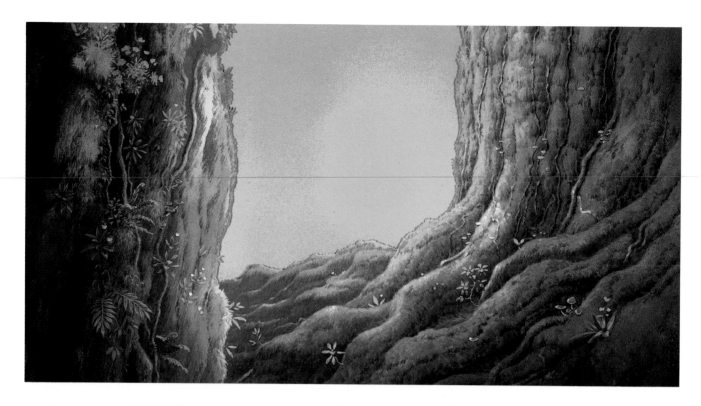

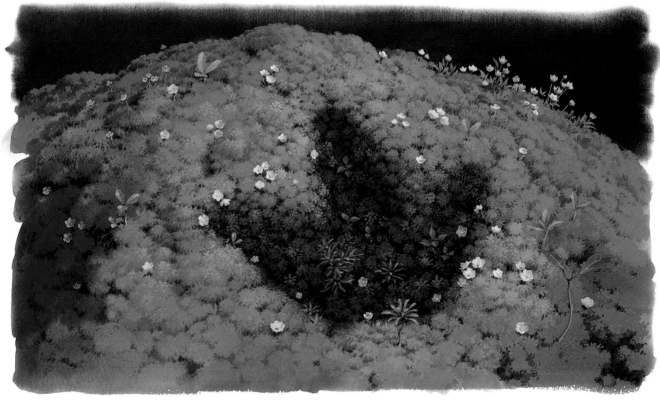

(Top left, background drawing) A corner of the forest where Ashitaka, who has been led to the dwelling place of the Deer God, first sees this god of the forest. Enveloped in light, the Deer God reveals his divine form in the gap between the two giant trees. (Bottom left, art board) Ashitaka finds the huge footprint of the Deer God on the surface of the green moss. (Right, background drawing) The forest that leads to the ironworks, at the foot of the deep mountains.

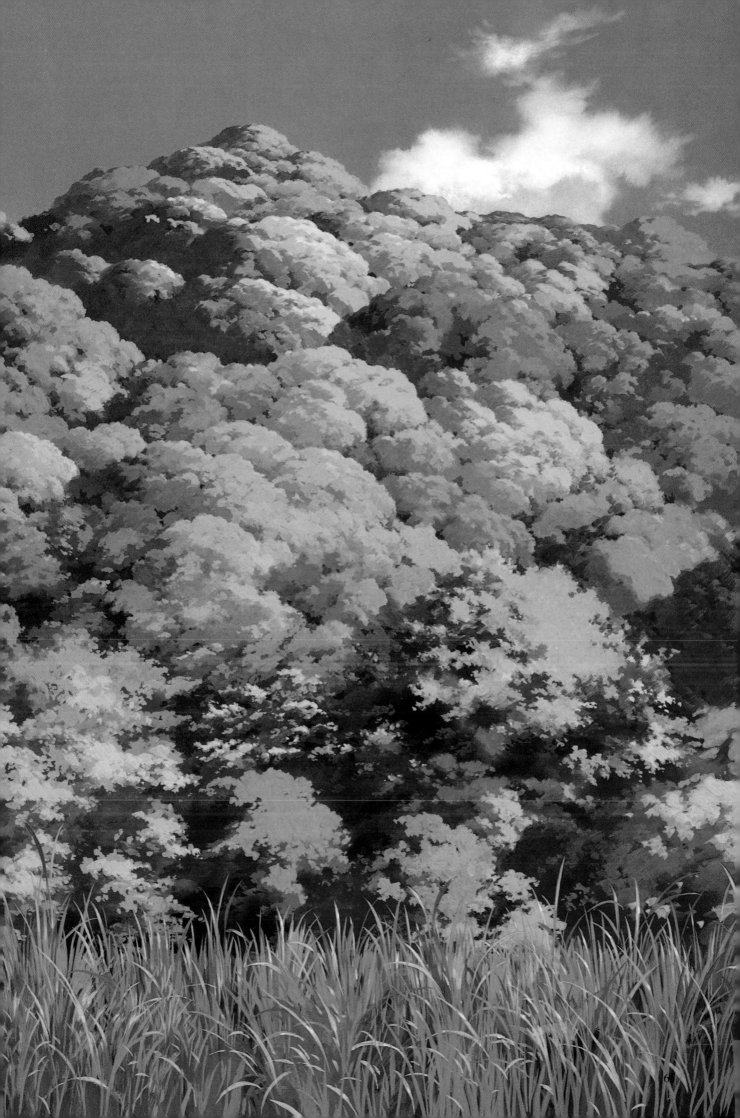

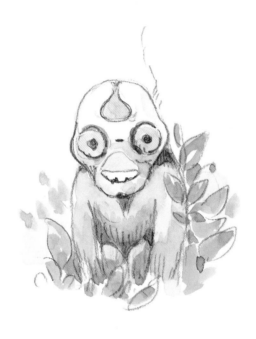

The Tatara Clan of Ironworkers

Ashitaka meets Lady Eboshi, who leds the ironworkers of
the Tatara clan. Lady Eboshi has been struggling with San
and the forest gods over the Deer God's forest. Lady
Eboshi has been trying to destroy the forest for the sake
of her commerce, while San and her allies have been
trying to protect it. Ashitaka learns that a shot from Lady
Eboshi's musket transformed a Boar-god into the Demon-
god. Soon after, San attacks the ironworks.

(Left, image board) Early drawing of a Kodama. *(Right, image board)* Early
bird's-eye-view drawing of the ironworks. In the film it fronts on a lake.

The Great Ironworks

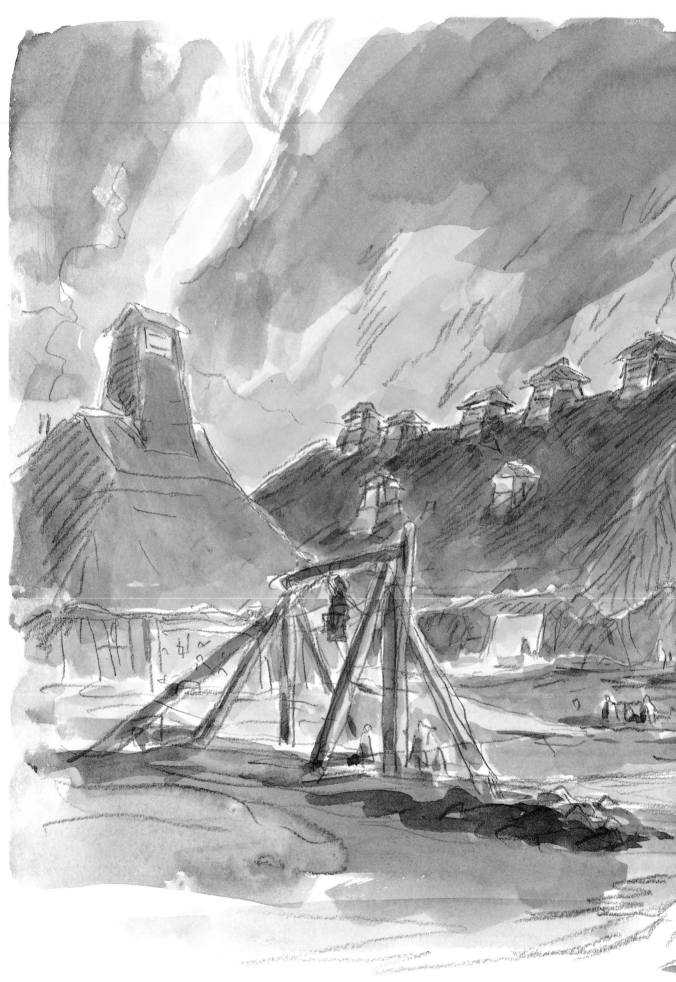

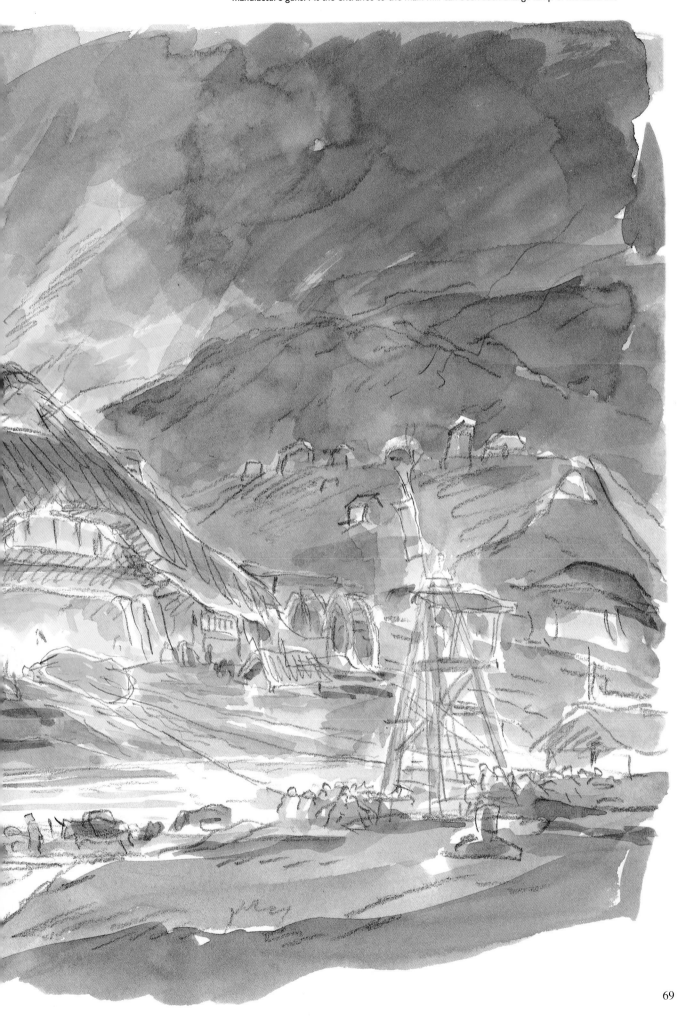

(Image board) The ironworks, whose workers denude the mountains of trees, smelt iron ore, cast iron, and manufacture guns. At the entrance to the main mill can been seen a large lump of molten iron.

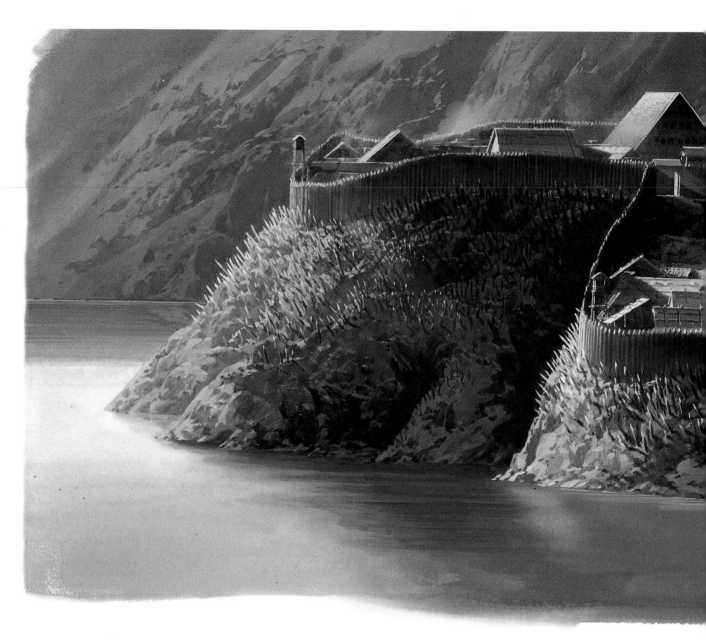

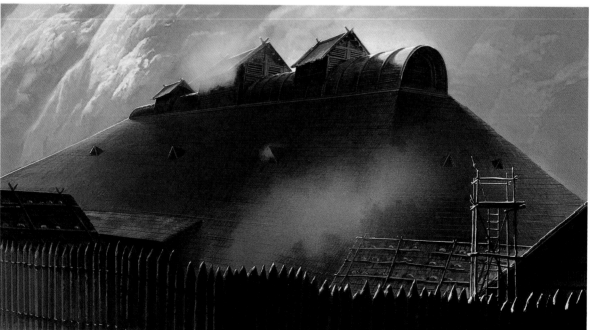

(Top, background drawing) In the foreground is the lake, in the middle of which sits the ironworks like a malignant tumor, belching clouds of white smoke. *(Bottom left, background drawing)* The main mill of the ironworks, from which rise clouds of white smoke against the background light. *(Bottom right, image board)* A panoramic view of the ironworks.

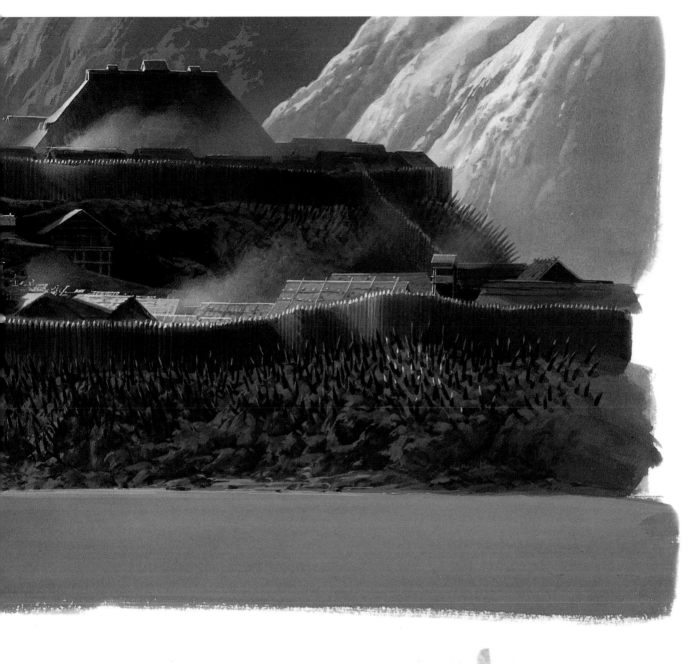

(Top left, background drawing) A stream inside the ironworks, next
to which a wooden storehouse has been built. (Bottom left,
background drawing) A slope in front of the entrance to the
ironworks. (Top right, background drawing) A row of charcoal kilns.
(Bottom right, image board) An early drawing of a blacksmith's shop.

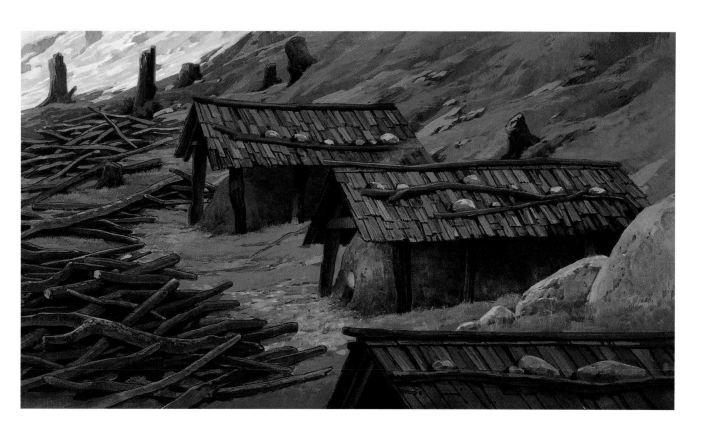

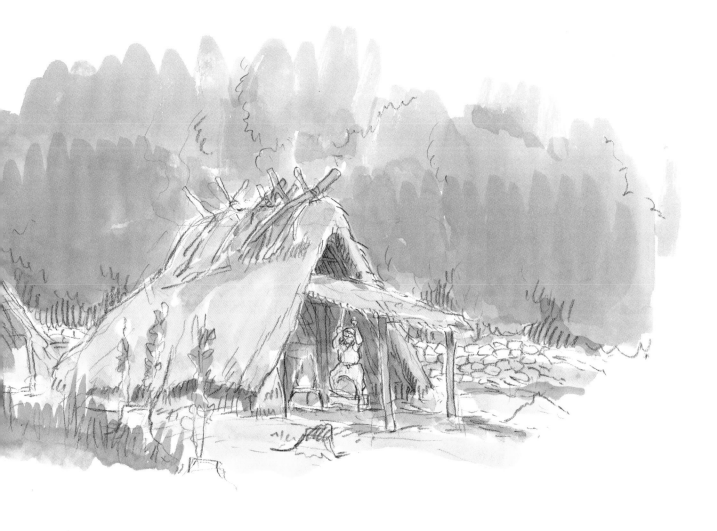

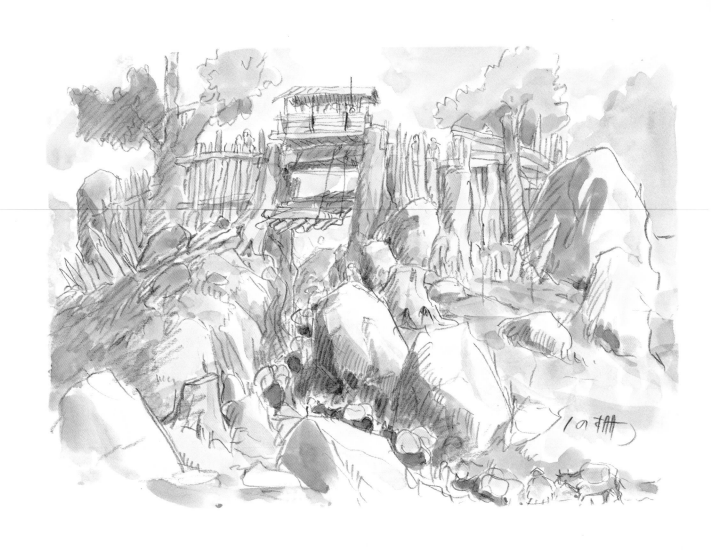

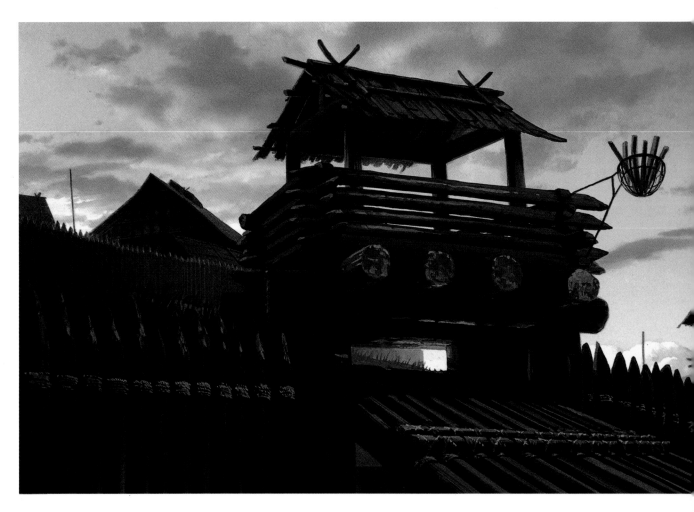

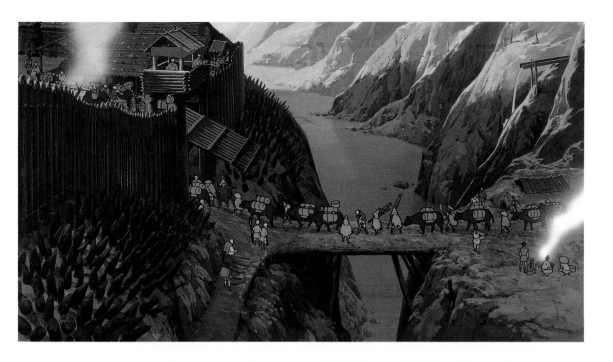

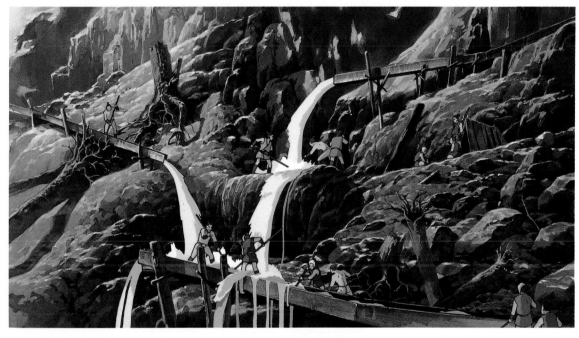

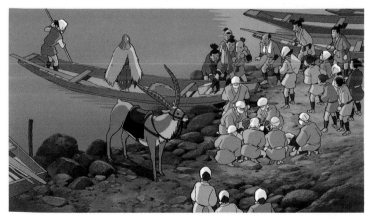

(Top left, image board) The gate to the ironworks. An ox train carrying bales of rice can be seen climbing the steep slope. *(Bottom left, background drawing)* The gate of the ironworks at dusk. *(Top right, cel drawing)* An ox train carrying rice crosses the bridge to the ironworks. *(Middle right, background drawing)* Using water from a stream, workers crush ore rocks and send the gravel flowing down sluices. *(Bottom right, cel drawing)* After crossing the lake in a boat carrying iron ore, Ashitaka and Kohroku arrive on the shore of the ironworks.

Lady Eboshi and the Ironworkers

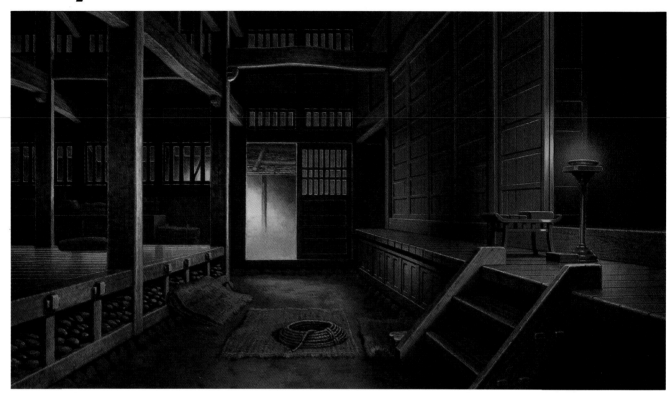

(Top left, background drawing) The interior of the ironworks. (Bottom left, image board) The interior of the ironworks. (Right page, top left, cel drawing) Lady Eboshi invites Ashitaka to stay as a guest. (Right page, top right, cel drawing) At the main mill of the ironworks, Lady Eboshi asks Ashitaka why he has made his journey. (Right middle, cel drawing) Ashitaka learns that a shot fired by Lady Eboshi is the cause of the Demon God's curse. Lady Eboshi responds coolly to Ashitaka, who is trembling with anger. (Bottom right, image board) Character drawings of Lady Eboshi.

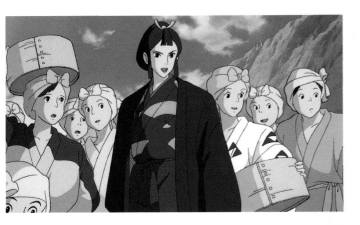

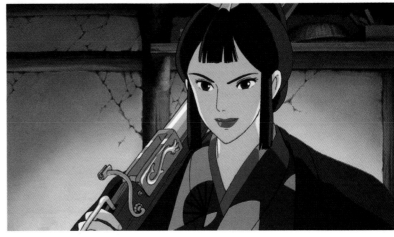

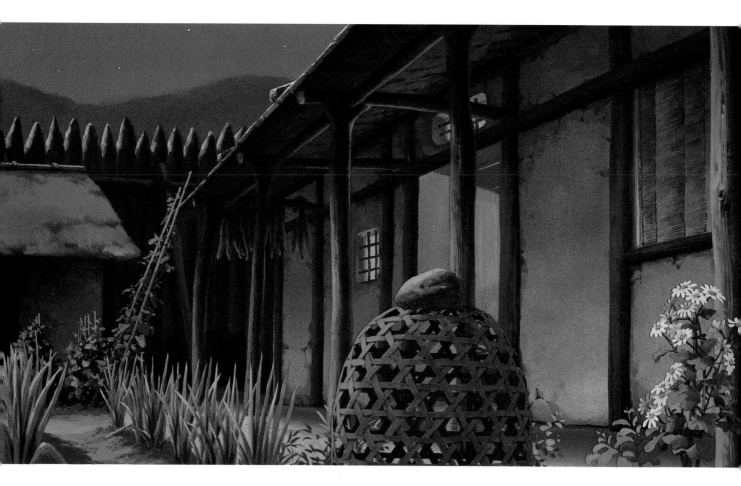

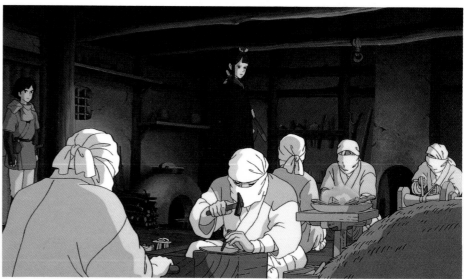

(Top left, background drawing) A dim light seeps out from the lowered straw blind of the ironworks infirmary. *(Bottom left, cel drawing)* In the detached infirmary to which Lady Eboshi takes Ashitaka, patients are making guns. *(Top right, image boards)* Cheerful, lively women are working the foot bellows and engaged in other tasks. *(Right middle, cel drawing)* Inside the ironworks, women in two facing lines press the foot bellows. *(Right page, bottom left, cel drawing)* Curious to see the manly young Ashitaka, the women peek into the ox herders' lodging where he is staying. *(Right page, bottom right)* Toki, the leader of the foot bellows workers.

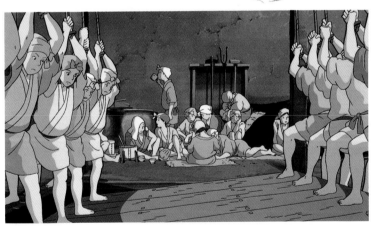

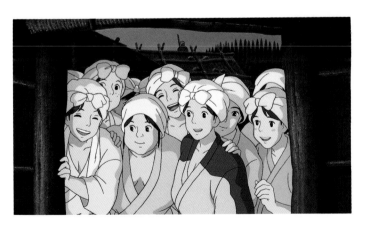

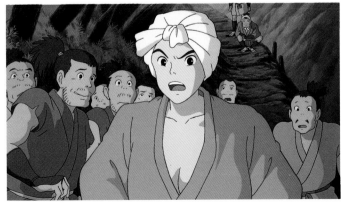

(Top, storyboard) Musketeers on night duty prepare for an attack by wolves. (Middle, image boards) Drawings of musketeers. (Bottom, cel drawing) Lady Eboshi, together with the musketeers and her top lieutenant, Gonza, advances into the night. (A cut from a scene in which Ashitaka hears the ox herders describe a battle between Lady Eboshi's men and the boar gods.)

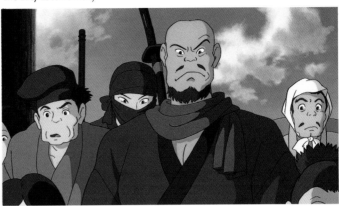

(Top left, image board) Gonza, the commander of the ox herders and the musketeers, and a Tatara woman in black costume. (Top right, cel drawing) At first, Gonza regards Ashitaka as an enemy and suspects him of being a spy for the samurai. (Middle) Character sketches of Gonza. (Bottom, CG image) Ashitaka learns why Nago became the Demon God. (A scene from the battle between Nago and Lady Eboshi's men.)

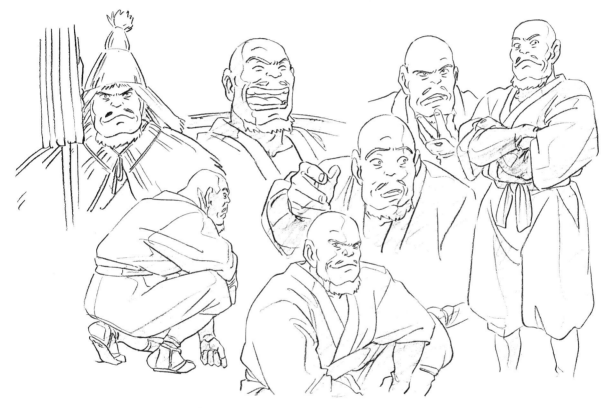

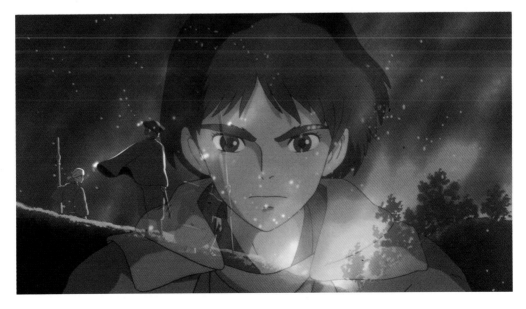

The Night Raid of Princess Mononoke

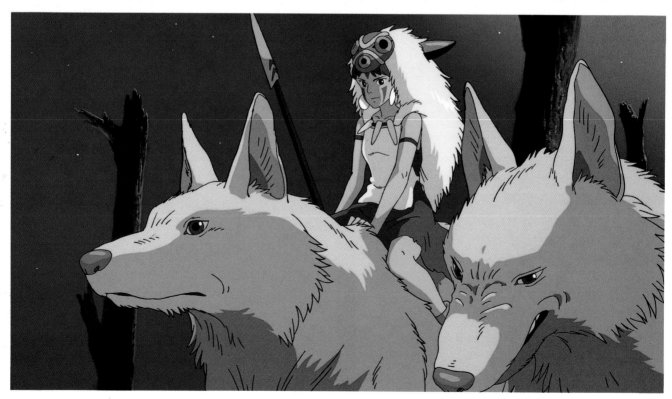

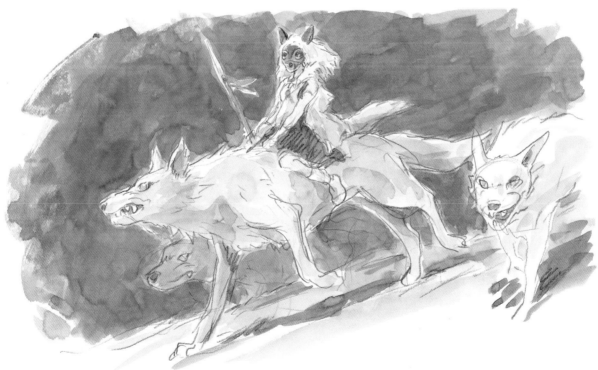

(Top, background drawing) The howls of the wolves can be heard over the moonlit naked hills as if they were announcing a portent. *(Bottom left, cel drawing)* San riding Moro the wolf god past ravaged trees. *(Bottom right, storyboard)* Wearing a "domen" mask, San, together with the wolves, go to attack the ironworks.

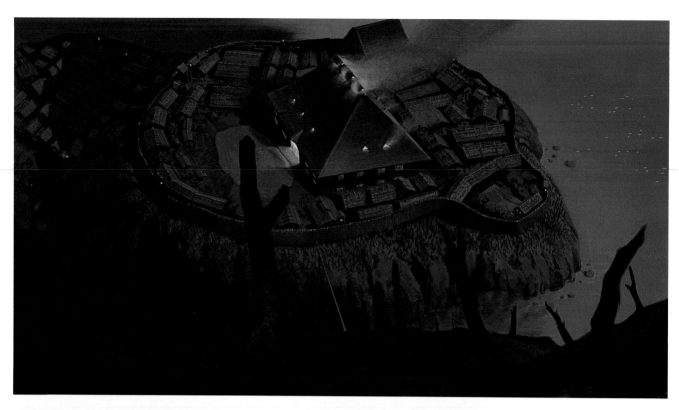

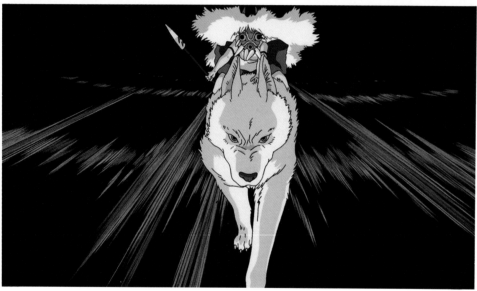

(Top left, background drawing) A panoramic view of
the ironworks wrapped in sleep. In the darkness
of night, light shines and steam rises only from the
main mill. (Middle left, cel drawing) San and Moro
race toward the ironworks in the night. (Bottom
left, cel drawing) A ravaged slope that, untouched
by moonlight, overlooks the ironworks. Apes
who emerge in the darkness to plant trees are
frightened by the sound of gunfire from Lady
Eboshi's musket and try to escape. (Right,
background drawing) A hill overlooking the
ironworks whose trees have been cruelly stripped
of their branches. San and Moro advance through
the desolate gully in the foreground.

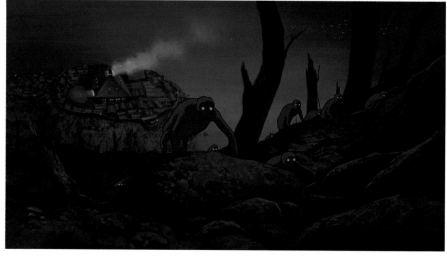

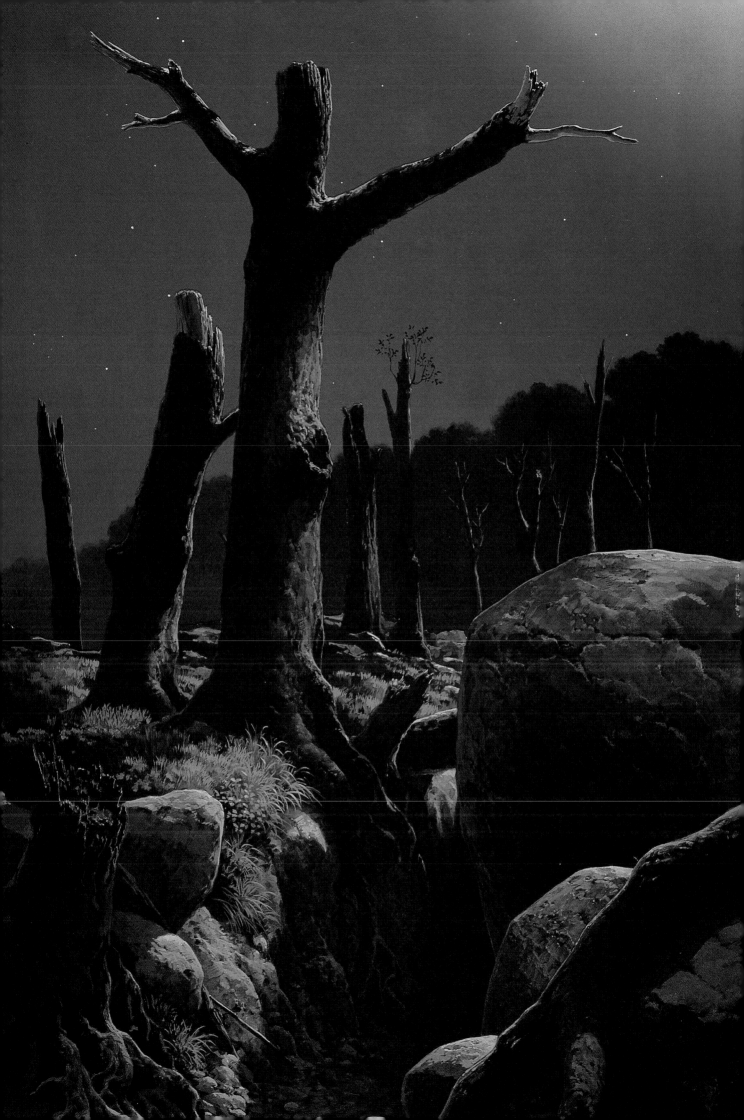

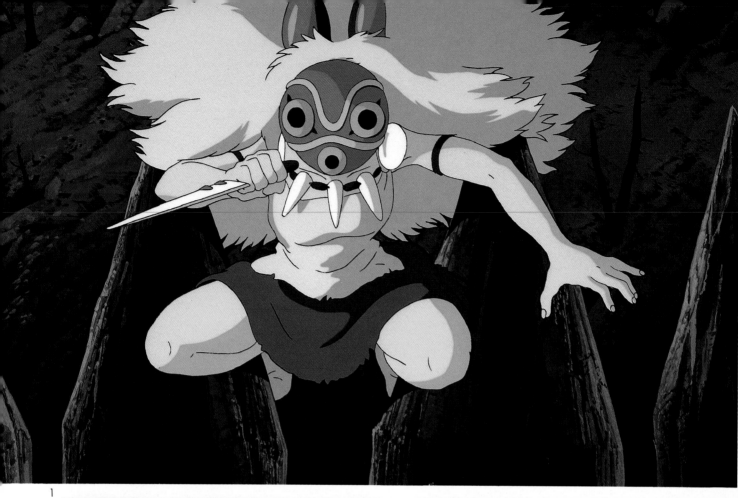

1

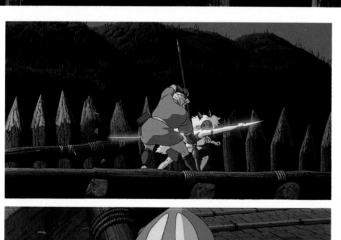

2

4

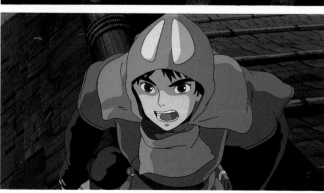

3

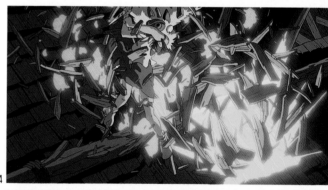

5

(From top left, all drawings) 1. Dodging musket shots, San leaps over the palisade that surrounds the ironworks and steals inside. 2. A musketeer confronts San. 3. Seeing that San has been cornered by the musketeers and has nowhere to escape, Ashitaka tells her to return to the forest. 4. A volley of shots from the muskets strike the roof on which San is standing. 5. San rolls off the roof. 6. Women take aim at San with old-fashioned muskets. 7. A bullet hits the center of San's "domen" mask. 8. Ashitaka tries to revive an unconscious San. 9. San suddenly opens her eyes, boiling with hatred and rage. 10. Still on the attack, San lunges at Ashitaka. 11. She then rushes at Lady Eboshi. 12. The finely honed sword of Lady Eboshi clashes with the knife of San, which is made from the fang of a wolf. *(Top right, storyboard)* San shows herself at the ironworks.

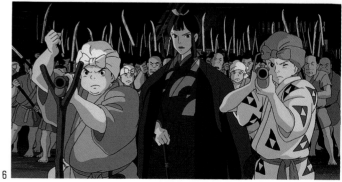

6

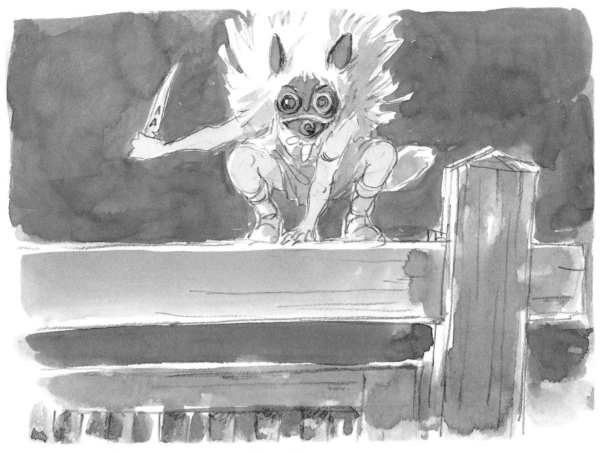

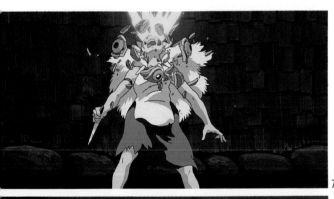

7

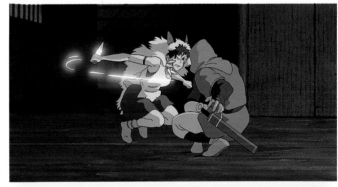

10

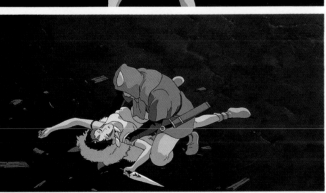

8

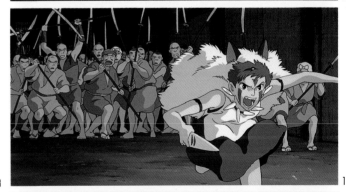

11

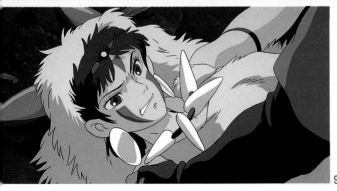

9

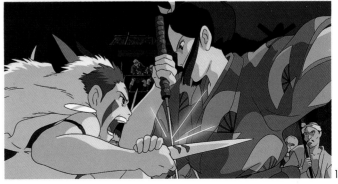

12

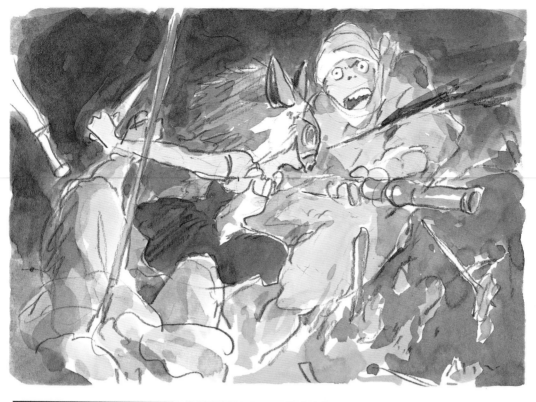

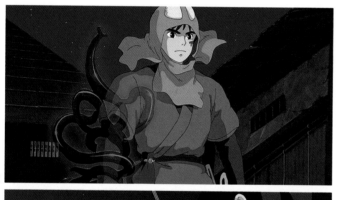

1

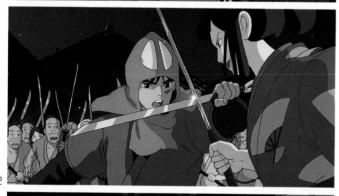

4

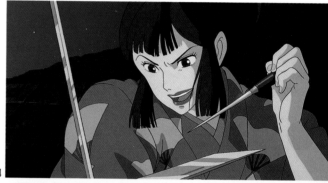

2

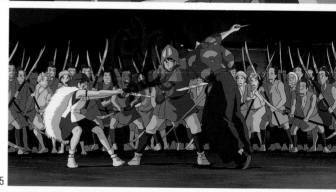

5

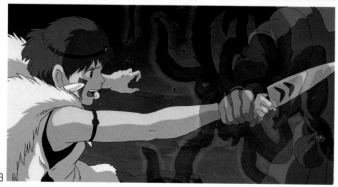

3

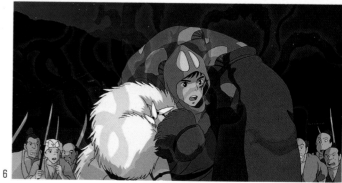

6

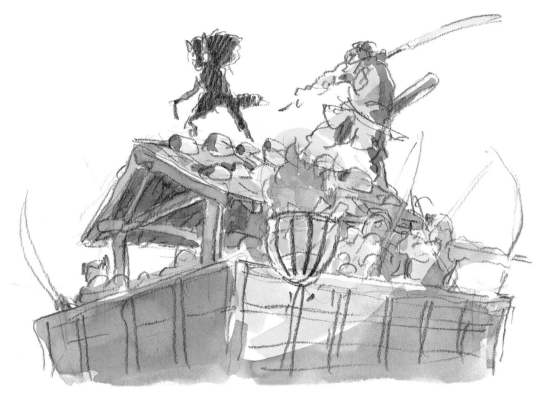

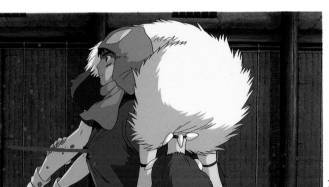

7

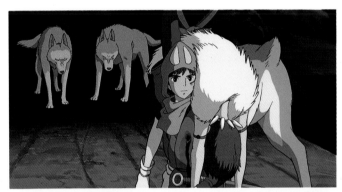

10

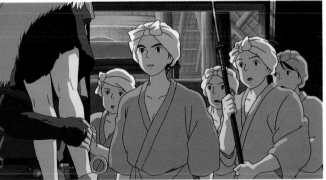

8

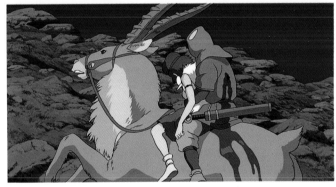

11

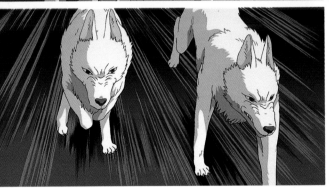

9

(Top left, storyboard) San battles the musketeers. *(Top right, storyboard)* San being pursued by the musketeers. 1. Anger and sadness contend within Ashitaka. The scar on his right arm changes into a black snake. 2. Stopping Lady Eboshi's sword with a blade he holds in his left hand, Ashitaka tries to mediate between Lady Eboshi and San. 3. The black snakelike tendrils on Ashitaka's right arm that are restraining San begin to writhe like fire. 4. Lady Eboshi takes aim at Ashitaka with an awl in her left hand. 5. After parrying Lady Eboshi's attack, Ashitaka fends off thrusts by Lady Eboshi and San to the pit of his stomach. 6. Ashitaka carries an unconscious San and Lady Eboshi. 7. Soon after Ashitaka gives Lady Eboshi to the women and tries to leave the ironworks with San, a musket bullet strikes him in the stomach and pierces his body. 8. Toki and the women do not understand what has happened. 9. Two wolves attack Ashitaka, who has just come out the gate of the ironworks. 10. Ashitaka walks away from the wolves and the ironworks. 11. With his blood pouring down Yakkuru's back, Ashitaka rides off into the lonely darkness. *(All cel drawings)*

The Forest Dwelling of the Deer God

Despite her hatred of humans, San cannot kill Ashitaka,
who has been severely wounded by a musket shot.
Instead, she takes him to Deer God Pond and entrusts
him to the Deer God, who has the power of life and
death. Brought back to life by the breath of the Deer
God, Ashitaka agonizes over whether he should aid the
humans or San, and what he can do to make peace
between the forest creatures and humans.

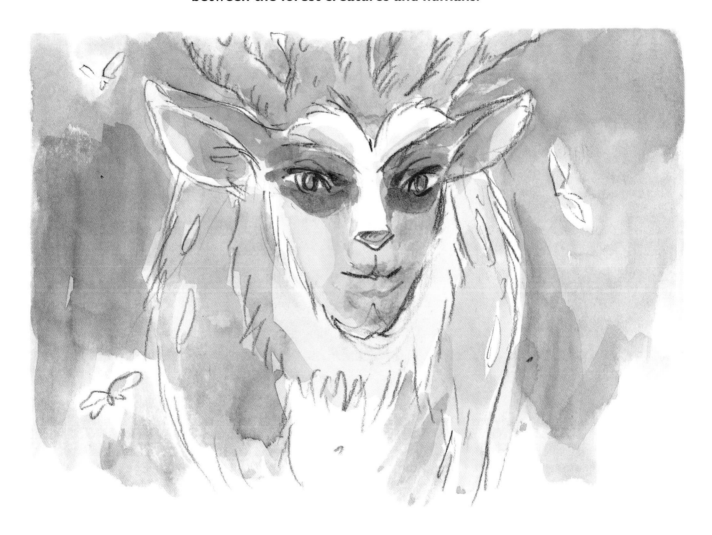

(Left, image board) An early drawing of a Kodama procession.
(Right, image board) The Deer God, who gives and takes life.

To the Forest of the Deer God

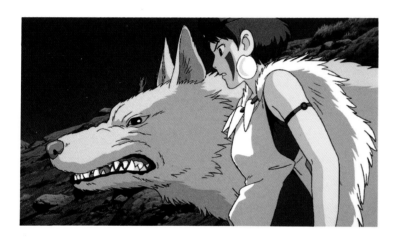

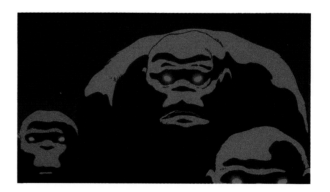

(Top left, continuity drawing) Ashitaka has suffered a deadly wound from the musket shot. Angry because Ashitaka interfered in her fight with Lady Eboshi, San is about to plunge a knife into his throat. (Middle left, cel drawing) San, who was about to kill Ashitaka, is stunned after hearing him say "Live. You are beautiful." (Middle right, cel drawing) Apes demand to eat the flesh of the human, Ashitaka. (Bottom right, cel drawing) The wolves are enraged at the apes' rude words and actions, which they regard as a slight to the pride of the Moro wolf pack. (Right page, background drawing) A group of giant rocks on the mountain over which Yakkuru runs, carrying San and the unconscious Ashitaka.

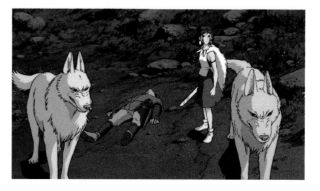

(Top left, background drawing) The sky above Deer God Forest. The rays of the sun are beaming
down on the green hills. *(Bottom left, art board)* The interior of the forest, where tall, ancient trees
have put down deep roots. *(Top right, art board)* The virgin forest and moss-covered rocks.
(Bottom right, art board) At the base of a tall tree mushrooms are growing and flowers are blooming.

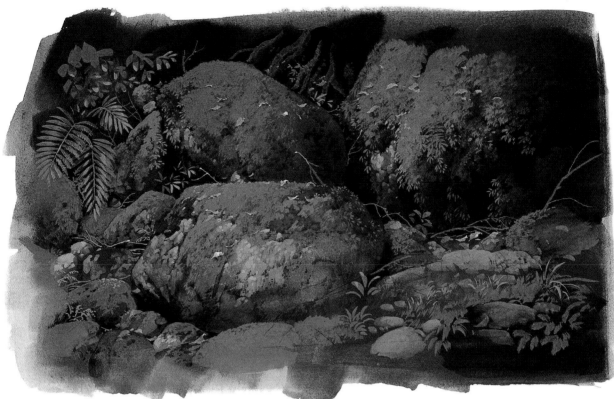

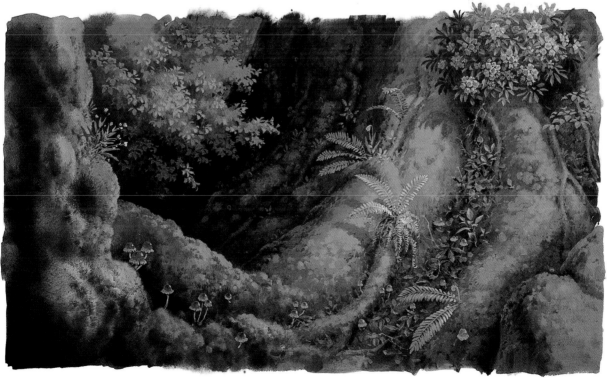

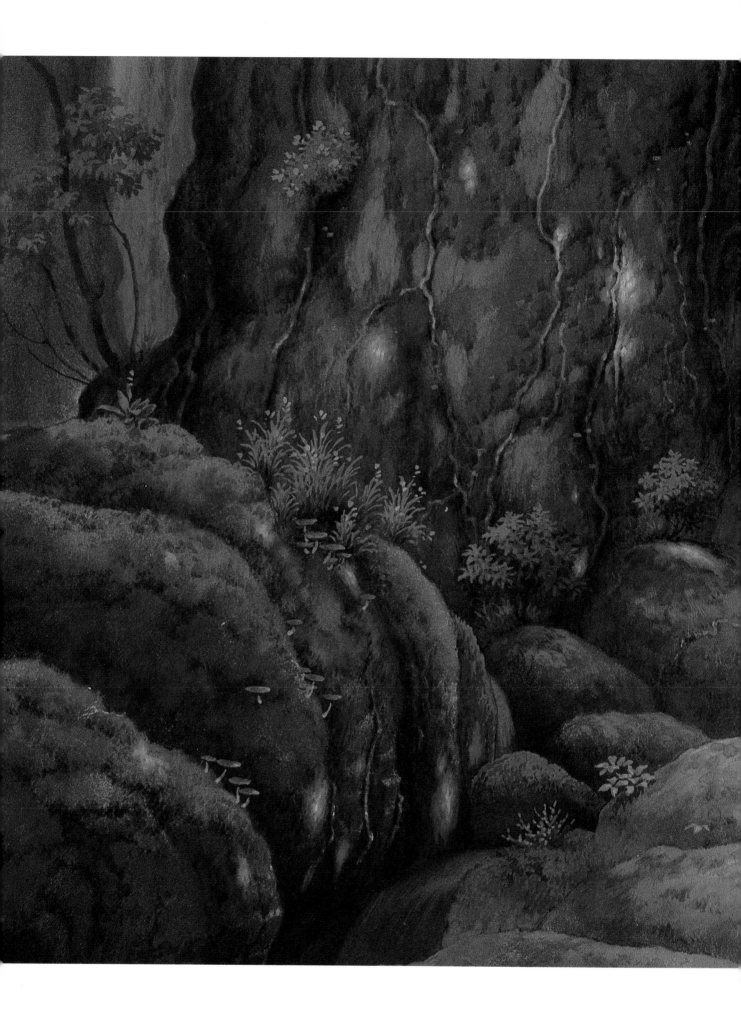

(*Background drawing*) The forest near Deer God Pond. In the night forest,
phosphorescent moss gives off a bluish light.

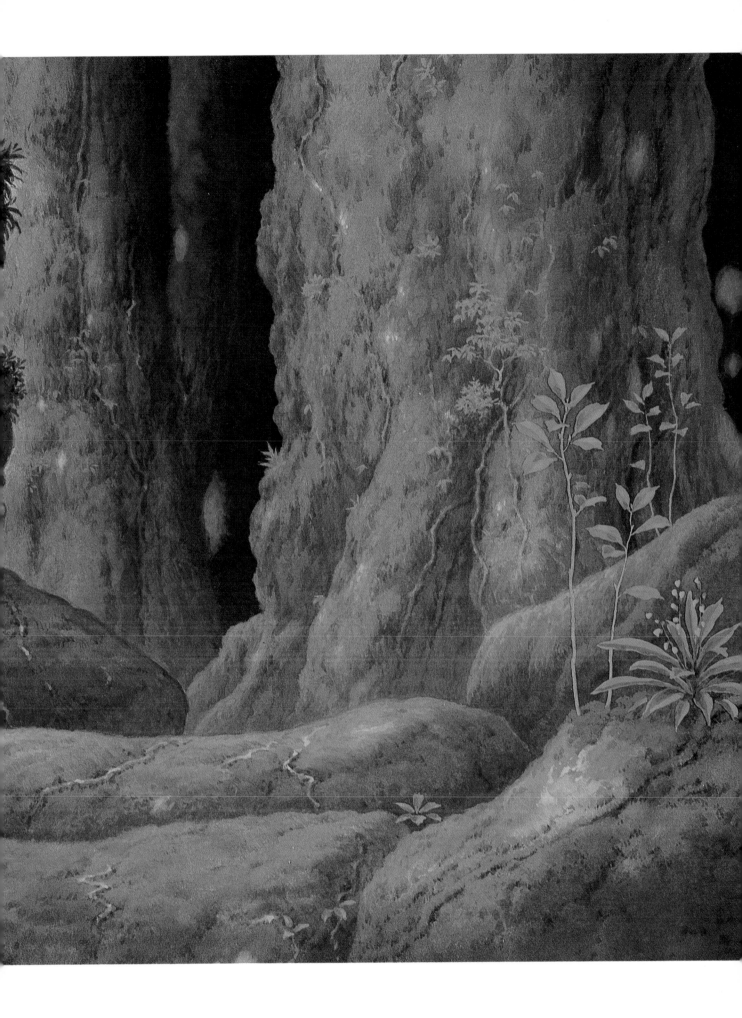

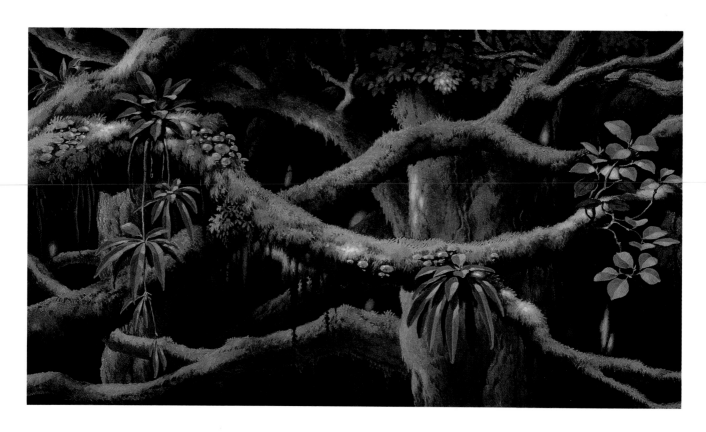

森には古い神々が すんていたのな

(Top, background drawing) Tree branches covered with moss.
(Bottom, storyboard) A drawing of Deer God Forest, on which Hayao
Miyazaki has written "Ancient gods were living in the forest."

The Forest of the Kodama

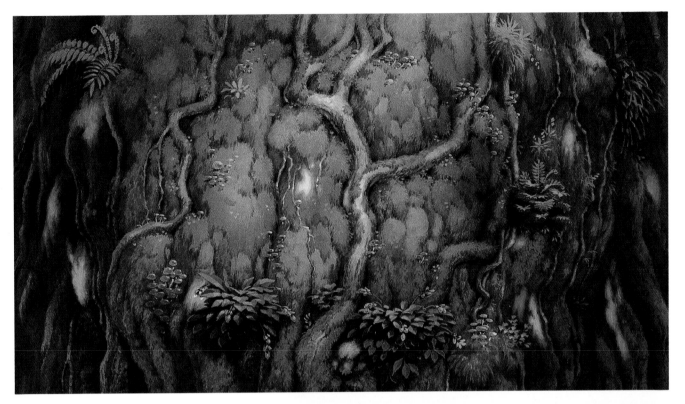

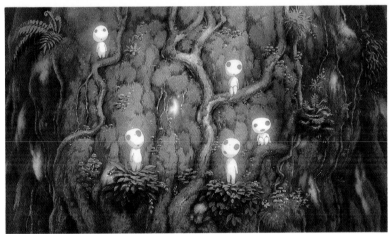

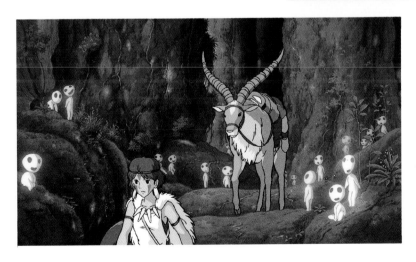

(Top, background drawing) The trunk of a tree by Deer God Pond. The Kodama—the spirits of the forest— appear where San and Ashitaka have passed. *(Middle, cel drawing)* The Kodama rise silently, like ghostly lanterns, through the branches. *(Bottom, cel drawing)* The Kodama silently watch San and the dying Ashitaka.

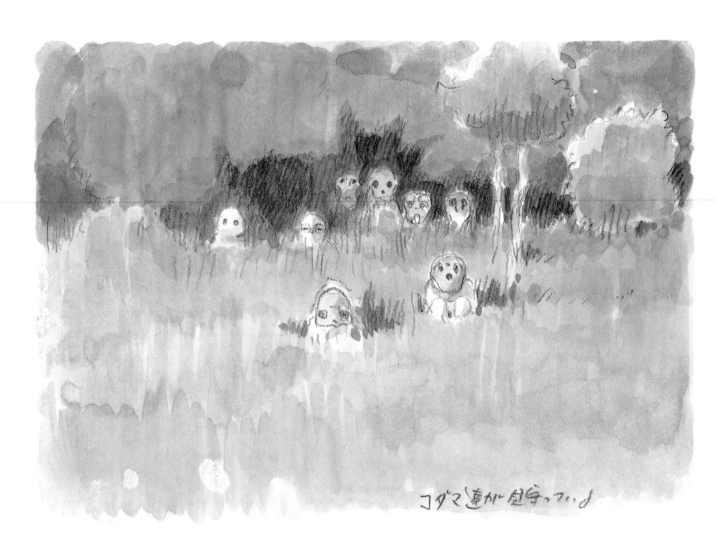

コダマ達が見守っている

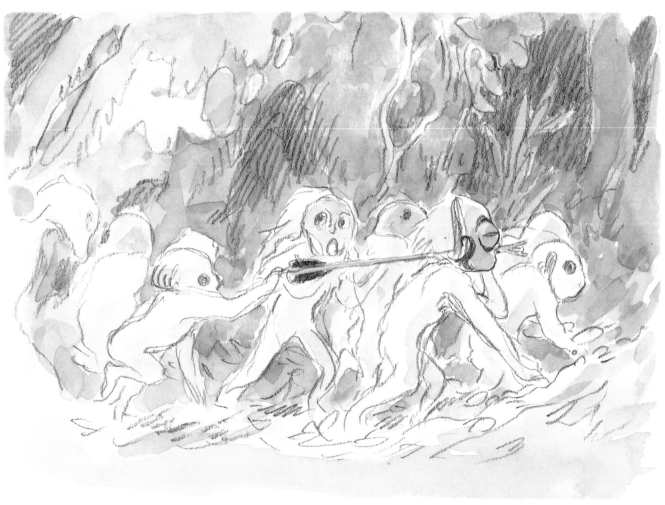

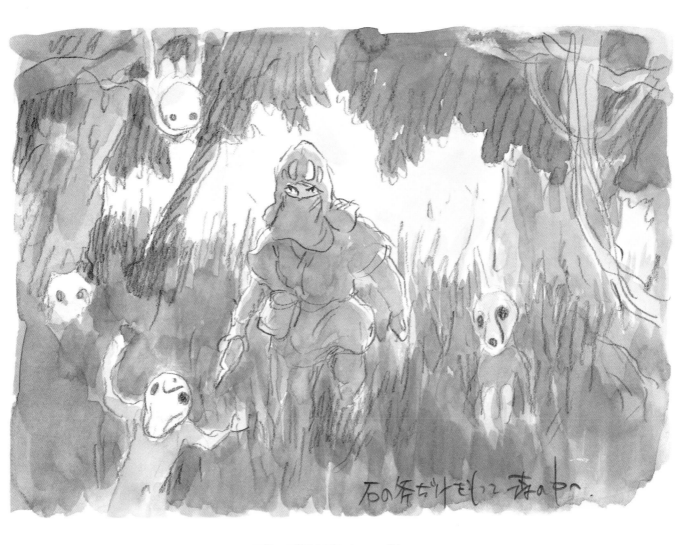

石の香だけをいこと森のか.

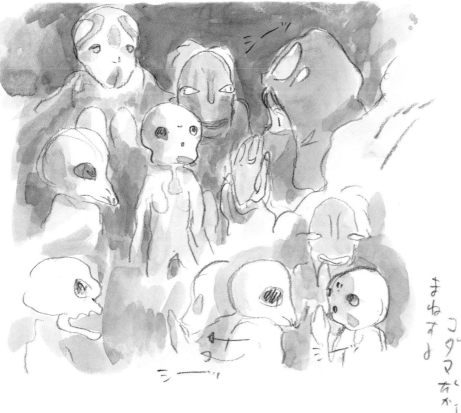

シーッ

シーーッ

まねする
コ
ダ
マ
だ
お
り

(Top left, top right, bottom right) Storyboards with comments by Hayao
Miyazaki (top left) "The Kodama look on," and (bottom right) "The Kodama
mimic." These scenes were not used in the film. (Bottom left, image board)
A drawing of the innocent and childish forest spirits, the Kodama.

By Deer God Pond

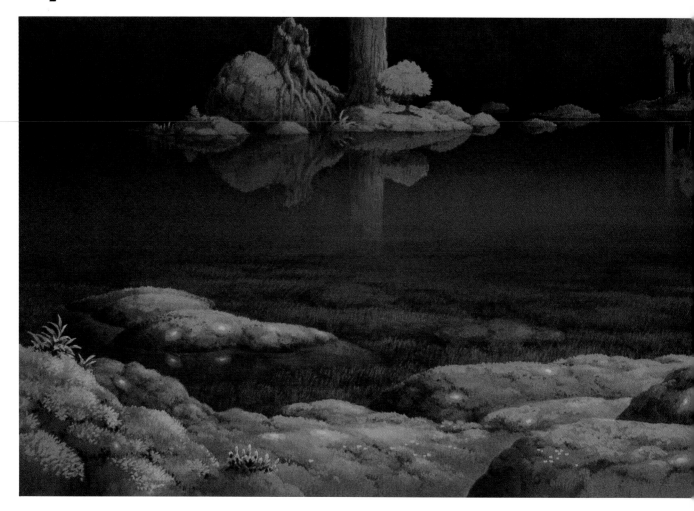

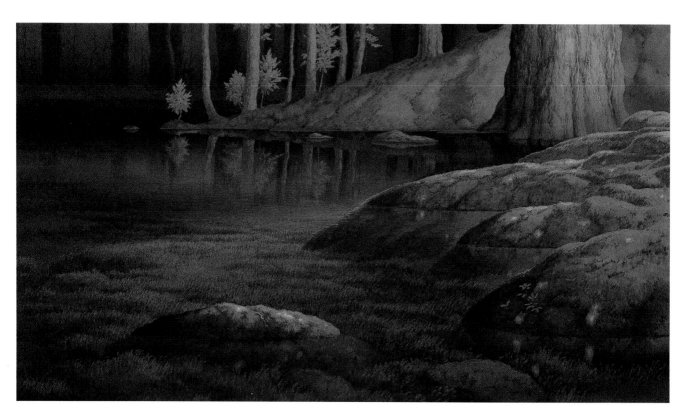

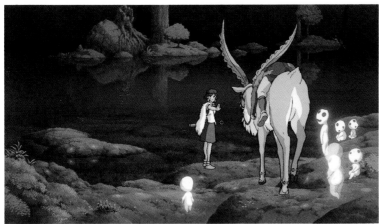

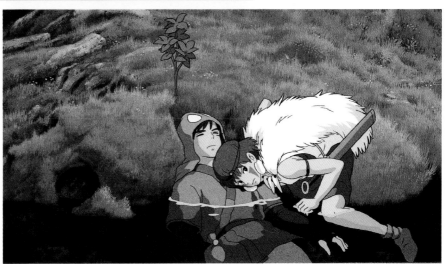

(Top left, background drawing) By Deer God Pond—the quiet surface of the water spreads out below. In the center of the pond is Deer God Island, covered with green moss. (Top right, cel drawing) San tells Yakkuru, who is carrying the dying Ashitaka, to stop by the side of the pond. (Middle right, cel drawing) San drags Ashitaka up to the rocky shore of the island, thrusts a small branch of the "sakaki"—a sacred Shinto tree—into the ground as a kind of headstone and, putting her ear to his chest, listens to his heartbeat. (Bottom right, background drawing) In the left foreground is Deer God Island. Behind it and to the right is the large rock on which the Deer God appears.

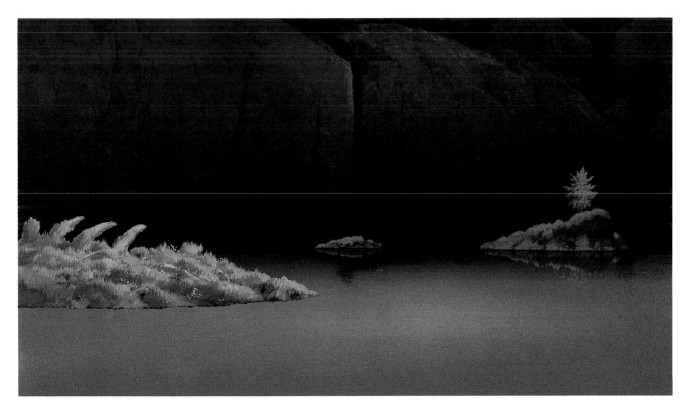

The Night Walker

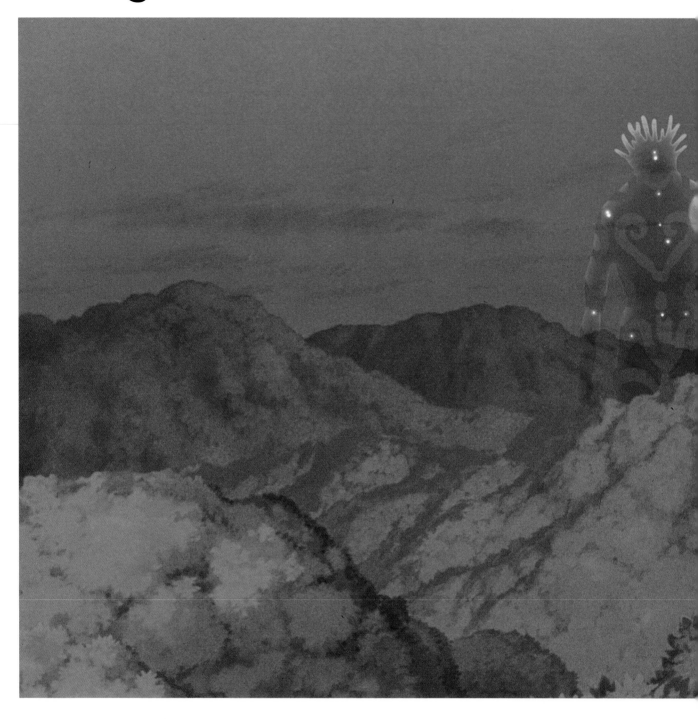

(Top, CG image) The night sky starts to grow bright.
Heralded by a chorus of Kodama, the Night Walker—the
night form of the Deer God—emerges from a sea of tall
trees. *(Bottom right, cel drawing)* The voices of the
Kodama's chorus rise up like crashing waves.

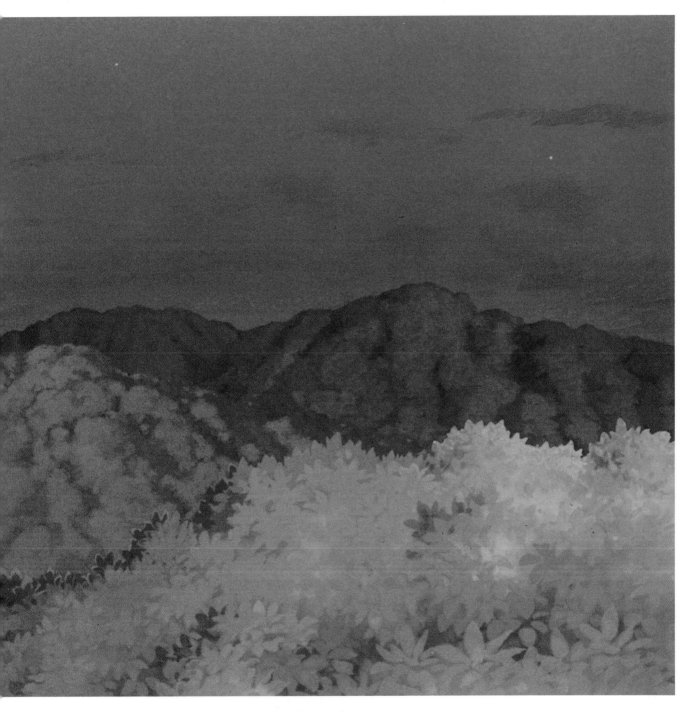

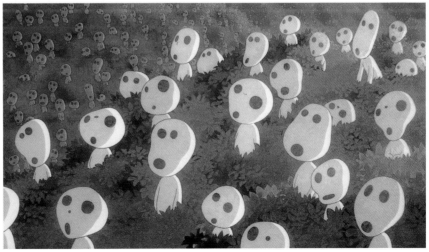

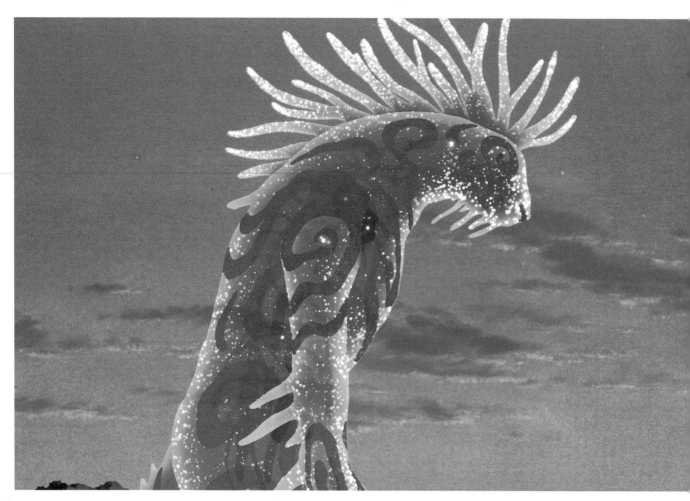

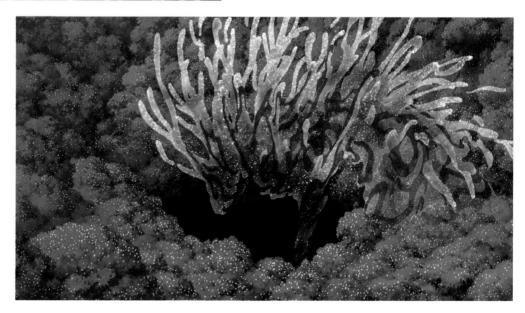

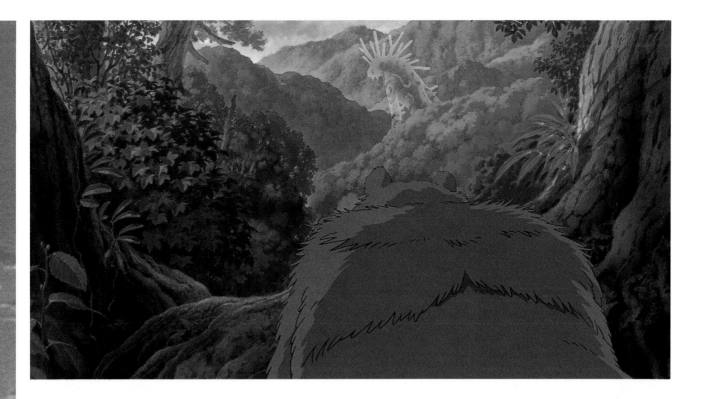

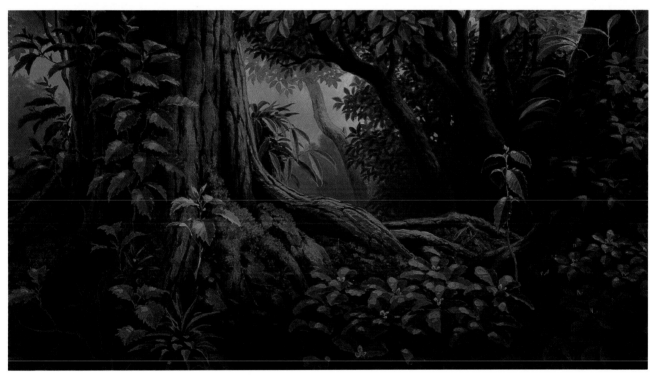

(Top left, CG image) The Night Walker serenely surveying the forest. His body is dark like the night and twinkles like the stars. (Middle left, CG image) The horns of the Night Walker expand and contract like the sap of a tree. (Bottom left, CG image) Before dawn breaks, the Night Walker returns to his dwelling through a hole that opens in a sea of foliage. (Top right, CG image) Wearing an animal skin and accompanied by the hunters, Jiko Bo is searching for the dwelling of the Deer God. He has just spotted the Night Walker. (Bottom right, background drawing) Jiko Bo and the hunters observe the Night Walker from the base of a tree on a mountain ridge overlooking a sea of foliage.

The Deer God and Ashitaka

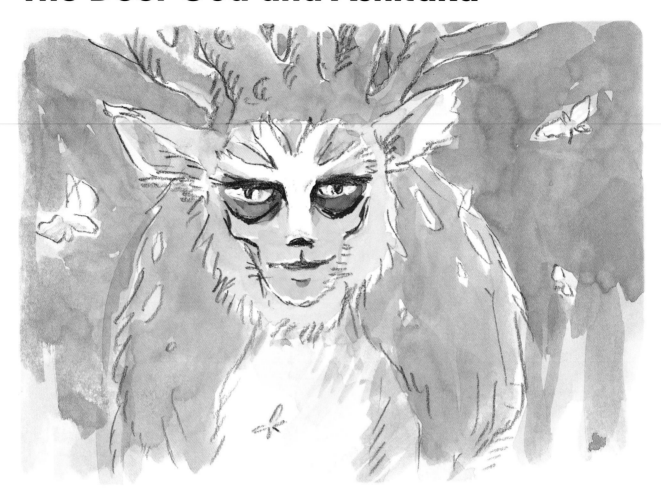

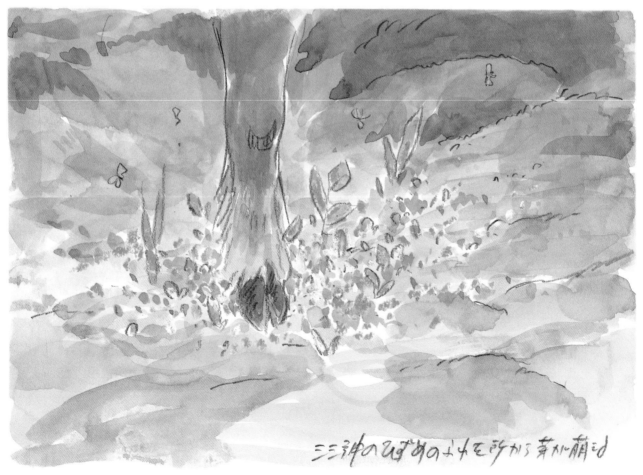

ニシシ神のひずめのよ人を多から芽が萌える

108

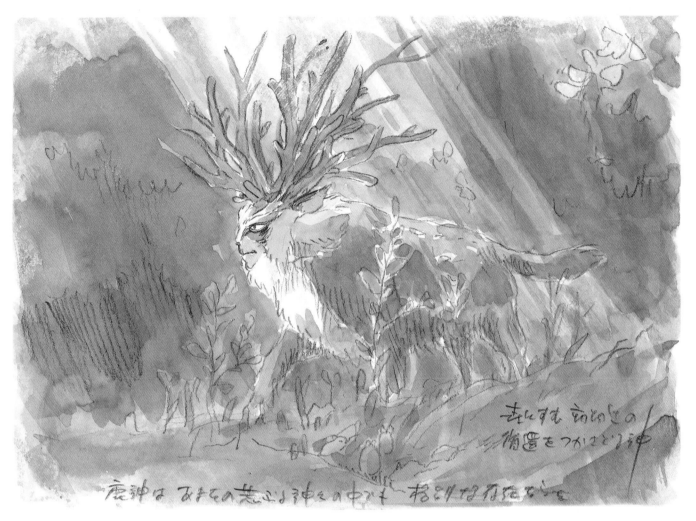

鹿神は あらその志ぶる神をのゆびて おこりな存在だ

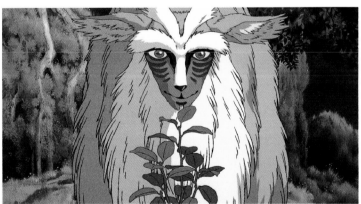

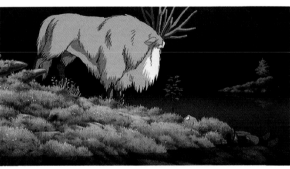

(Top left, bottom left, top right) Storyboards with comments by Hayao Miyazaki *(bottom left)* "The god who rules the lives of the forest animals" and *(top right)* "Plants bloom when touched by the hooves of the Deer God." *(Right page, middle right, cel drawing)* The Deer God stands before the "sakaki" branch. *(Right page, middle left, cel drawing)* The Deer God is looking at either Ashitaka or the "sakaki." His expression seems to be overflowing with love and pity. *(Right page, bottom left)* Wherever the Deer God's hooves touch, trees and plants grow, but after the Deer God passes on, they begin to wither and die.

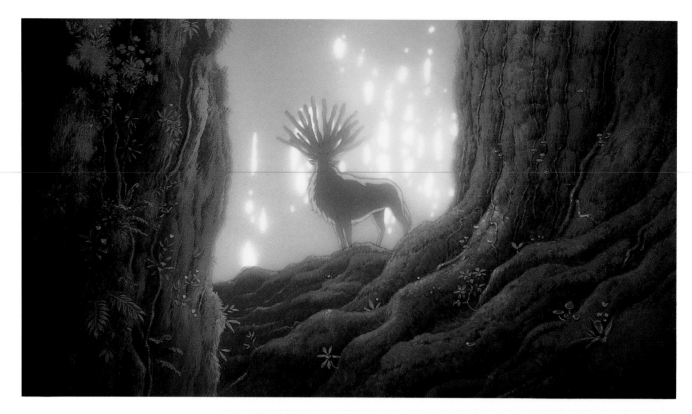

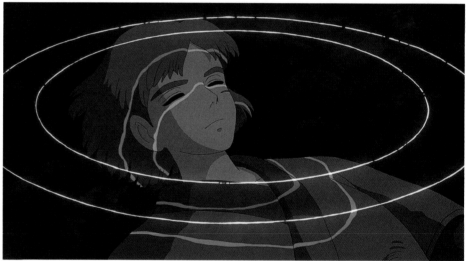

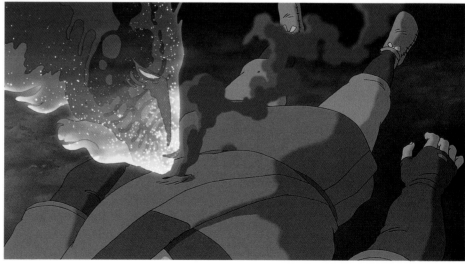

(Top, cel drawing) The Deer God can be seen between two tall thick trees near the pond. *(Middle, CG image)* Ashitaka floating in Deer God Pond. *(Bottom, CG image)* Ashitaka's life blood is flowing from his wound. The golden glowing Deer God brings his lips to Ashitaka's wound and closes it.

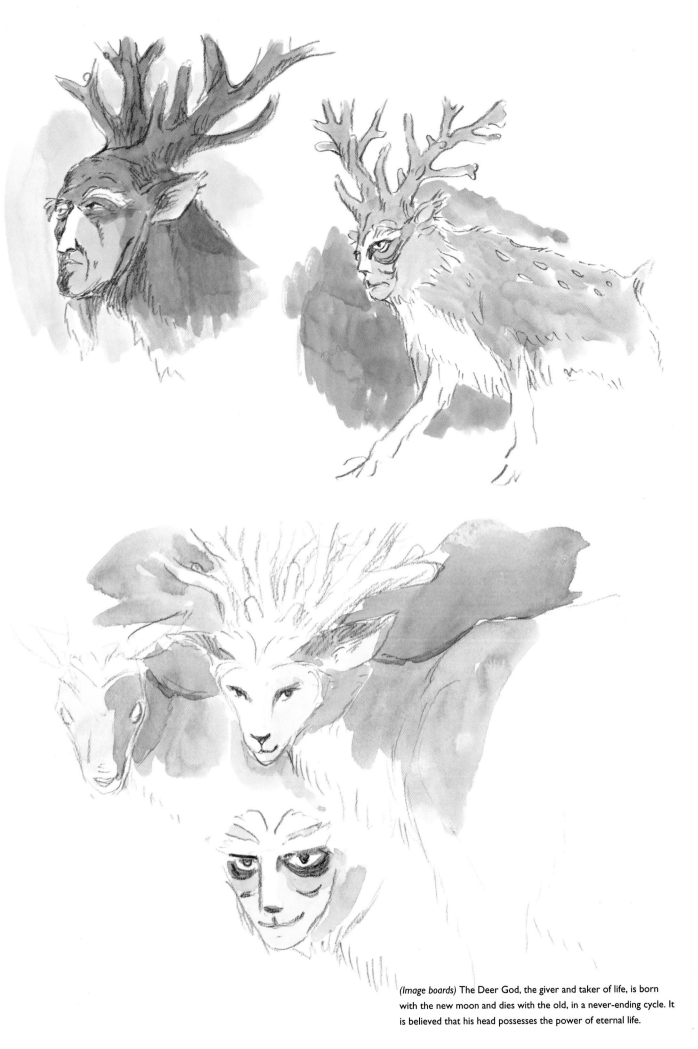

(Image boards) The Deer God, the giver and taker of life, is born with the new moon and dies with the old, in a never-ending cycle. It is believed that his head possesses the power of eternal life.

111

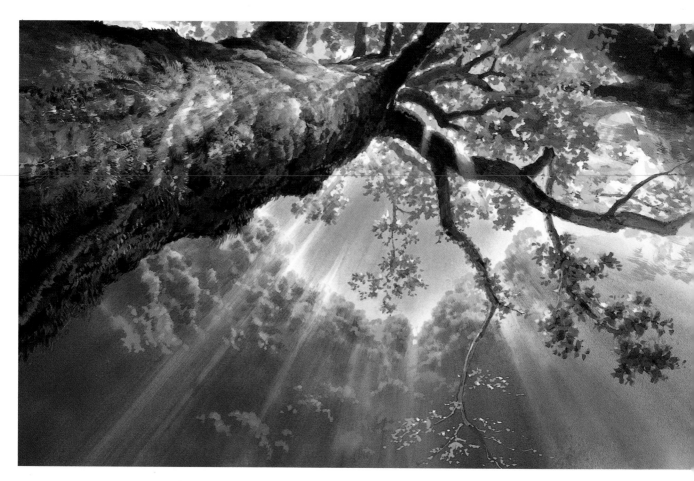

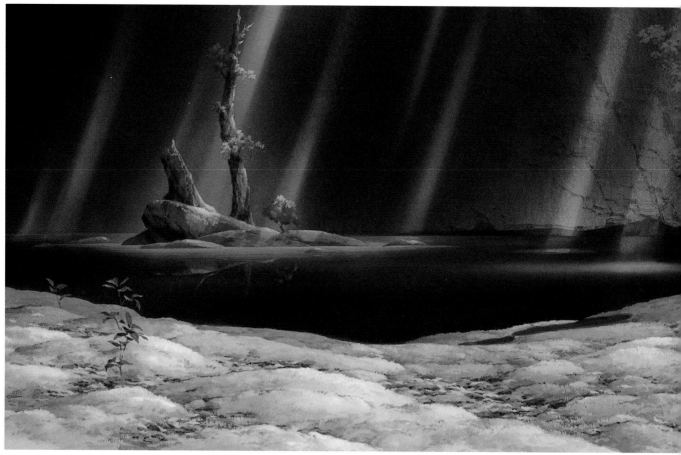

(Top, background drawing) A gap in the foliage near Deer God Pond. The trunks of the
great trees extend upward and light pierces the leaves from the blue sky above.
(Bottom, background drawing) Beams of light shine down on Deer God Pond.

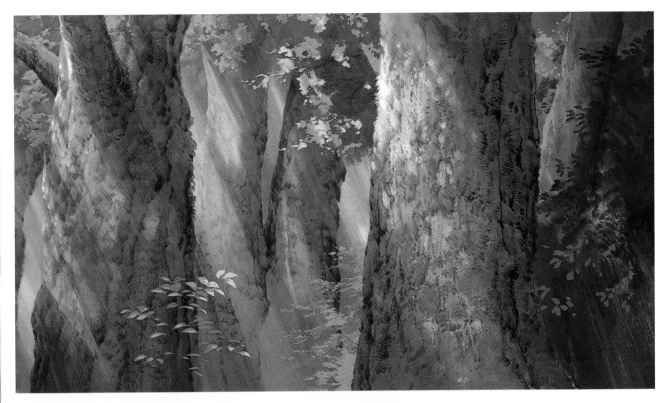

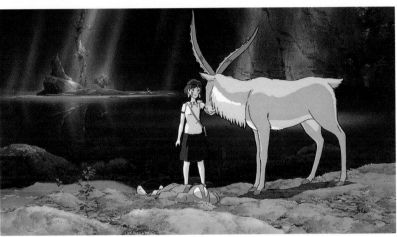

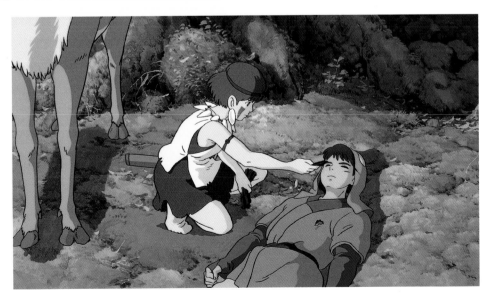

(Top, background drawing) Rays of sunshine bathe the trunks of trees by the shores of Deer God Pond. *(Middle, cel drawing)* San tells an awakened Ashitaka that he has been restored to life by the Deer God. *(Bottom, cel drawing)* San gives Ashitaka some dried meat she has brought.

The Rampaging Boar Gods

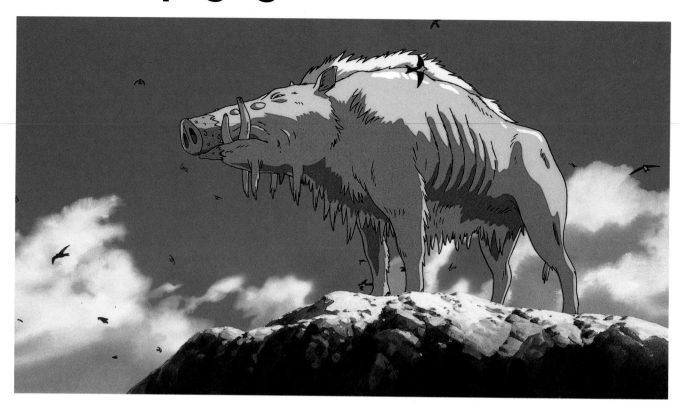

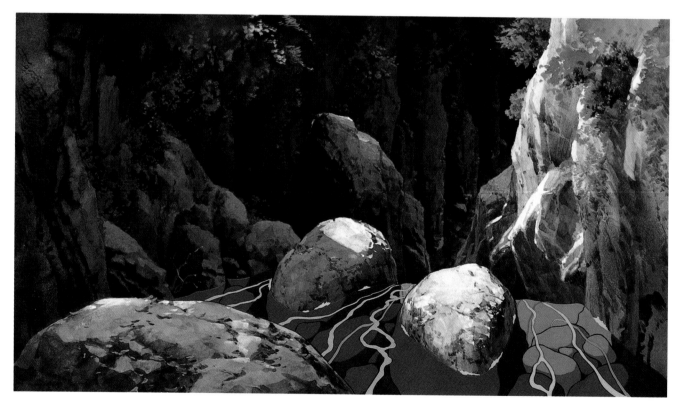

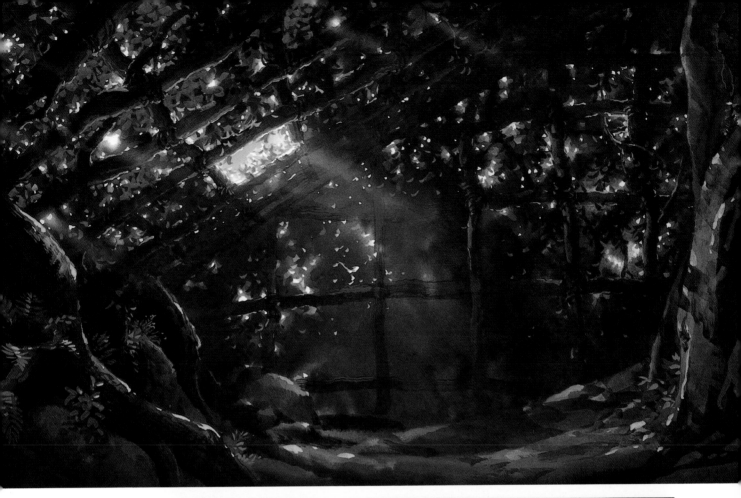

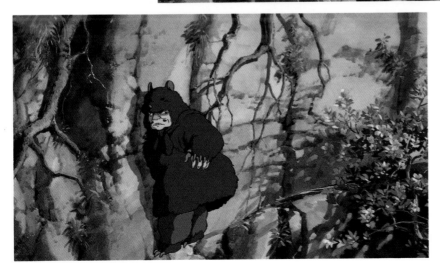

(Top left, cel drawing) Okkotonushi stands atop a rocky peak and looks out over a sea of foliage. Leading a family of boar gods, he has come from Chinzai (the old name for the island of Kyushu) to protect the forest. *(Left bottom, background drawing)* Jiko Bo and two master hunters, who have observed the boar gods from a hidden blind, have been spotted by them and must now make their escape. The drawing shows a valley that they cross during their flight. *(Right top, background drawing)* The interior of the hidden blind built on a ledge of a rock face that overlooks a sea of foliage. *(Right middle, background)* The middle of a rock face opposite the hidden blind of Jiko Bo and the hunters. *(Right bottom, cel drawing)* Wearing a bear skin as camouflage, Jiko Bo climbs down the rock face.

115

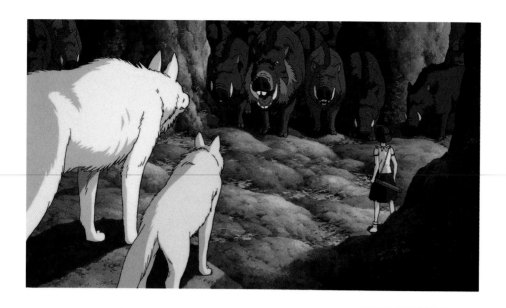

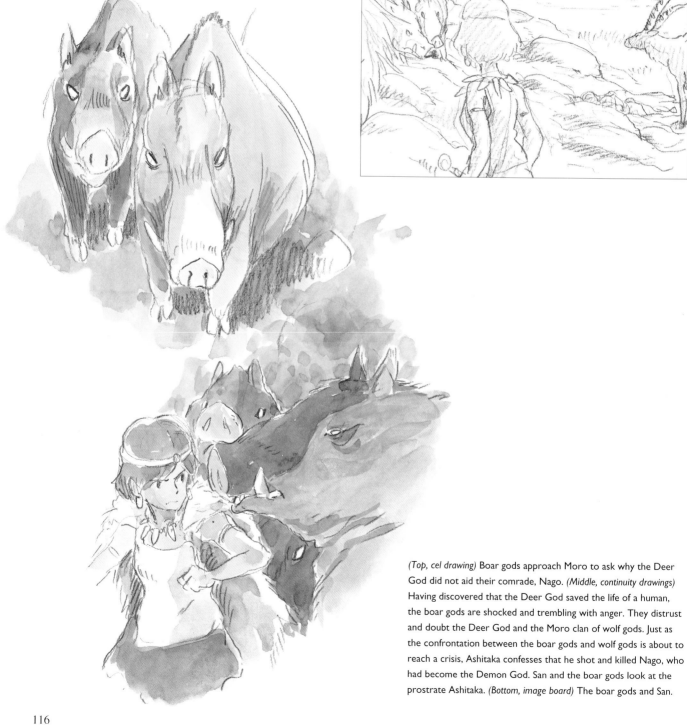

(Top, cel drawing) Boar gods approach Moro to ask why the Deer God did not aid their comrade, Nago. (Middle, continuity drawings) Having discovered that the Deer God saved the life of a human, the boar gods are shocked and trembling with anger. They distrust and doubt the Deer God and the Moro clan of wolf gods. Just as the confrontation between the boar gods and wolf gods is about to reach a crisis, Ashitaka confesses that he shot and killed Nago, who had become the Demon God. San and the boar gods look at the prostrate Ashitaka. (Bottom, image board) The boar gods and San.

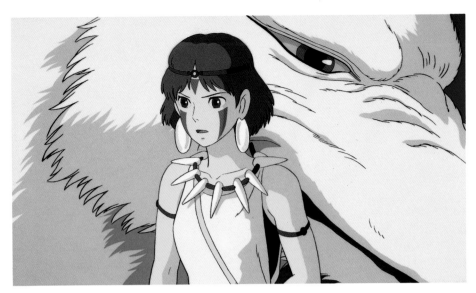

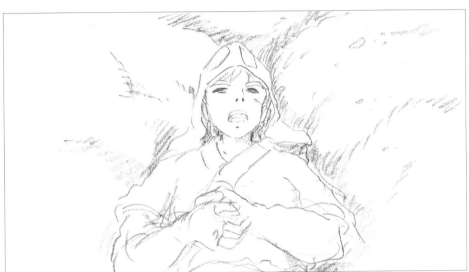

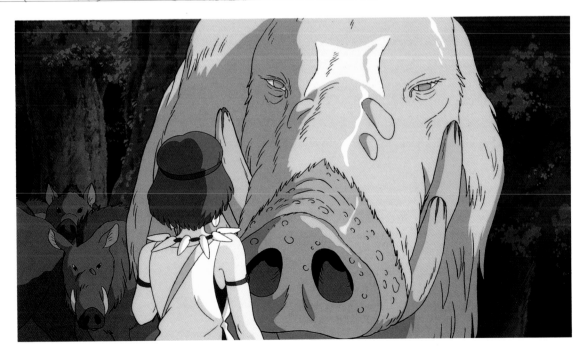

(Top, cel drawing) As proof that he shot Nago, Ashitaka thrusts out his right arm. San looks with disbelief at Moro, with narrowed eyes at Ashitaka's scar, which now extends to the palm of his hand. *(Middle, continuity drawing)* Ashitaka tells how, to protect his village from danger, he had no choice but to kill the Demon God. *(Bottom, cel drawing)* Okkotonushi appears. He is a 500-year-old boar god with four tusks and is the oldest of the boar gods. Thinking to rip Ashitaka to death with his tusks, he advances on the prostrate youth, but is stopped by San. When Ashitaka asks how to rid himself of the curse of death, Okkotonushi tells him to leave the forest.

Moro's Cave

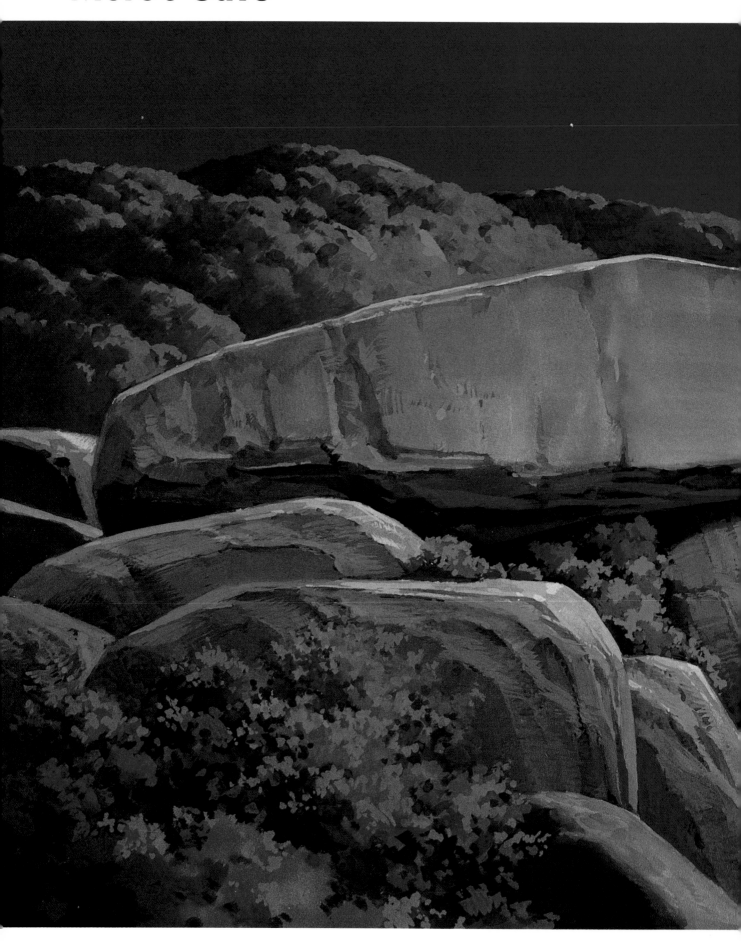

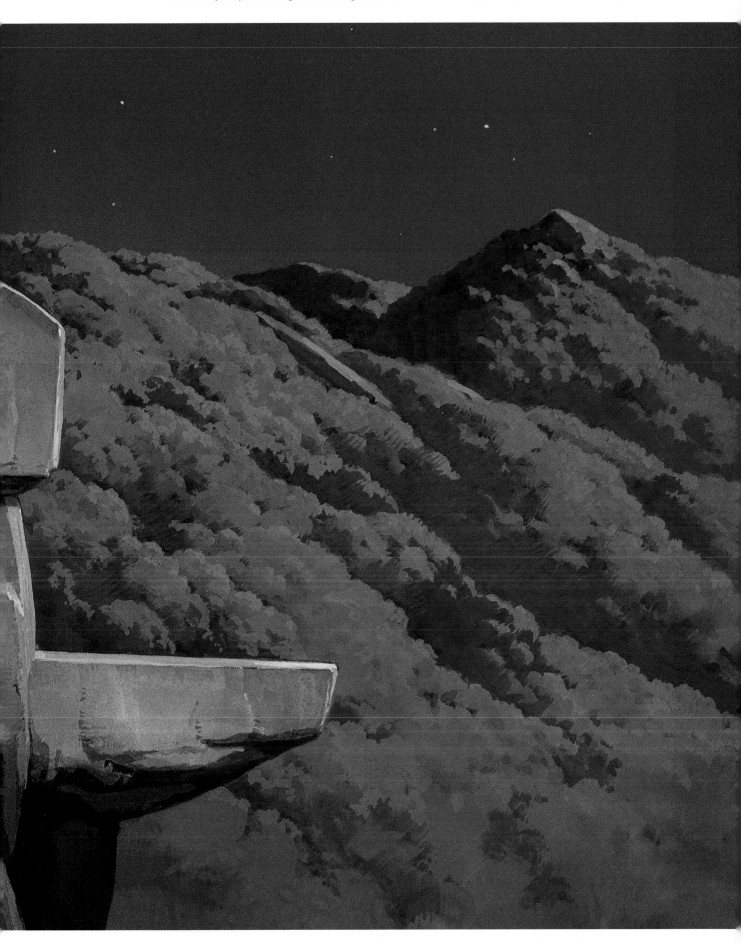

(Top, background drawing) The rock ledge on which Ashitaka stands. While resting in the cave of the Moro clan, Ashitaka is awakened by the pain in his right arm. Leaving the cave, he stands on the ledge outside and looks out over the forest.

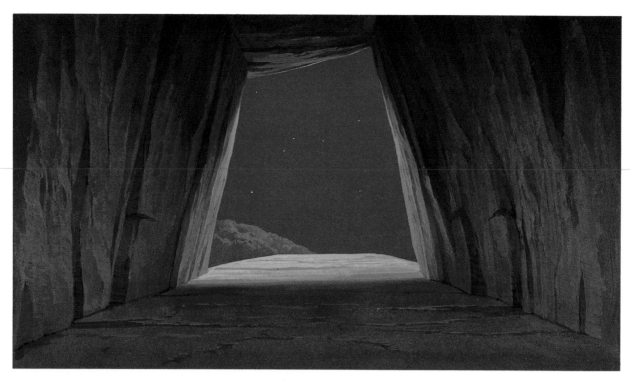

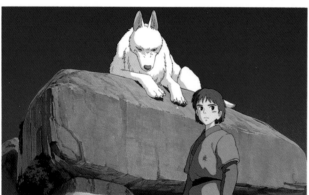

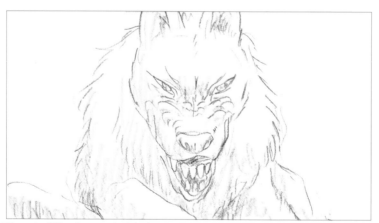

(Top left, background drawing) The exit of Moro's cave, which leads to the ledge. (Middle left, cel drawing) As he recovers his strength, Ashitaka begins to feel intense pain from his scar. Moro tells Ashitaka, who is standing on the ledge, that if he jumps to his death he will be freed from his pain. (Middle right, continuity drawing) Ashitaka asks, "Isn't there any way for the forest and humans to live together without fighting?" and "Do you intend to make San one of you?" but Moro only sneers at his questions. When Ashitaka presses him to free San, a human being, Moro explodes with anger. "Do you think you can save that poor girl, who is neither a human nor a wolf?" he asks. (Bottom right, cel drawing) In response to Moro's sharp words, Ashitaka says, "We can live together." (Right, background drawing) The ledge of Moro's cave.

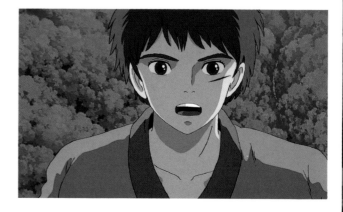

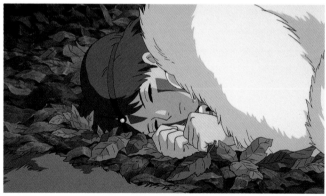

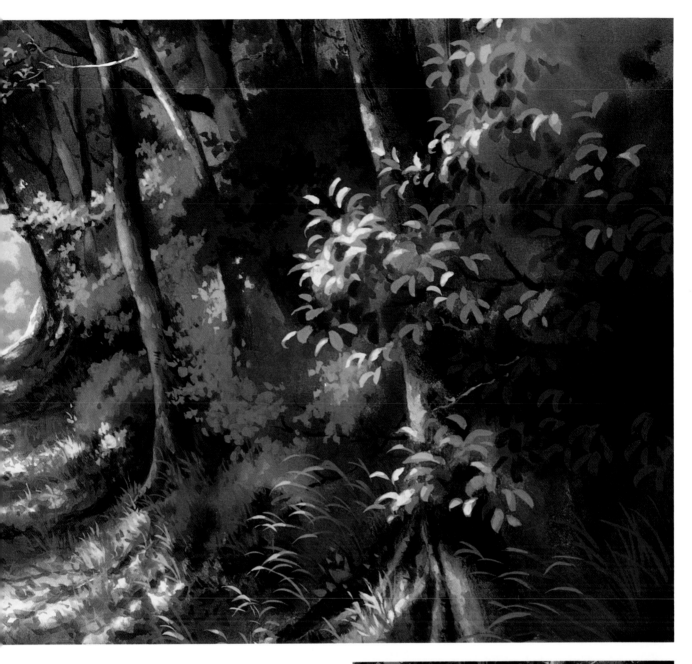

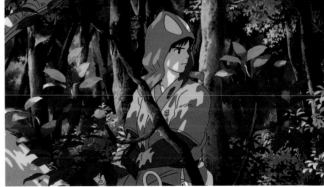

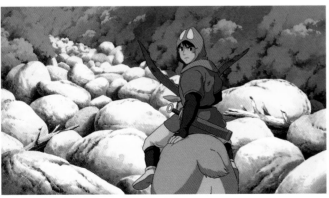

(Top, background drawing) Wolf trail in the leaf-covered forest floor.
(Middle left, cel drawing) San snoring in Moro's cave. (Bottom left, cel drawing)
Just as he is about to leave the cave, Ashitaka notices his sword, which San
had taken from him, his hood, which she has neatly folded, and a lunch she
has carefully prepared. Ashitaka realizes that San is telling him to leave the
forest. (Middle right, cel drawing) Riding Yakkuru on the wolf trail, Ashitaka
thinks it strange that no Kodama have appeared and that the forest is so
silent. (Bottom right, cel drawing) Coming to a gully filled with large round
rocks, Ashitaka catches the faint smell of the ironworks in the wind.

The Pitched Battle Between the Humans and the Animal Gods

The time for the decisive battle has come. The terrible struggle of San and the rampaging boar gods against Lady Eboshi's Tatara clan produces many casualties on both sides. San is enveloped in the tendrils of Okkotonushi, who has been transformed into a Demon God by a fatal musket shot. Ashitaka risks his life in trying to rescue her. Together with Lady Eboshi, Jiko Bo tries to take the head of the Deer God. The story approaches its climax.

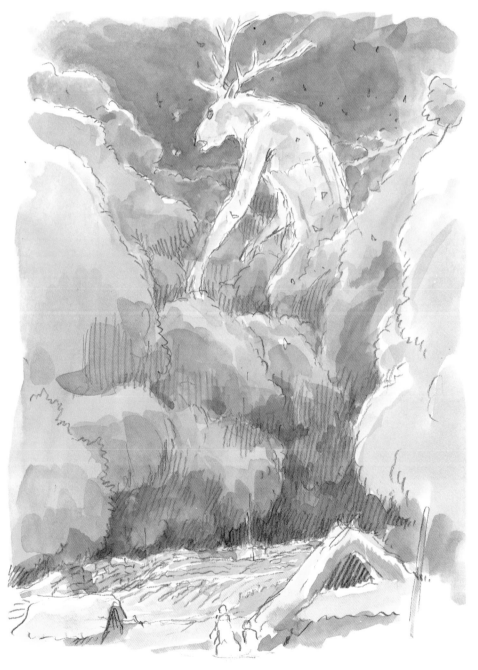

(Left, image board) An early drawing of a Kodama. *(Right, image board)* An early drawing of the giant Night Walker heading into the forest.

The Final Battle Begins

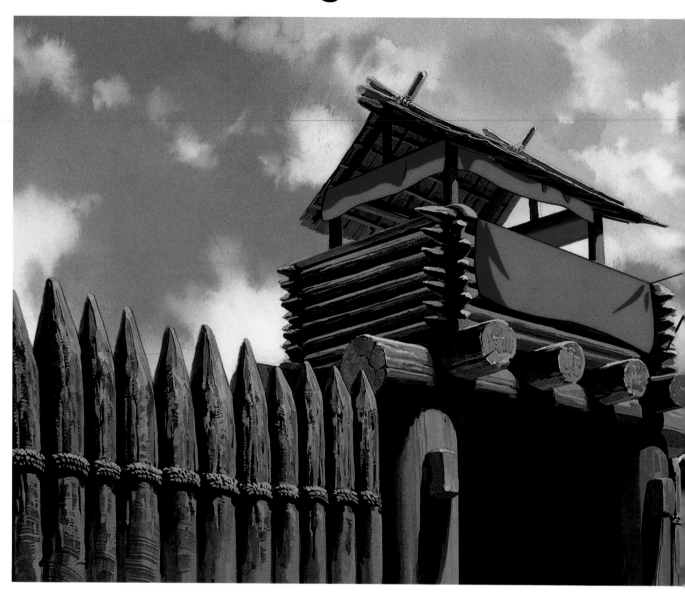

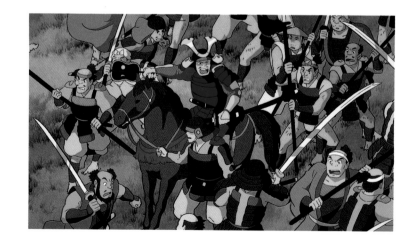

(Top left, background drawing) The ironworks awaits the return of the ox train led by Lady Eboshi. Red cloth for deflecting arrows has been hung in various places around the ironworks. *(Bottom left, cel drawing)* Marauding samurai attack Lady Eboshi and her men on their way back to the ironworks. *(Top right, background drawing)* A road on a bald mountain slope over which the exhausted ox herders return to the ironworks after leaving the field of battle. *(Bottom right, image board)* Early drawing of a samurai.

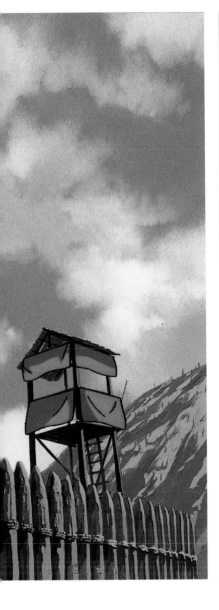

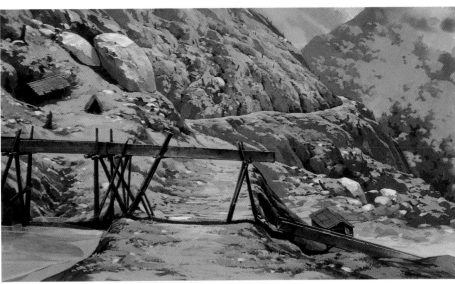

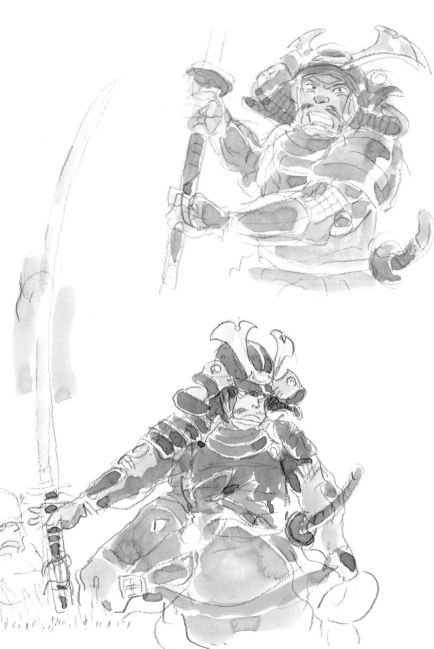

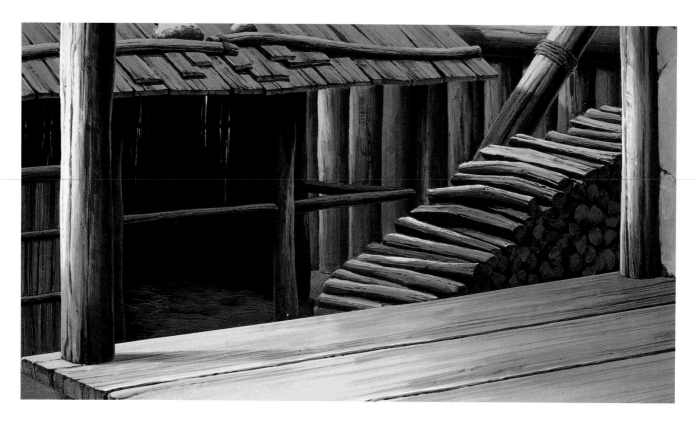

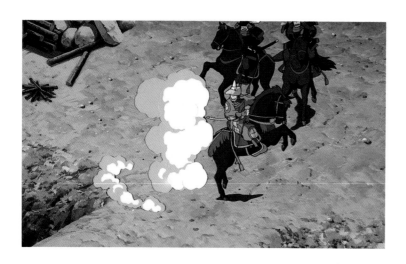

(Top left, background drawing) Verandah of an ironworks guard house. *(Bottom left, cel drawing)* The warlord Asano exhorts the marauding samurai to attack the ox train, with the intention of seizing the iron of the ironworks. Brandishing their swords, messengers have come to deliver an ultimatum from Asano, but are driven from the gate by the women of the ironworks. *(Top right, cel drawing)* On the verandah of the guardhouse, Jiko Bo shows Lady Eboshi a document from the emperor. Jiko Bo tells Lady Eboshi that, using the imperial mandate, they must assemble a band of hunters and seize the head of the Deer God for the emperor as soon as possible. *(Right middle, cel drawing)* In return for her help in obtaining the head of the Deer God, Lady Eboshi will be given the use of musketeers from Shishoren, a mysterious organization in the service of the emperor. Unlike Shishoren, Lady Eboshi does not believe that the head of the Deer God can bestow eternal life, but she says she will keep her promise to aid Jiko Bo, who is a member of Shishoren. *(Bottom right, background drawing)* The guardhouse of the ironworks.

128

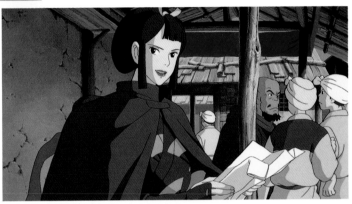

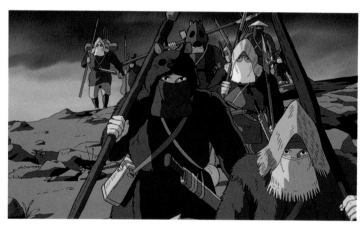

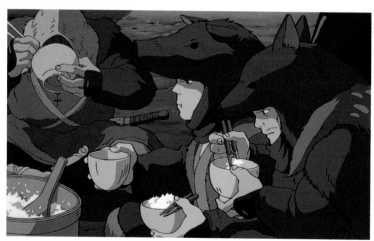

(Top left, background drawing) A steep slope from which the members of Karagasaren (The Paper Umbrella Society), a band of hunters secretly organized by Jiko Bo, descend on the ironworks. *(Middle left, cel drawing)* Wearing boar and bear skins, a band of hunters head for the ironworks. *(Bottom left, cel drawing)* While the Tatara gaze suspiciously, the strange hunters who have entered the ironworks form a circle on the ground and silently eat their meal. *(Top right, image boards)* Early drawings of the hunters. *(Bottom right, background drawing)* The dim interior of the ironworks gate, through which the hunters file.

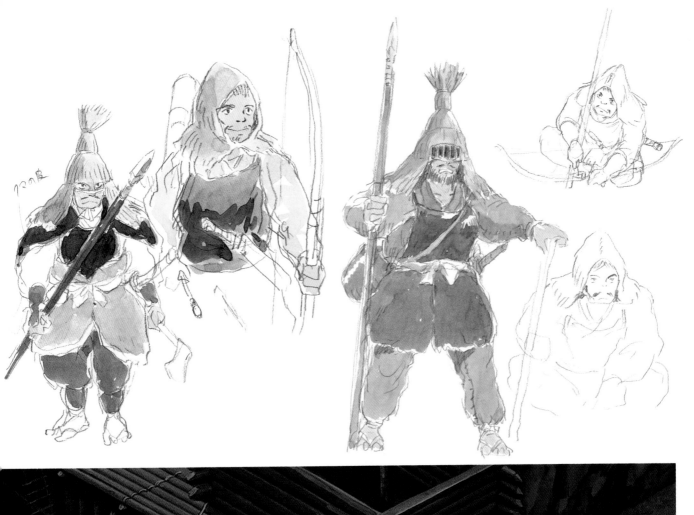

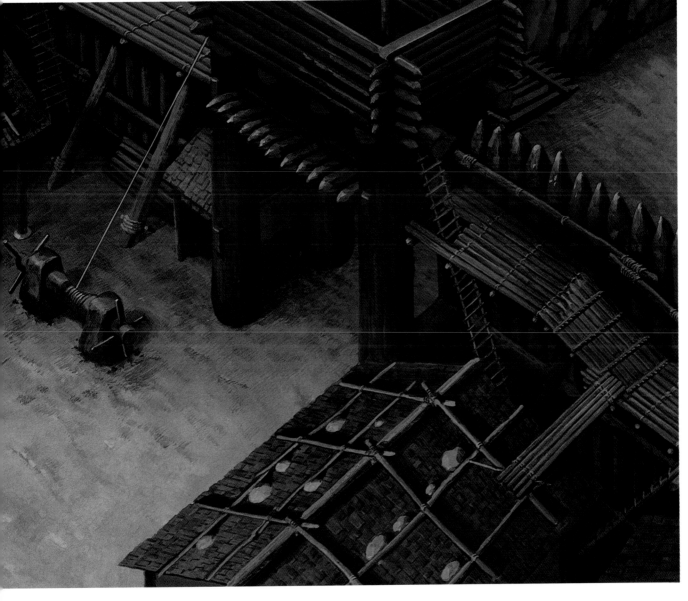

Two Battlefields

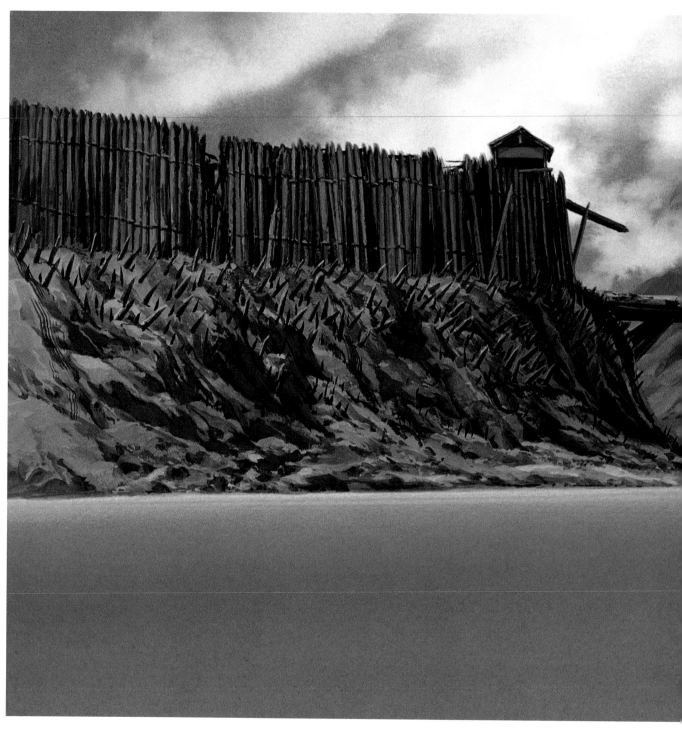

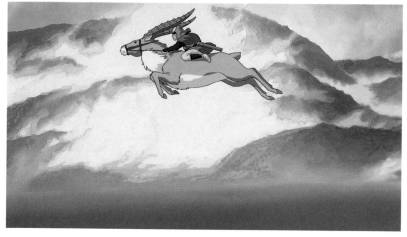

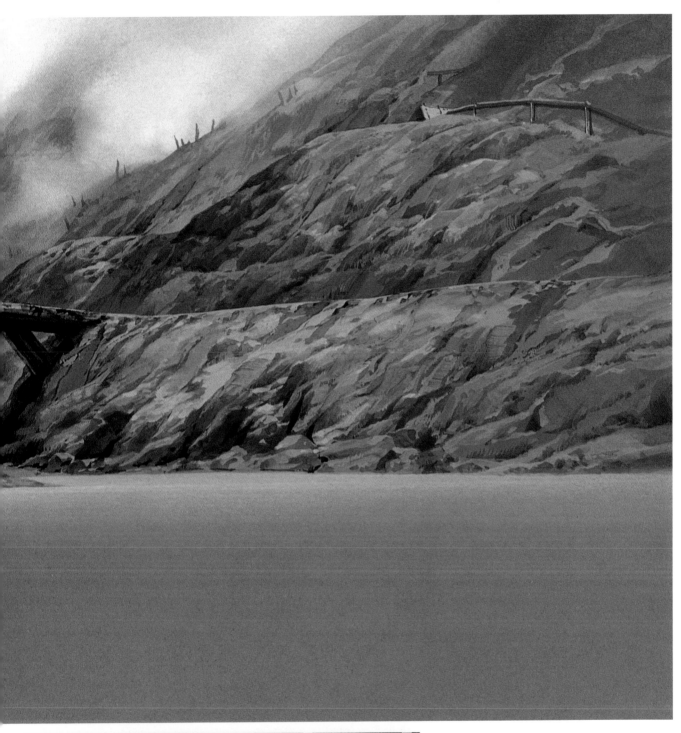

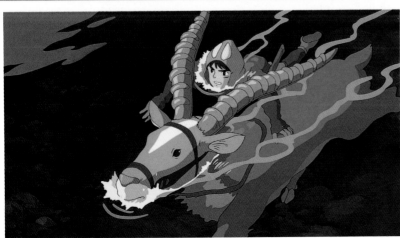

(Top, background) Noticing something strange afoot at the ironworks, Ashitaka crosses the lake on Yakkuru. Above the bare hillside near the ironworks, which can be seen from the opposite shore, ill-omened clouds are rising. (Bottom left, cel drawing) Ashitaka arrives at the shore opposite the ironworks. He battles a band of samurai, who want to stop him from going to the ironworks, and jumps into the lake. (Bottom right, cel drawing) Riding on Yakkuru, Ashitaka speeds across the lake to the ironworks.

133

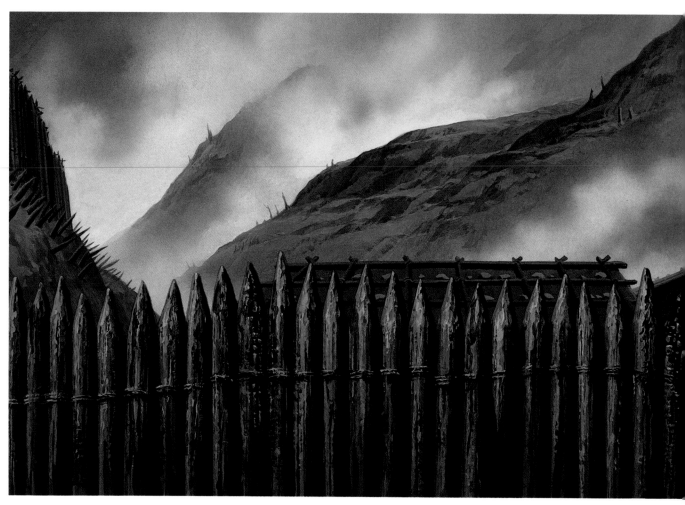

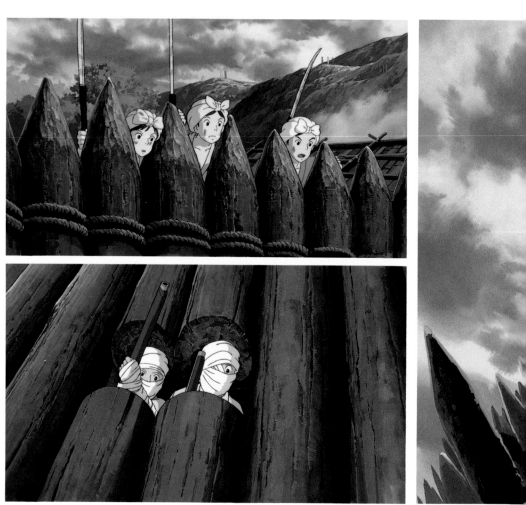

(Top left, background drawing) After Lady Eboshi and her men leave to hunt for the Deer God, Asano's samurai suddenly attack the ironworks. The burn marks from the firing of muskets can be seen on the ironworks' front palisade. *(Middle left, cel drawing)* Toki *(on the far right)* and other women guarding the palisades at the rear of the ironworks spot Ashitaka swimming in the lake. *(Bottom left, cel drawing)* Men poke their heads out from gaps in the palisades to fire their guns at the boats of Asano's samurai. *(Bottom right, background drawing)* Palisades to the rear of the ironworks.

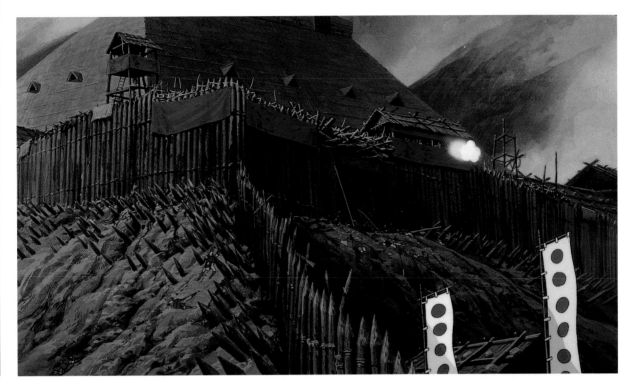

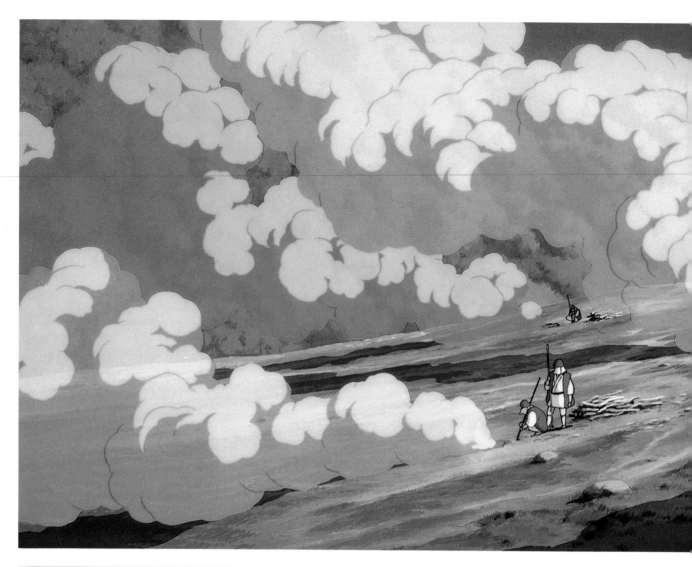

(Top left, cel drawing) Not knowing that Asano's men are about to attack the ironworks, Lady Eboshi's men prepare for a final battle with the rampaging forest gods. To baffle the forest gods' sense of smell, they are sending up columns of smoke to the forest beyond. *(Bottom left, background drawing)* A shoulder of the rocky hillside from which Lady Eboshi's men are sending columns of smoke. *(Bottom right, cel drawing)* With paper umbrellas serving as shelter, Lady Eboshi's men set up camp at the base of the rocky hill.

136

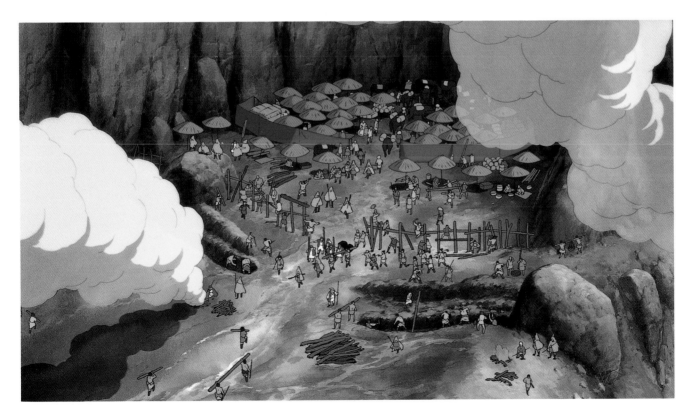

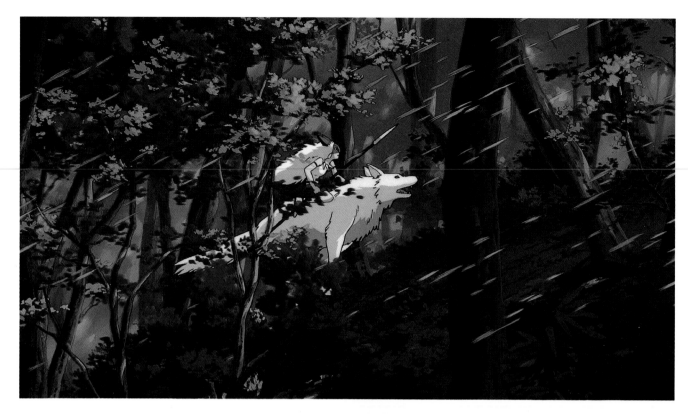

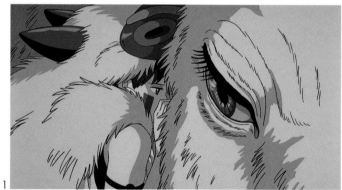

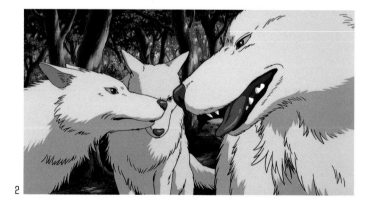

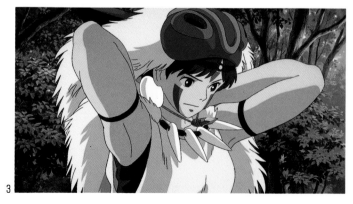

(Top left, cel drawing) Riding a wolf, San plunges into the dark forest toward the place where Moro is watching Lady Eboshi's men. (Bottom, all cel drawings) 1. Moro and San realize that Lady Eboshi is trying to entice the boar gods out of the forest with the aim of springing a trap. Deciding to fight at the side of the boar gods, she bids farewell to Moro. 2. A wolf gives San a stone knife amulet that was entrusted to her by Ashitaka. Saying that she will remain by the side of the Deer God, Moro tells the wolves, her children, to go with San. 3. Hanging Ashitaka's knife around her neck, San sets out resolutely to battle.

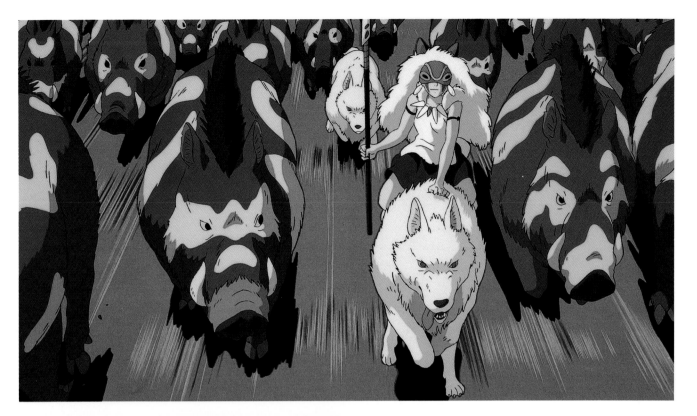

4

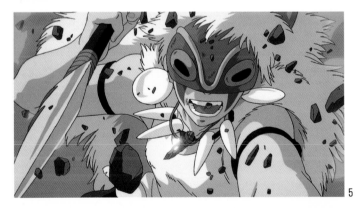

5

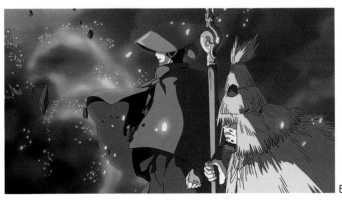

6

(Top left, cel drawing) A troop of boar gods rushing to attack Lady Eboshi's men. Telling them that "the Moro clan will fight with you," San joins the wildly charging boars. *(Bottom, cel drawings with the exception of number 6, which is a CG image)* 4. The boars attacking Lady Eboshi's camp are blown sky high by charges of gunpowder laid by Lady Eboshi's men. 5. San, the wolves, and the boars keep charging in the midst of the explosions. The knife that San received from Ashitaka remains securely around her neck. 6. Lady Eboshi stands calmly amidst the smoke and tremors of the explosions.

Ashitaka Races On

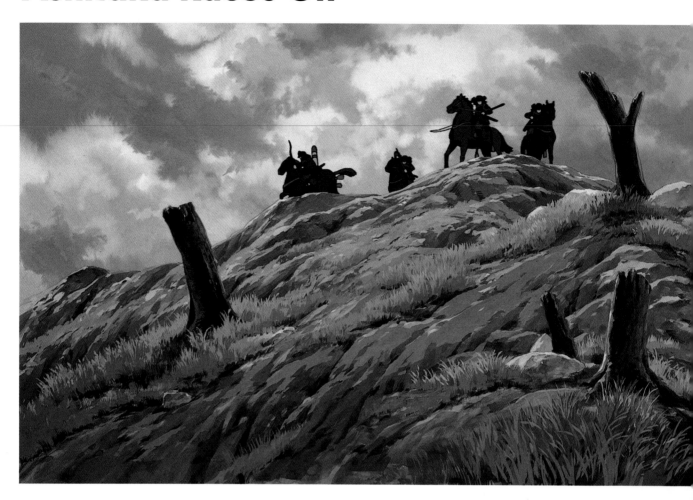

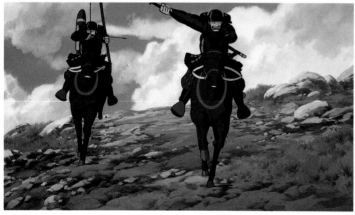

(Top left, cel drawing) Ashitaka races to the battlefield to tell Lady Eboshi about the danger to the ironworks. Suddenly, from the crest of the bare hillside above him, Asano's cavalry appears. (Left middle, cel drawing) The cavalry in hot pursuit of Ashitaka. (Bottom left, cel drawing) Urging on Yakkuru, Ashitaka makes his escape. (Right top, cel drawing) A cavalryman is about to cut down Ashitaka, who has fallen off Yakkuru after his faithful steed was struck by an arrow. (Middle right, cel drawing) Ashitaka draws an arrow from the writhing Yakkuru. (Bottom right, background drawing) Pursued by cavalrymen, Ashitaka suddenly leaps from a rock.

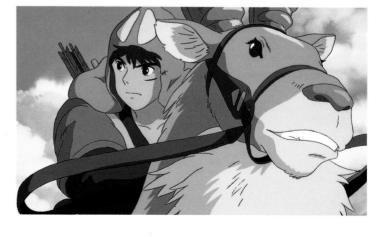

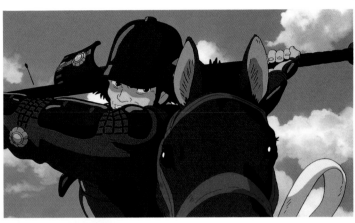

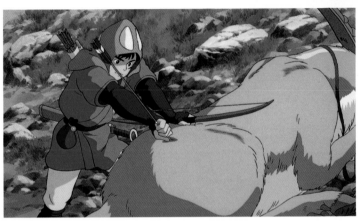

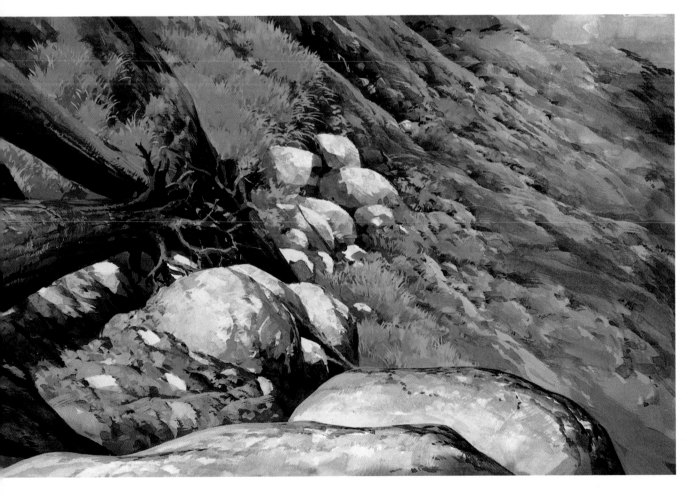

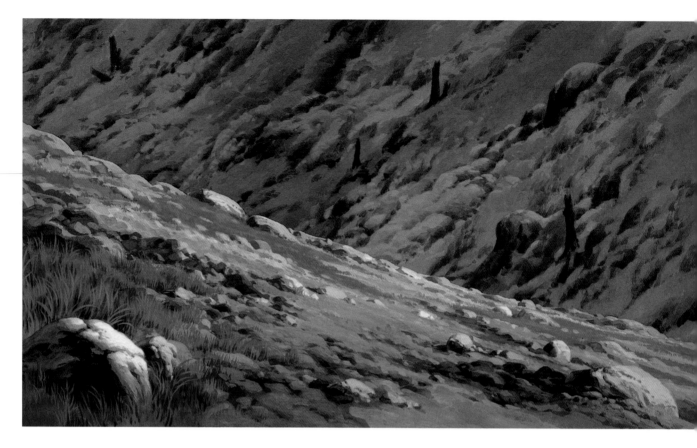

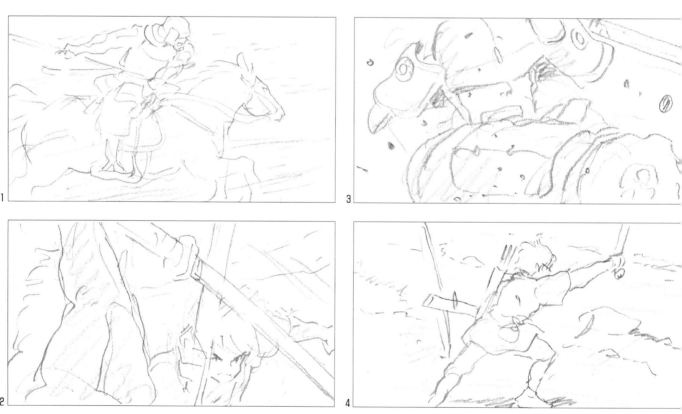

1

2

3

4

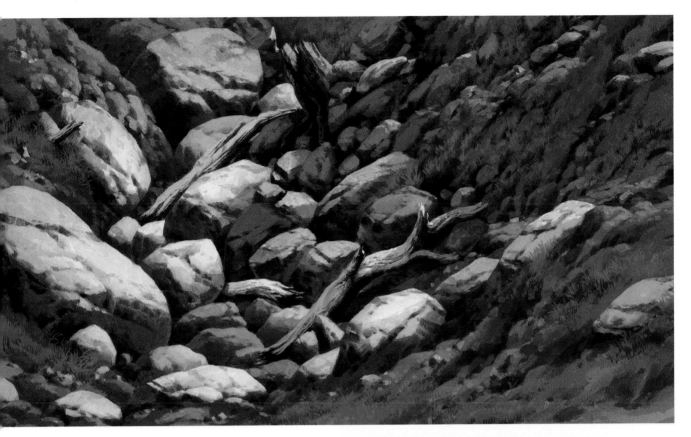

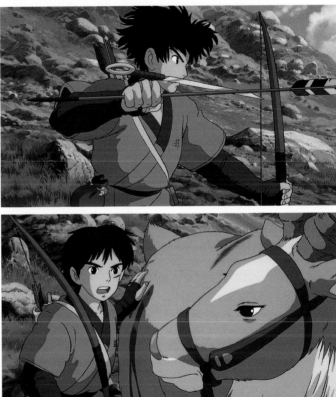

(Top left, background drawing) The slope where Ashitaka takes his last stand against his pursuers. *(Bottom left, continuity drawings)* 1. A cavalryman attacks a resolute Ashitaka. 2. Ashitaka's sword clashes with the long sword of the cavalryman. 3. One sweep of Ashitaka's sword slices off the cavalryman's sword hand at the elbow. 4. The cavalryman's long sword is thrust into the ground. *(Top right, background drawing)* The rock-strewn gully into which Ashitaka leaps alone after leaving Yakkuru. *(Right middle, cel drawing)* After felling the cavalryman, Ashitaka turns and grabs an arrow shot by an archer. *(Bottom right, cel drawing)* Ashitaka leads away the wounded Yakkuru.

A Sea of Death

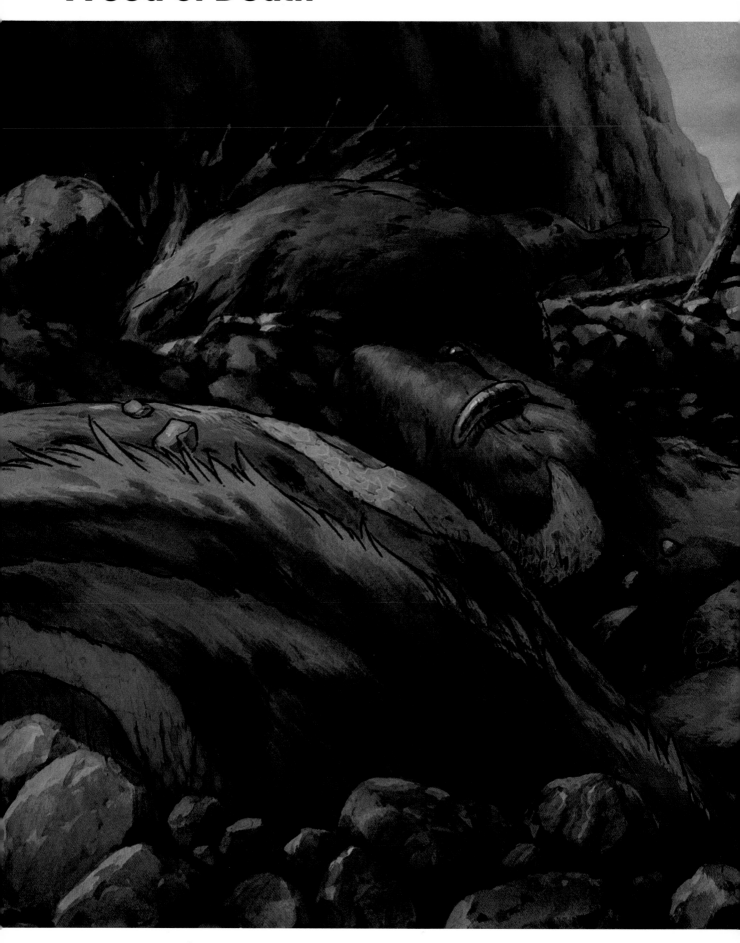

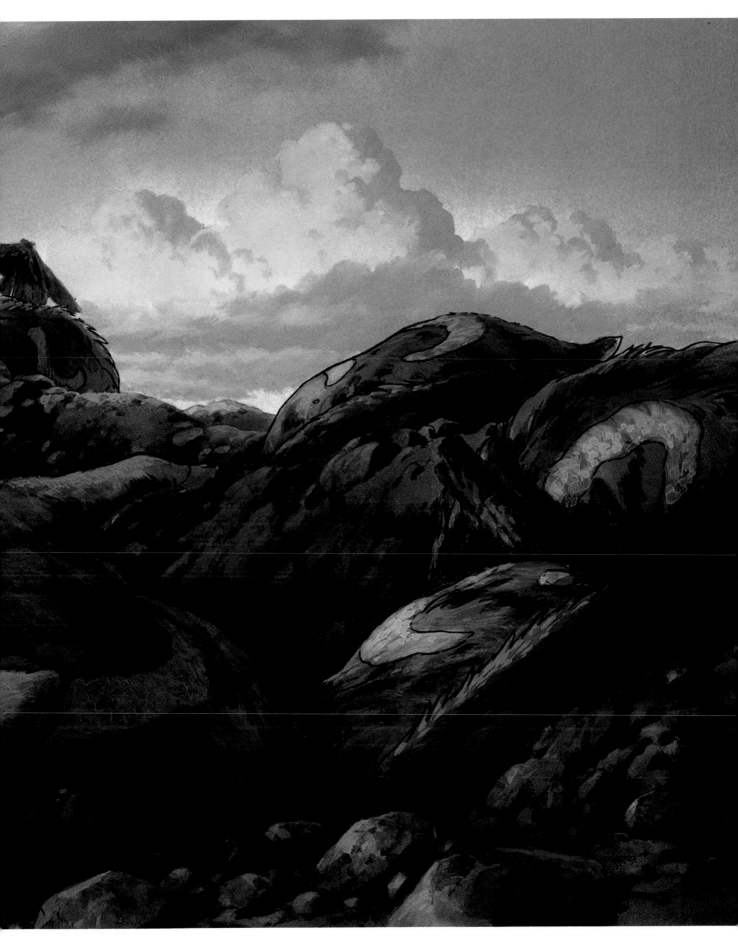

(*Background drawing*) The base of the rocky hill where Lady Eboshi's men fought the boar gods. The aftermath bespeaks a heroic struggle.

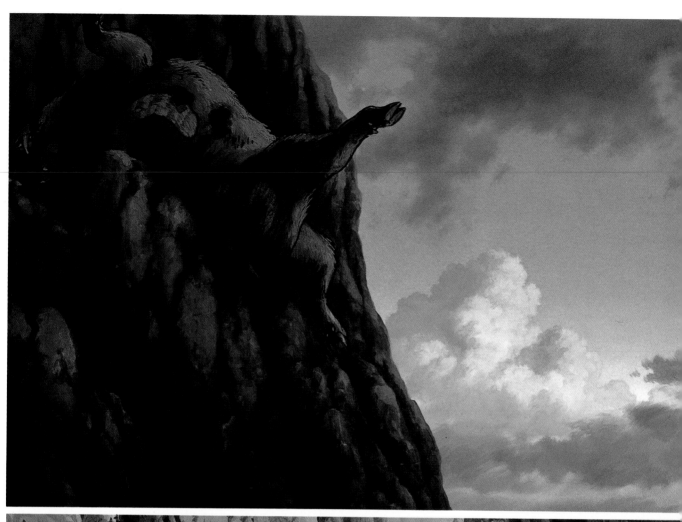

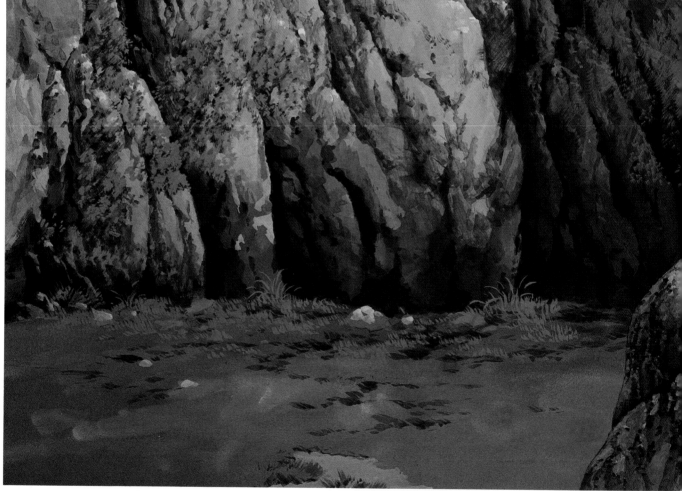

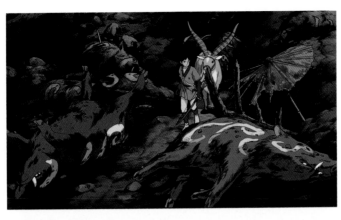

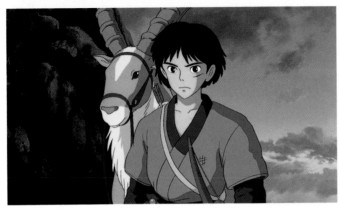

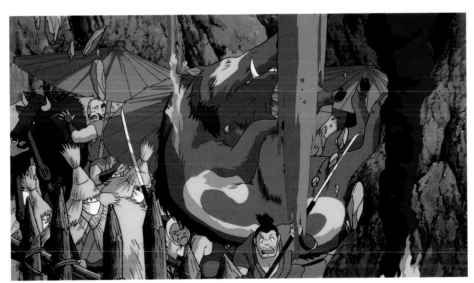

(Top left, background drawing) A sheer rock face darkened by blood and flames from the gunpowder. The corpse of a boar god is caught on a ledge. *(Bottom left, background drawing)* The foot of the rocky hill before it is transformed into a battleground. *(Right top, cel drawing)* Ashitaka examines the carnage at the foot of the rocky hill. *(Middle right, cel drawing)* Passing between the corpses of the boar gods, Ashitaka is stunned by the large number of Tatara casualties, laid side by side on the ground. *(Bottom right, cel drawing)* Ashitaka hears about the battle between the boar gods and Lady Eboshi's men from the Tatara survivors. He learns that, as part of Karagasaren's strategy, the Tatara ox herders and musketeers guarding the foot of the hill were used as bait to entice the boar gods into charging.

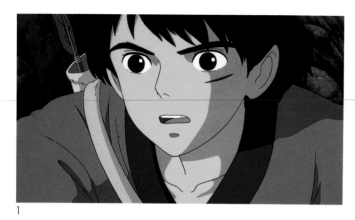

1

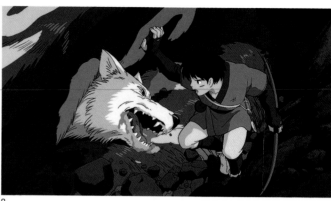

2

5

6

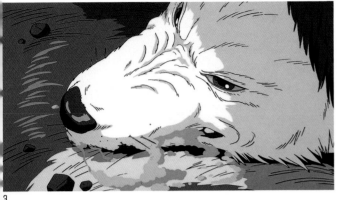

3

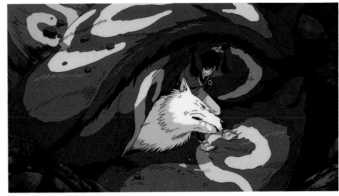

4

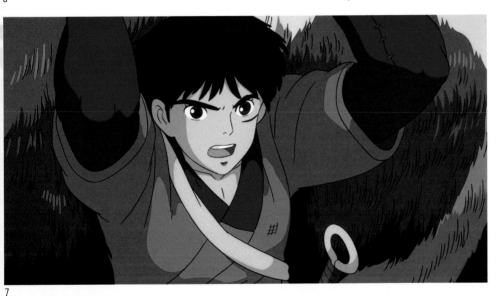

7

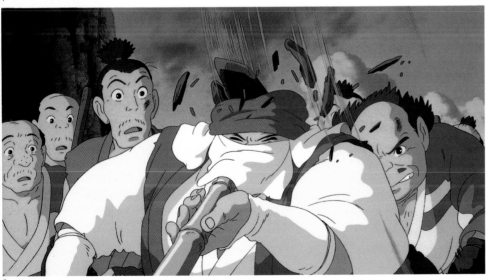

8

(Beginning at top left, cel drawings with the exception of numbers 5 and 6, which are continuity drawing) 1. Hearing about the tragedy from the Tatara survivors, Ashitaka feels pity for San, the boar gods, Lady Eboshi, and her men. Soon after, he notices something stirring—a dying wolf. 2. Ashitaka tries to save the wolf, who is trapped under the corpse of a giant boar. 3. The wolf writhes about, trying desperately to free itself from the body of the dead boar. 4.–6. Using all his strength, Ashitaka tries to lift up the body of the boar. 7. The Tatara men watch Ashitaka trying to help the wolf, but don't know what to think. Ashitaka, who has come to tell Lady Eboshi about the danger to the ironworks, asks them which is more important, the head of the Deer God or the ironworks. 8. A Karagasaren hunter pushes his way through the Tatara men and tries to stop Ashitaka by shooting him with a poison dart from a blowpipe with an umbrella emblem, but the Tatara men quickly come to Ashitaka's aid.

The Blood-Soaked Forest

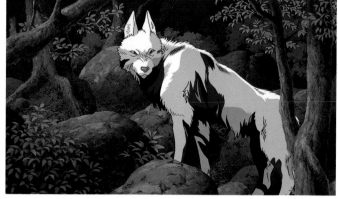

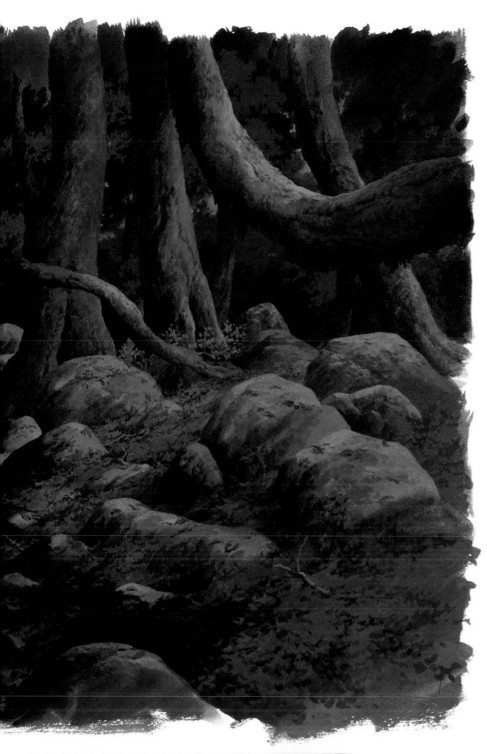

(Top left, background drawing) The forest soaked with the blood of Okkotonushi and a wolf, who were wounded in the battle with Lady Eboshi's men. *(Bottom left, cel drawing)* The wolf who accompanied San is suffering from a terrible wound. *(Bottom right, cel drawing)* Encouraging the dying Okkotonushi, San leads him to Deer God Pond.

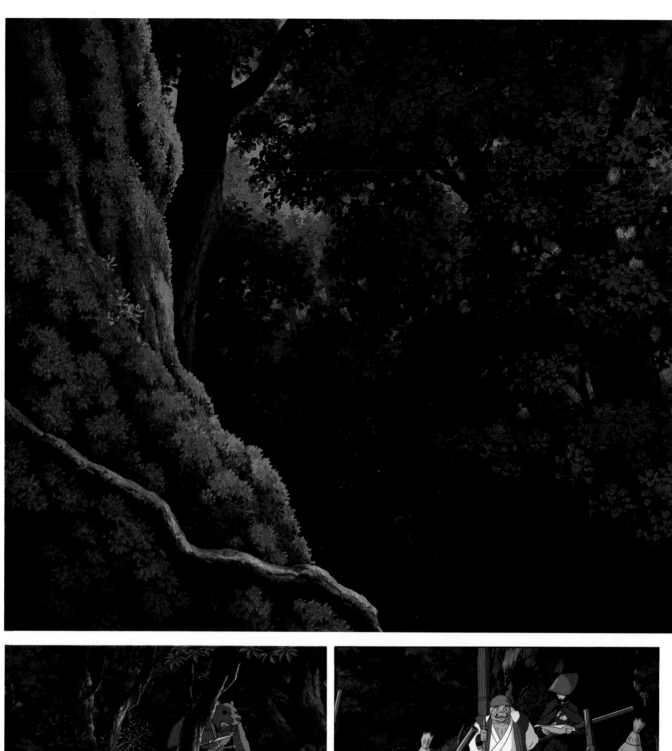

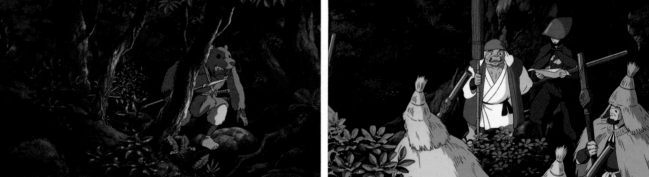

(Top left, background drawing) The forest through which march a column of musketeers and Karagasaren hunters led by Lady Eboshi and Jiko Bo, in search of the head of the Deer God. *(Left page, bottom left, cel drawing)* Jibashiri returning to tell Jiko Bo that Okkotonushi and San are on their way to Deer God Pond. *(Left page, bottom right, cel drawing)* Standing at the base of a tree, a step above the others, Lady Eboshi examines a map, while Jiko Bo, at her side, urges on the marching men. *(From the top right, all cel drawings)* 1. San desperately encourages Okkotonushi, who has slipped and fallen on his side. 2. Standing by Okkotonushi, San and the wolf sense that someone is coming and feel their chests thumping. 3. From between the dark branches of the deciduous trees, apes toss twigs at San and Okkotonushi to show their fear and despair. "Because of you, this forest will be no more," they shout. Then, seeing that ghost boars are approaching, the apes run away. 4. Noticing that the ghost boars are human beings—Jibashiri and his men in disguise—San sends the wolf to warn Moro of the situation. Believing that the boars are his comrades returned to life, Okkotonushi begins to run toward Deer God Pond, telling them to follow. This is a sign that Okkotonushi is about to transform into the Demon God. When Okkotonushi falls, exhausted, he is surrounded by the ghost boars. Determined to sacrifice her own life if necessary, San defends Okkotonushi. 5. With dark hollow eyes, the ghost boars stealthily advance toward San and Okkotonushi.

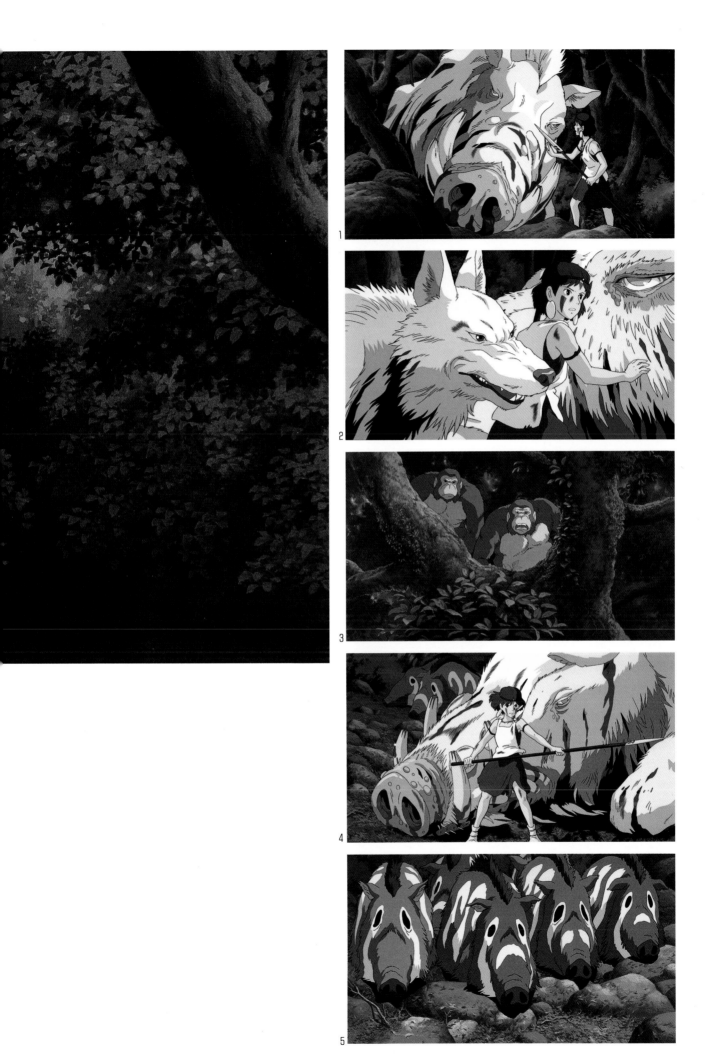

San and Ashitaka Meet Again

(Top, background) Ashitaka and the wolf struggle along in search of San. The edge of a cliff overlooking the forest. *(Bottom, cel drawing)* The wolf howls at the evening sky as though to send a message to San, whom she and Ashitaka have not been able to find.

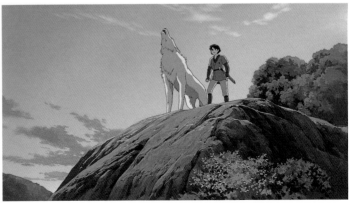

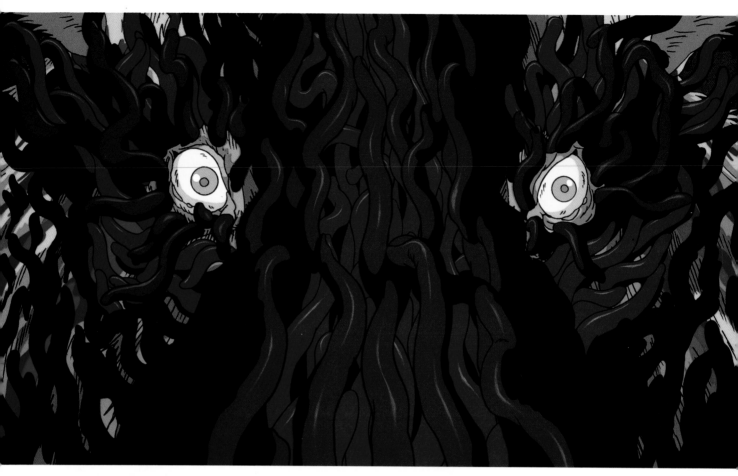

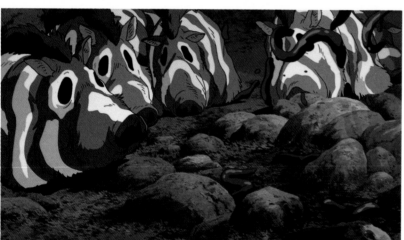

(*Top left, cel drawing*) Okkotonushi metamorphoses into the Demon God before San's eyes. (*Middle left, cel drawing*) The tendrils surrounding the body of Okkotonushi burn the ground. Falling back in fear, the ghost boars surround Okkotonushi from a distance. (*Left bottom, cel drawing*) A stone thrown by one of the humans in ghost boar disguise hits San on the back of the head. Losing consciousness, she becomes entangled in the tendrils of Okkotonushi. (*Top right, continuity drawing*) Okkotonushi seethes with rage as tendrils envelop his body. (*Right middle, continuity drawing*) San becomes enveloped in the tendrils. (*Bottom right, continuity drawing*) Regaining consciousness inside the tendrils, San tries desperately to free herself, but tendrils begin appearing from her own body. Together with Okkotonushi, San starts to metamorphose into the Demon God.

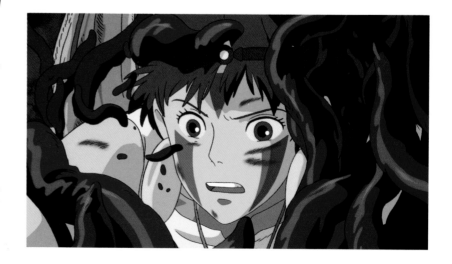

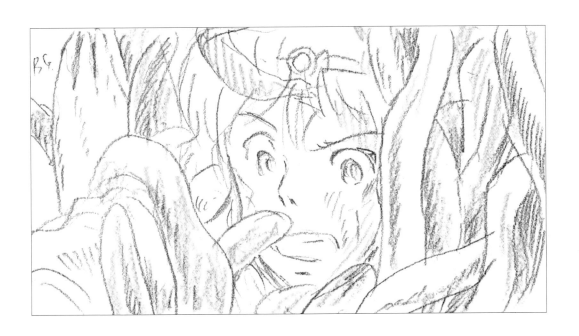

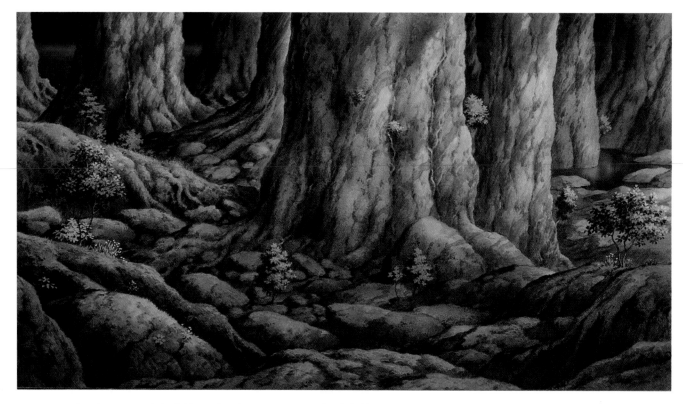

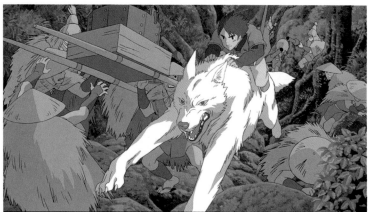

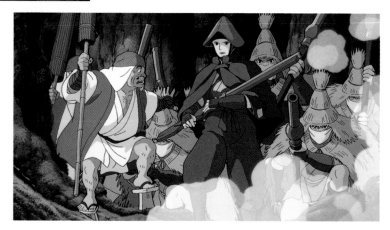

(Top, background drawing) Hurrying to rescue San, Ashitaka and the wolf encounter Lady Eboshi's men near Deer God Pond. *(Middle left, CG image)* Surprised at the sudden appearance of Ashitaka and the wolf, the column of Lady Eboshi's men falls into confusion. Two of the men are carrying an iron box that is to hold the head of the Deer God. *(Bottom left, cel drawing)* Passing through a hail of gunfire from the muskets, Ashitaka and the wolf rush on toward Lady Eboshi. She realizes that the boy calling her name is really Ashitaka. Standing beside Lady Eboshi, Jiko Bo orders the musketeers to hold their fire.

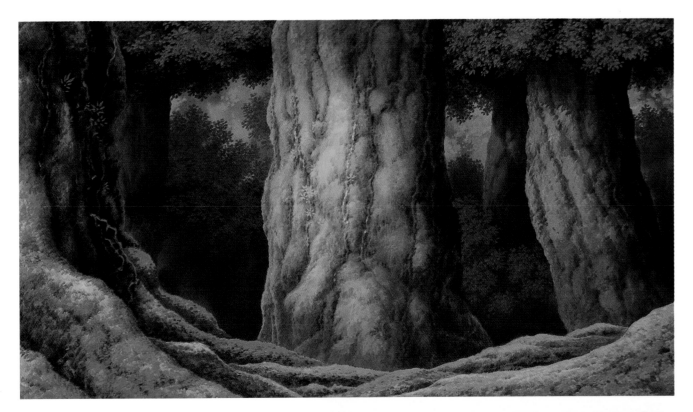

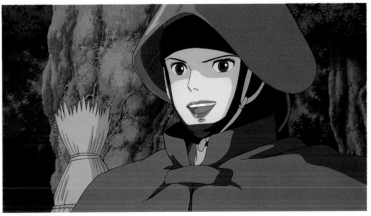

(Top right, background drawing) The forest near Deer God Pond, where Ashitaka and Lady Eboshi confront each other. *(Middle and bottom right, cel drawings)* Eboshi listens to Ashitaka describe Asano's assault on the ironworks. "What proof do you have that would make me believe you?" she asks. "None," says Ashitaka and adds that he "wanted to stay at the ironworks and fight." "Are you telling us to stop trying to kill the Deer God and kill men instead?" Lady Eboshi asks sarcastically. "No," says Ashitaka. "I want both the forest and the ironworks to live." He then rushes off to save San.

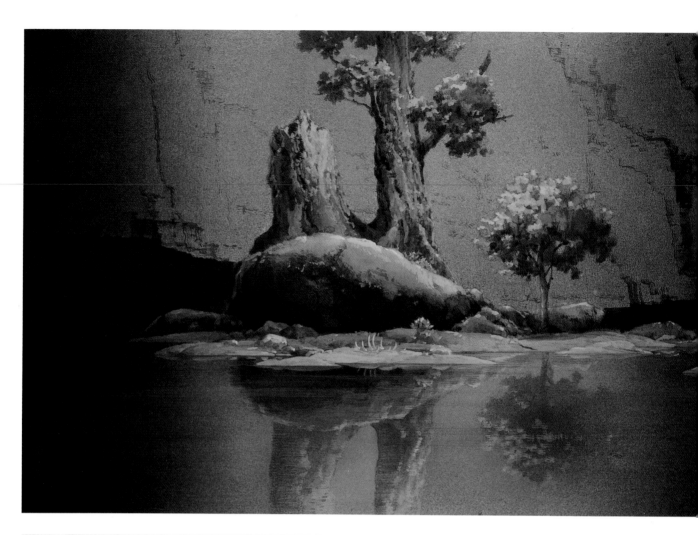

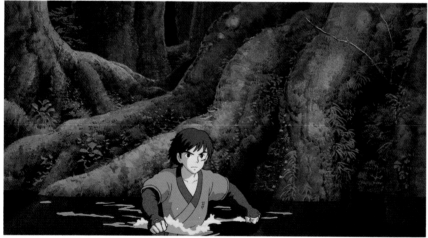

(Top left, background drawing) Light from the darkening
sky pours through a hole in the forest canopy over
Deer God Pond. *(Bottom left, cel drawing)* Wading
through the water of Deer God Pond, Ashitaka finds
Moro lying on the shore, near the point of death.

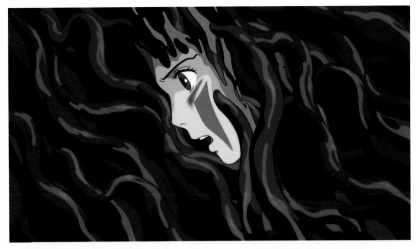

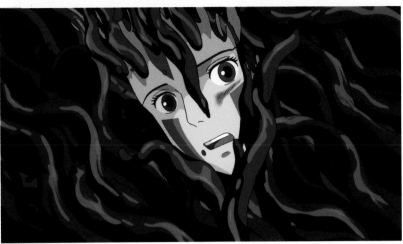

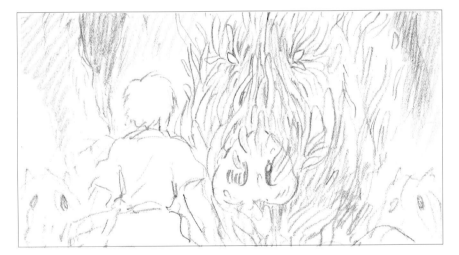

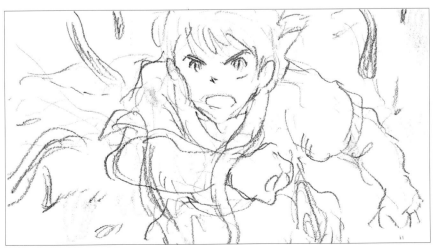

(*Top right and middle, cel drawings*) Standing by Moro, Ashitaka calls San's name. Hearing his voice, she calls his name in return, even though she is caught in the tendrils of Okkotonushi, who is metamorphosing into the Demon God. (*Upper bottom right, continuity drawing*) Ashitaka confronts the ghost boars and Okkotonushi, who is wobbling closer. (*Lower bottom right, continuity drawing*) San writhes in pain in the tendrils of Okkotonushi, which burn like black fire. Seeing San's left leg, Ashitaka desperately brushes aside Okkotonushi's tendrils to reach her struggling body.

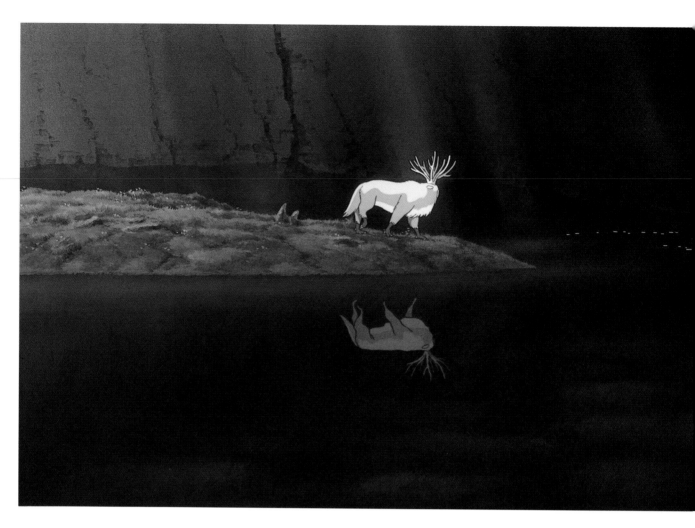

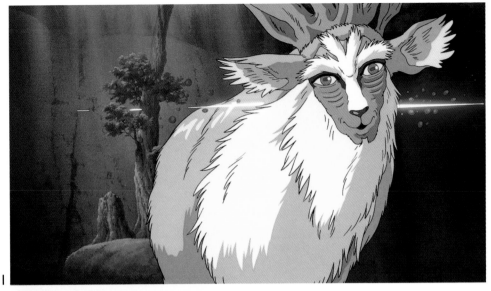

1

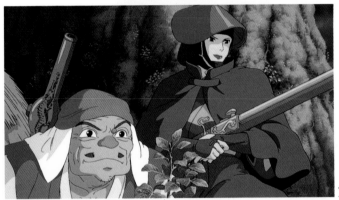

2

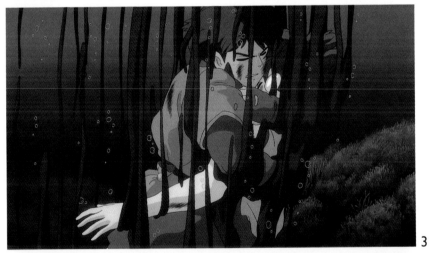

3

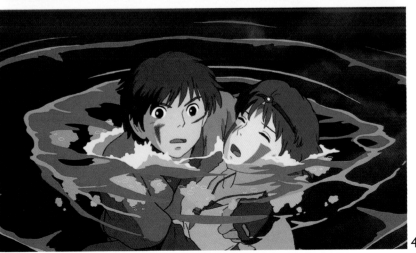

4

(Top left, cel drawing) Ashitaka plunges into the tendrils to rescue San, while two wolves attack the ghost boars. In the midst of this confusion and at the point of death herself, Moro stands before Okkotonushi and says, "Give me back my daughter!" In hiding not far away, Jiko Bo and Lady Eboshi spot the Deer God on the shore of the pond island. (Middle left, continuity drawing) San and Ashitaka meet again in the tendrils of Okkotonushi. (Bottom left, continuity drawing) Realizing that Ashitaka has come to save her, San calls his name. Okkotonushi gives his neck a hard shake, throwing off Ashitaka. (From top right, cel drawings) 1. A bullet from Lady Eboshi's musket pierces the Deer God's neck. 2. After Moro saves San, the Deer God takes Okkotonushi's life. Okkotonushi breathes his last while Moro lies exhausted nearby. Lady Eboshi and Jiko Bo watch as the Deer God metamorphoses into the Night Walker in the moonlight. 3. Hugging San, whom Moro has rescued at the risk of her own life, Ashitaka dives into the pond. In the water, the black tendrils drift away from her body. 4. Poking his head out of the water, Ashitaka watches incredulously as the Deer God's neck stretches toward the heavens.

The Forest Dies

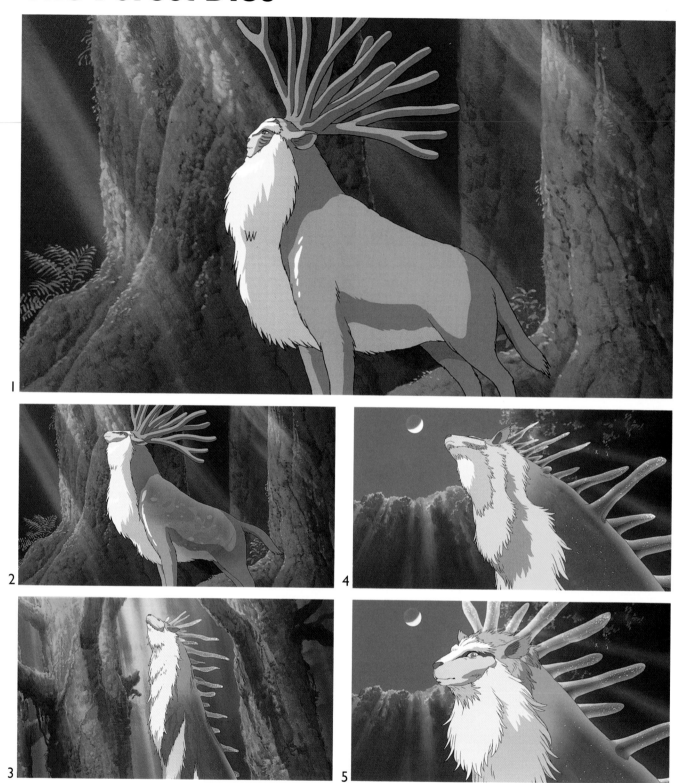

(From top left, CG images) 1. Before Lady Eboshi's astonished eyes, the Deer God begins to metamorphose into the Night Walker. 2. The Deer God's neck begins to stretch. 3. The Deer God—already quickly becoming the Night Walker—as seen by Ashitaka after he pokes his head out of the water. 4. The Deer God continues to reach toward the moon above. 5. The Deer God notices Lady Eboshi taking aim with her musket. 6. The Deer God looks directly at Lady Eboshi. 7. The Deer God smiles as he continues to gaze at Lady Eboshi. 8. Without flinching, Lady Eboshi aims her musket at the Deer God and pulls the trigger. The Deer God's expression does not change. 9. The bullet strikes the Deer God on the neck. 10. In a swirling circle of light particles, the Deer God's head flies away.

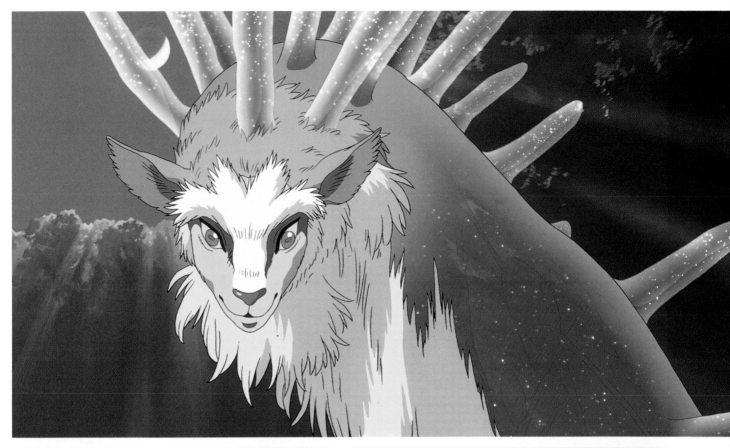

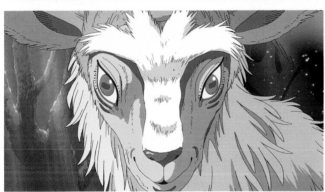

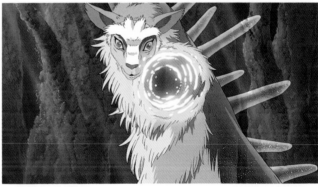

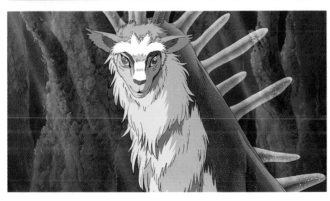

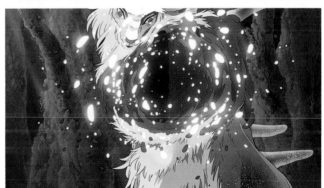

165

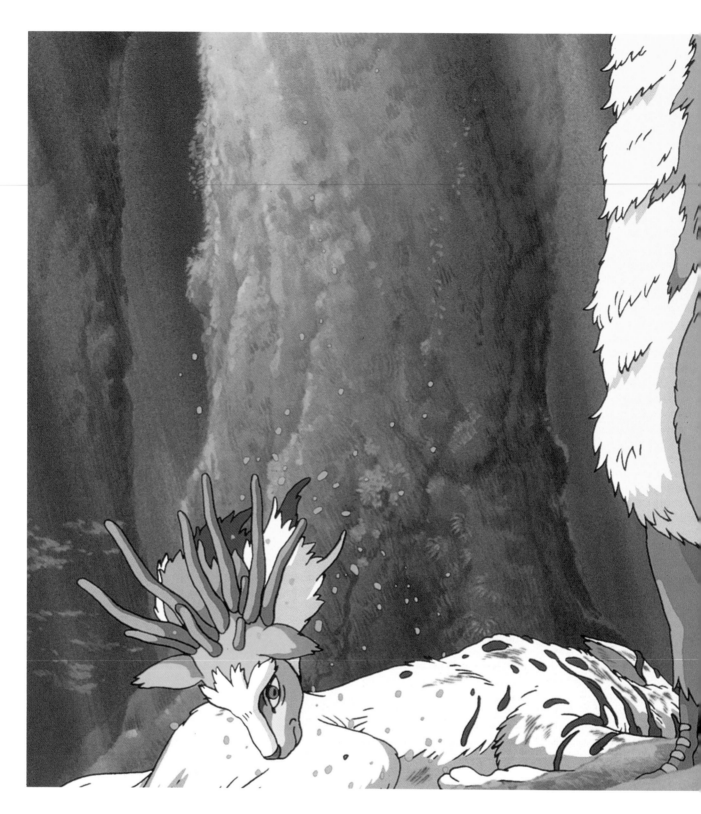

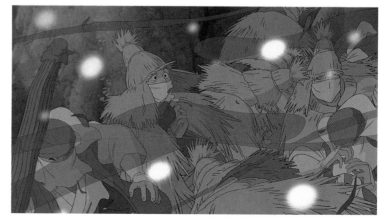

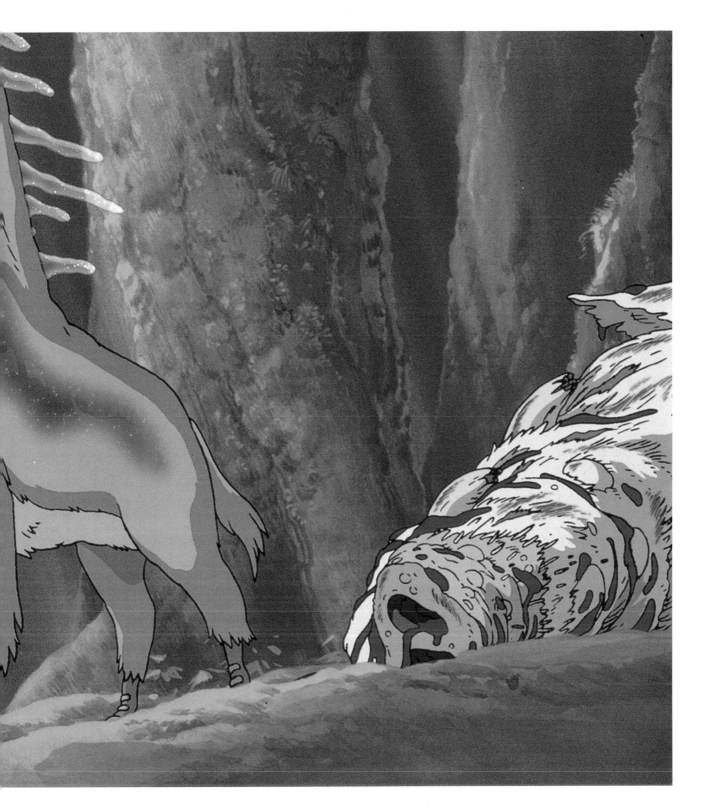

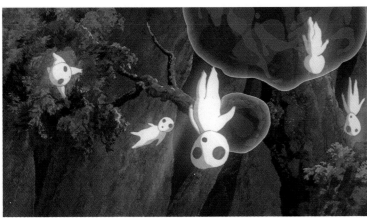

(Top left, CG image) The fallen head of the Deer God bounces softly on the shore of the pond, near where Moro and Okkotonushi are lying. *(Bottom left, CG image)* Cheering, Jiko Bo and his men rush to recover the head of the Deer God. Meanwhile, a large globule rises and expands from the neck of the Deer God. The globule bursts into cylindrical jets that fly in all directions with the force of a raging torrent able to knock down anyone in its path. *(Bottom right, CG image)* The jets change to globules that stick to the branches of trees. The branches quickly wither and die and Kodama fall from them.

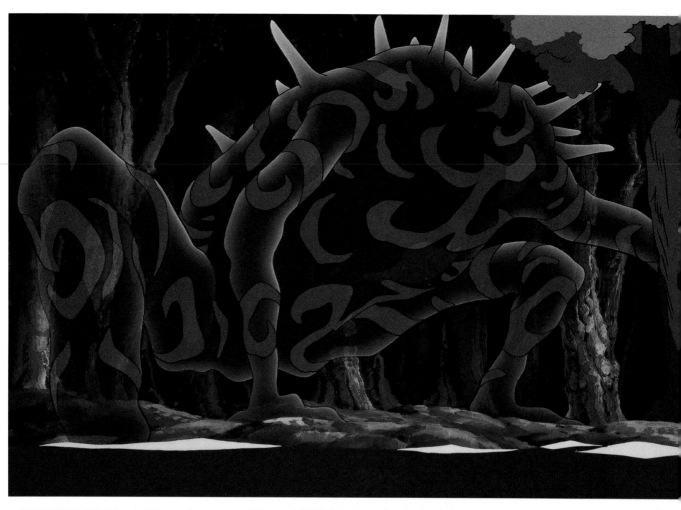

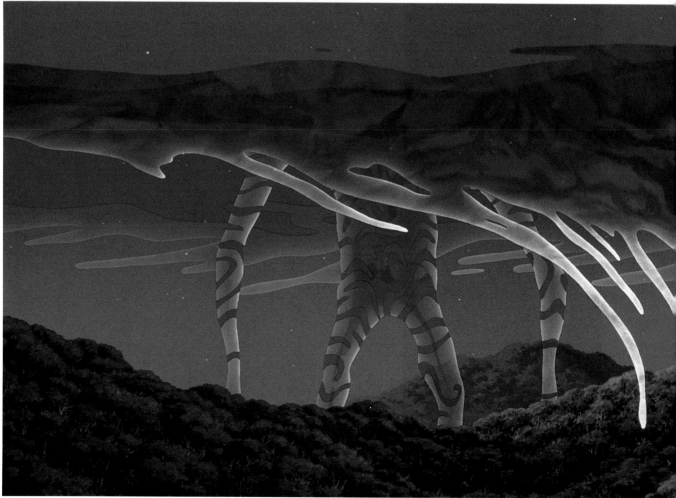

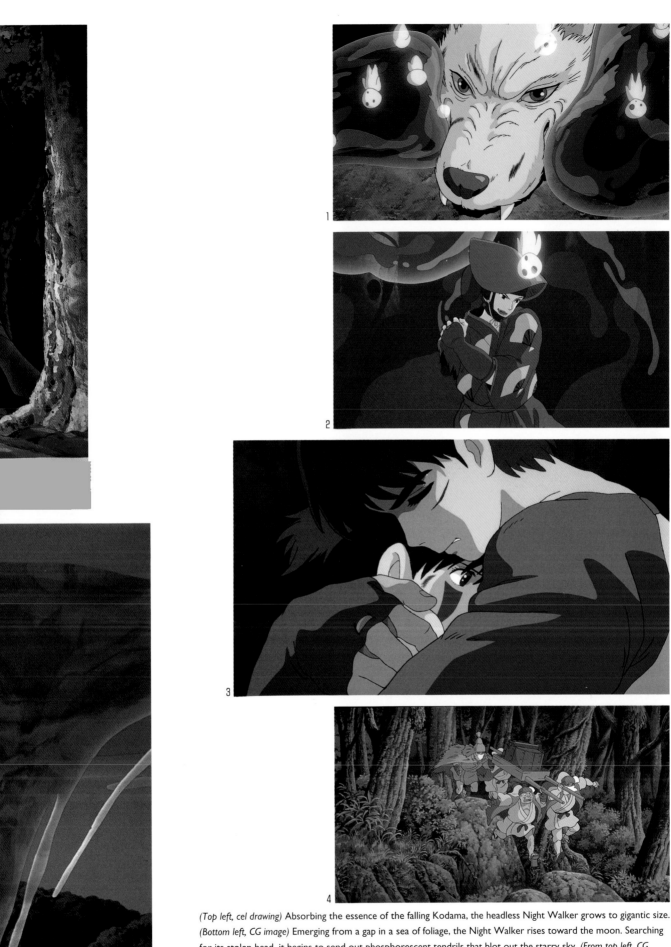

(Top left, cel drawing) Absorbing the essence of the falling Kodama, the headless Night Walker grows to gigantic size. (Bottom left, CG image) Emerging from a gap in a sea of foliage, the Night Walker rises toward the moon. Searching for its stolen head, it begins to send out phosphorescent tendrils that blot out the starry sky. (From top left, CG images with the exception of number 4) 1. While globules continue to fly about, Moro's head moves toward Lady Eboshi. 2. Lady Eboshi has been bitten on the arm by the head of Moro. 3. Ashitaka cares for the wounded Lady Eboshi. In sadness and anger, San stabs Ashitaka in the chest. Ashitaka absorbs the pain without flinching and then embraces San tightly. 4. Carrying the head of the Deer God in an iron box, Jiko Bo and his men run for their lives.

Chaos Descends

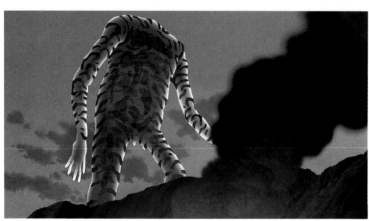

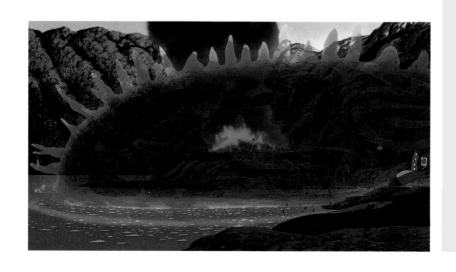

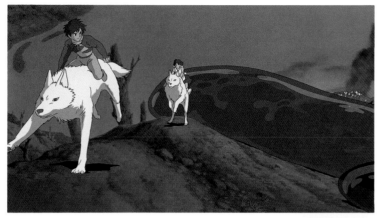

(*Top right, CG image*) The Night Walker attacks the ironworks, which has become a battleground of the Tatara and samurai. Toki and the other women escape to the lake. (*Middle left, CG image*) The ironworks goes up in flames while the Night Walker continues to search for its head. (*Bottom left, cel drawing*) Having recovered its head, the Night Stalker plunges into the lake as the sun rises. (*Top right, CG image*) Hoping to recover the Deer God's head, Ashitaka and San pursue Jiko Bo, who is carrying it in an iron box. (*Middle right, CG image*) Ashitaka and San fight with Jiko Bo and his men, but they are suddenly attacked by the Night Walker. (*Bottom right, cel drawing*) Ashitaka holds up the head of the Deer God.

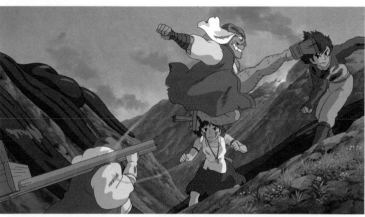

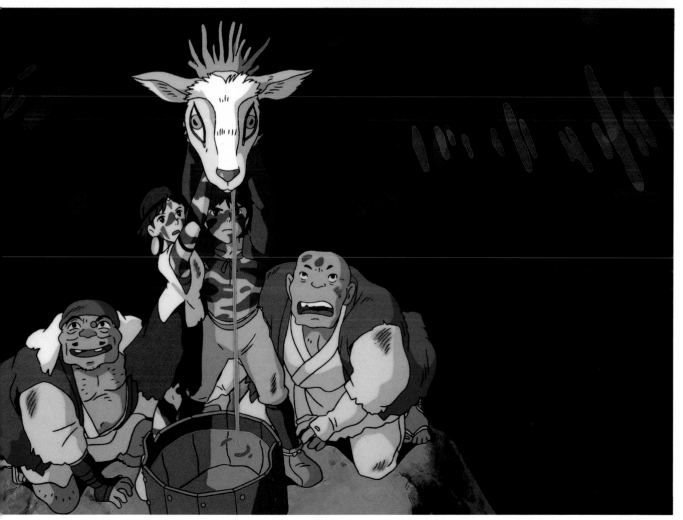

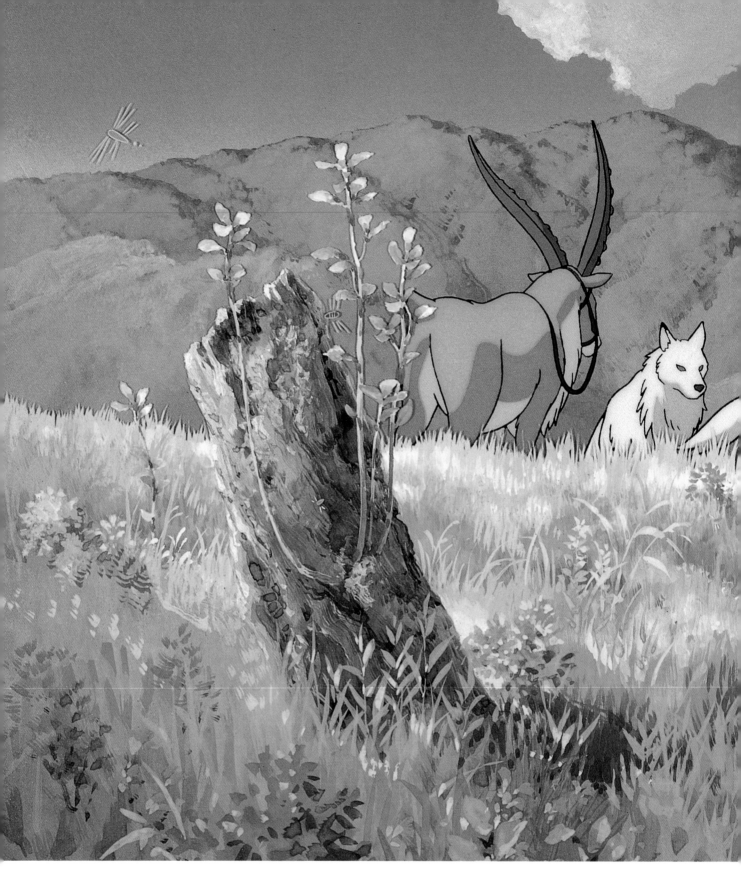

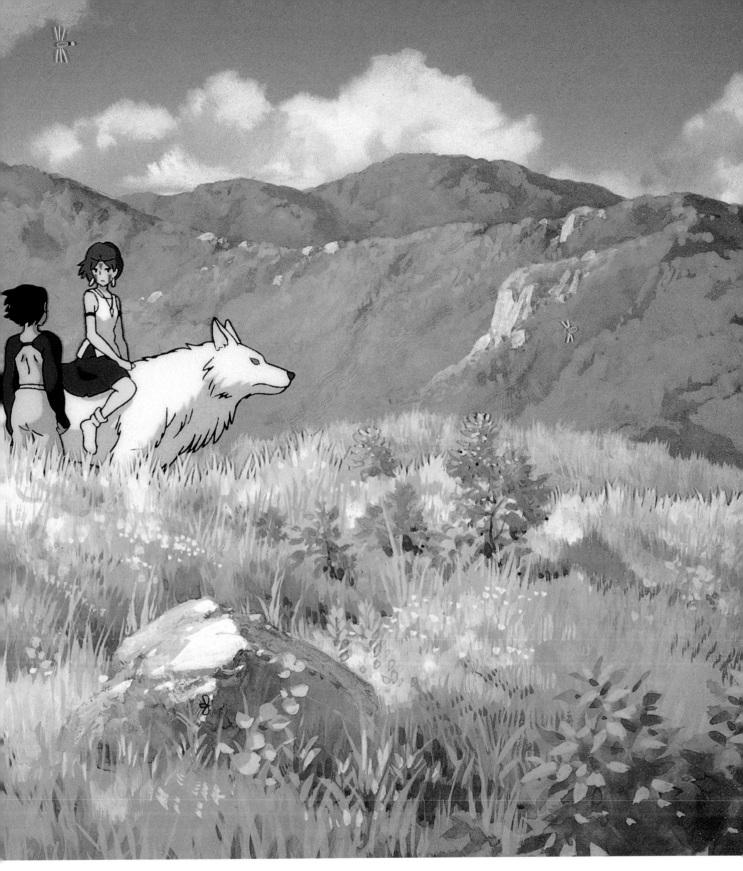

(Top, cel drawing) When the Night Walker disappears, plants and flowers revive. Ashitaka tells San that "The Deer God hasn't died. Because he is life itself, he is both life and death." When they part, San says, "I like you, Ashitaka, but I can't forgive humans." Ashitaka replies, "That's all right. You will live in the forest, and I in the ironworks. Let's live together in peace." (Bottom left, cel drawing) The scar on Ashitaka's right arm has disappeared—a sign that the Deer God wants him to live. (Bottom right, cel drawing) "I'll come see you on Yakkuru," says Ashitaka. San nods silently. (Page 174, background drawing) Green buds sprout on the giant trees.

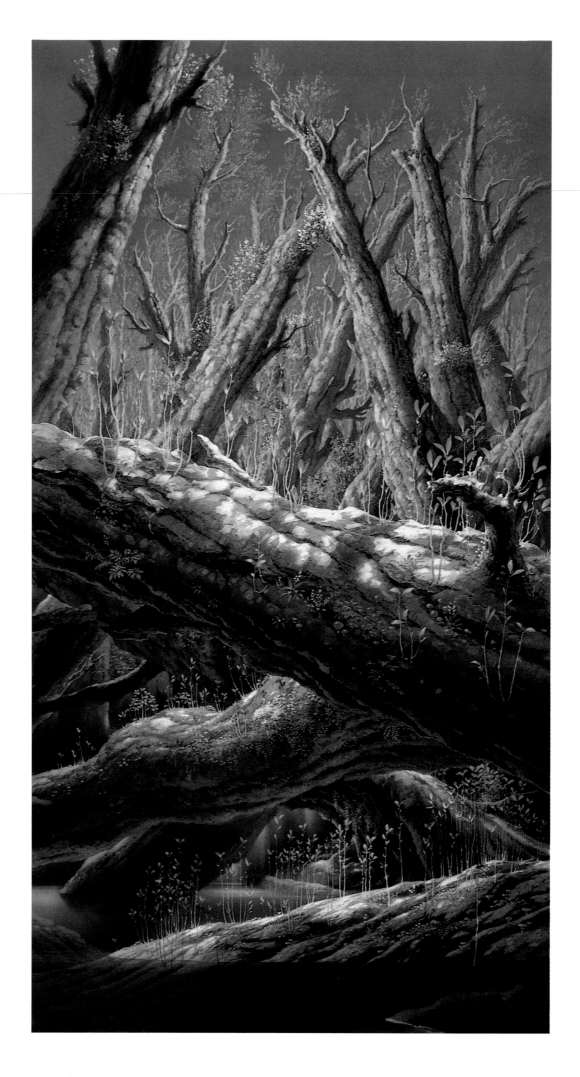

Computer Graphics

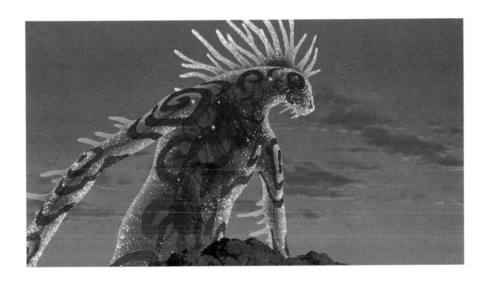

In previous Studio Ghibli films, animators made only limited use of computer graphics and digital technology, but for *Princess Mononoke* they began to employ both technologies extensively for the first time in a variety of ways, from large-scale applications to minute details. How did they make those images? Based on interviews with the Studio Ghibli computer graphics (CG) staff, the following chapter explains how Studio Ghibli made the digital images used in *Princess Mononoke*.

Making Three-Dimensional Images with Computer Graphics

Computer Graphics That Don't Look Like Computer Graphics

Studio Ghibli's CG Department was in charge of CG (computer graphics) image processing for *Princess Mononoke*. The CG Department team worked in close coordination with other departments, including camera, painting, postproduction, and special effects. The following is an interview with CG director Yoshinori Sugano, who is the head of the CG Department, that examines the making of the computer graphics for *The Princess Mononoke*.

First, a brief profile of Yoshinori Sugano. After joining Nippon Television Network (NTV) in 1990 and becoming involved in the production of information programs, Sugano joined the network's computer graphics research and development team. He worked on the computer graphics for *Pom Poko*, a 1994 Studio Ghibli film that NTV partly financed, including a scene in a library that made extensive use of a moving camera. He was then transferred to the newly formed Studio Ghibli CG Department to work on the 1995 *Whisper of the Heart* and *Princess Mononoke*.

When the CG Department was launched, it had all of two staff members, but now, in addition to Sugano, the staff consists of animators Yoshiyuki Momose, Mitsunori Kataama, and Masashi Inoue, digital paint artist Hiroaki Ishii, and several other members (for a full list of credits, see page 217). The CG Department also has two servers that it uses as host computers, twenty-one desktop client computers on which the staff members do their work, and perpheral equipment such as printers and scanners. Also, computers in the Camera Department are used in compositing. Camera Department staffers take digital data produced by the computers and transfer it to film. Other than film recording, which is done at the Imagica film developing lab, nearly all CG-related work is done in house at Studio Ghibli.

The following is an interview with Sugano about the CG Department's work on *Princess Mononoke:*

Q: Princess Mononoke is the fist major Studio Ghibli film to make extensive use of computer graphics and digital technology. What goal did you and the Computer Graphics Department staff have in tackling this assignment? What problems did you encounter?

Sugano: First, Mr. Miyazaki asked us if we could create a three-dimensional computer graphics sequence for a snakelike mass of tendrils growing from the Demon God called Nanzen Nanman. This was the hardest assignment—it was extremely difficult to intergrate a three-dimensional object made by computer graphics into cel animation.

Q: Computer graphics is a realistic medium. You can create natural gradations of shadow with photographic accuracy, but with animation made from painted cels, shaded and lighted surfaces use completely different color grades. NO computer program yet made can handle that kind of image processing.

Sugano: Ordinarily, computer graphics animation produces images like the ones in *Toy Story*. But Mr. Miyazaki wanted computer graphics that could be seamlessly integrated into cel animation, so we had to begin by developing software that could do that. We asked Microsoft to develop software that could mimic the feel of thickly applied paint, sharp contour lines, and other characteristics of cel animation.

Q: As a result of your partnership with one of the world's leading software makers, you were able to develop the Toon Shader software program for *Princess Mononoke*. In the CG Department you use computers made by Silicon Graphics, which has a strong reputation in the film industry, and software from Avid and other software makers in the United States, England, and Canada. Given all these resources, it seems somewhat paradoxical that you deliberately made images that don't look like computer graphics.

Sugano: Computer graphics can be used in various ways. It's all right to use them in a flashy way so that people know they're computer graphics, but in *Princess Mononoke* our goal was to make computer graphics images conform to the level of realism you find in cel animation. We wanted to present these images so they wouldn't look out of place in a flat two-dimensional animated environment. We didn't want them to stand out in some odd way. At the same time, we wanted the kind of solidity and presence that is only possible with computer graphics. That was also the aim of Mr. Miyazaki as a director. Basically, we wanted to use computer graphics, but retain a hand-drawn flavor in the final image.

Q: What exactly do you mean by images that can be created only by using computer graphics?

Sugano: One example would be when we need a feeling of depth or a sense of space. In scenes of Ashitaka riding Yakkuru, we can produce a more realistic feeling of speed and three dimensionality by creating a three-dimensional space with the computer and having the camera seem to move inside it. We can give the animated character the same presence as a human character riding over an open plain. Of course we are working with cels and images photographed from cels, but by using computer graphics and digital technology we can create and composite images in ways that would be impossible with conventional photographic techniques alone. The range of what we can express has become much greater.

Q: Tasks that require a great deal of time and effort when done by hand, such as painting and multilayer compositing, can now all be done on the computer screen. You told me that the digital technology used in *Princess Mononoke* can be roughly divided into three categories: computer graphics, digital compositing, and digital painting. We'll talk about digital compositing and painting later, but first let's discuss computer graphics. Here again we can define two broad categories of CG techniques: one used for creating three-dimensional images and the other for image processing, that is, the production of cels and backgrounds on the computer.

Sugano: When most people think of CG, they imagine the generation and animation of three-dimensional objects. The methods for doing that include mapping to integrate a three-dimensional model into a background (see page 177) and particle animation to animate light particles and other fine objects (see page 179). In both cases, we basically follow the same procedure of first making a wireframe and then digitally processing the images in various ways, such as rendering and painting.

Computer Graphics

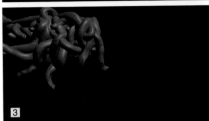

In the scene of Ashitaka shooting an arrow while riding Yakkuru (cut 8), the snakelike tendrils curling around his right arm were made with three-dimensional computer graphics. Fig. 1 is the computer screen used for making a three-dimensional model of the tendrils. Data concerning various elements, including vertical and horizontal paths, shadows, and movement are input into the computer. Fig. 2 shows the completed model displayed on a wireframe. Fig. 3 is a reference screen on which coloring and shading have been added to the three-dimensional model. A paint program for creating the feel of cel animation then automatically processes the model, with the result shown in Fig. 4. The animation drawing in Fig. 5. is digitally painted as shown in Fig. 6 and then combined with the background in Fig. 7 to produce the finished image in Fig. 8.

Mapping

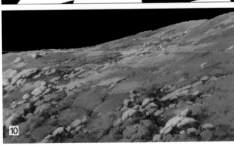

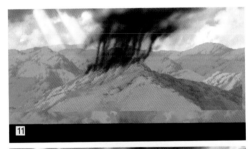

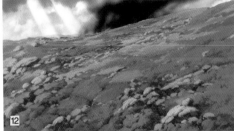

The images on the left show an example of mapping from cut 1102 in the film. Fig. 9 is a three-dimensional model of the topography used in the scene, made by calculating surface undulations, as well as the speed and the distance at which the camera will move. Fig. 10 is a background drawing of a slope that will move into the foreground during the scene. Fig. 11 is a background drawing that shows a mountain ridge in the distance. Fig. 12 is the finished image in which the drawing of the foreground (Fig. 10) has been composited on the drawing of the background (Fig. 11). The drawing of the foreground (Fig. 10) has in turn been attached to the 3D topographical drawing (Fig. 9). When the finished image is animated on the computer screen, the scenery in the distance gradually comes into view as the camera moves forward. On the computer this effect can be achieved smoothly and seamlessly.

Software Used in the Production of *Princess Mononoke*
*Softimage/3D
Software for the production of 3D images used in making 3D characters and topography.
*Softimage/Eddie
Image processing software used for almost all the CG images in the film.
*Softimage/Toonz
Digital paint software used for painting all the CG images in *Princess Mononoke*. Studio Ghibli was the first Japanese animation house to use this software.
MentalRAY
Software for creating shadows used for the scene in which Okkotonushi transforms into the Demon God.
*Flint
Compositing software used in all scenes that required digital multilayer compositing.

CG Technology Used in Various Scenes

Q: The scene in which the Demon God's tendrils are superimposed on Ashitaka's arm (explained on page 177) is perhaps the simplest example of the computer graphics used in the film. If you had simply composited the two images on the computer, the tendrils would have looked too much like computer graphics, so you had to use tone shader to give the images more of a cel animation feel. This cel animation look is a major feature of the CG images in *Princess Mononoke*. How did you do the mapping (as mentioned in the example on page 177)?

Sugano: First of all, we created a three-dimensional wireframe topography on the computer. Next, we attached a background drawing to the topography. After that, we affixed the cel drawings of people and trees that were to go in the foreground and background of the finished image to a clear sheet and placed the sheet between the camera and the background drawing. By moving the camera we could create the illusion of changing scenery. That process is called mapping. All we needed in the way of pictures were the background drawings and the cels of people and other objects. We then used computer graphics to make the in-between drawings that create the illusion of movement in the scene. As I explained before, in this way we can create drawings and movement that have a feeling of space and depth.

Q: Also, one of the tools for making CG images (see page 179) produced light particles that seem to move like living things—they float and whirl in the wind with realistic 3D movement. The tool set that generated these particles and simulated motion based on physical laws is called Particles, which is included in the Softimage 3D software program.

Sugano: Even though we call it 3D computer graphics, animating a large number of massive 3D objects takes a lot of computing time and in a lot of cases, current computers still can't do the whole job. On the other hand, it's relatively easy to generate a lot of particles that have only coordinates and no surface area. By animating these particles with calculations based on gravitation, wind direction, and other factors and compositing them on backgrounds, we can easily create a natural-looking configuration. One example is the scene in which globules rise up from inside the body of the Night Stalker.

Also, with computer graphics we have various ways to animate the image. One is a common technique called morfing. It is used to express change and passage of time with overlaps and by modifying—or morfing—an existing image.

Q: One good example of morfing is the scene in which the Demon God's corpse decomposes as we watch (see page 179). As the flesh falls off and the body collapses, we see that the essence of the object is also changing. CG images made using this and similar techniques appear in various places throughout the film, but as you mentioned before, there is also more to the digital technology that supports *Princess Mononoke*.

Sugano: Of the two other main digital technologies used in *Princess Mononoke*, digital compositing is the one in which the Camera Department played a central role. We didn't use the same kind of image processing that you've seen in 3D computer graphics images up till now. Instead, the background and art staff scanned drawings, converted them to digital data, and composited the elements on the computer. This was quite different from the optical compositing techniques that we had been using.

The other main digital technology used in the film was digital painting, which is, as the term implies, a means of painting the cel on the computer monitor. This is a job that used to be entrusted to part-timers, called painters.

Next, we interviewed the people at Studio Ghibli in charge of these two digital technologies.

Morfing

Morfing techniques were used in cut 1647, one of the last scenes in the film. In Fig. 1, the computer screen displays the growth of young plants. The computer has been programmed to confine its calculations to the area within the yellow dotted lines. In Figs. 2 and 3 from the same scene, the wireframe shows the movement of the young plants as they grow and bloom.

Figs. 4 to 6 show a scene in which morfing was used. Young plants shoot up one after another on a withered stump.

7

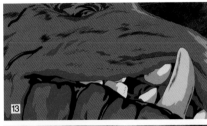

8

The same example of morfing shown on page 178. Figs. 7 and 8 show growing plants from cut 1647. Figs. 9 and 10 are background drawings in which the grass grows quickly. Figs. 11 and 12 are mask drawings in which the grass is spreading from the foreground of the picture. Figs. 13 to 15 are drawings of the decomposing Demon God that has been felled by Ashitaka. Digital animation software programs the in-between drawings to morf and overlap.

9

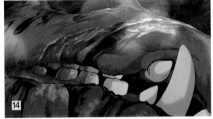

10

13

11

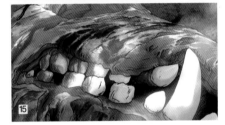

12

14

15

Particle

1

2

Examples of the Particle tool set used for cut 752 and other cuts in the film. In Fig. 1, particles are being generated from the 3D model of the Night Stalker. On the screen in Fig. 2, the particles generated in Fig. 1 are blended with the background so that the shading and the changing colors match the body of the Night Stalker.

3

4

In Fig. 3 (left) are light particles generated by the Particle tool set. Various data, including the force of gravity, the movement of the wind, and the direction of the air eddies are input into the computer and the particles are animated to look like bubbles rising up. Fig. 4 (right) is the image created with the Particle tool set by compositing the light particles in Fig. 2 to the body of the Night Stalker.

5

6

7

In Figs. 5 to 7, the particles are composited to the finlike protrusion from the back of the Night Stalker. Fig. 5 is the original drawing, while Fig. 6 shows the flow of the light particles. Fig. 7 is the finished drawing.

Multilayer Compositing **with Advanced Digital Graphics**

Volume of Images Won't Be a Problem

Multilayer compositing on a computer theoretically makes possible the seamless compositing of tens or even hundreds of images (see page 181 for examples). In Studio Ghibli's *Whisper of the Heart,* which was released in Japan in 1985, the scenes of the heroine Rei and her companion Baron the cat flying through the air were composited using as many as twenty elements, including backgrounds, clouds, and characters. Computer graphics artists were able to add various effects, such as individual clouds moving at different speeds.

Camera Department chief Atsushi Okui and his staff were in charge of digital compositing for *Princess Mononoke* as well. Okui is a veteran cameraman who has been involved in many animated films, including every Studio Ghibli feature since *Porco Rosso,* which was the highest-grossing Japanese film of 1993.

Okui: For *Whisper of the Heart* we commissioned an outside company to do the digital effects. The methods they used were no different from conventional optical compositing done at a developing lab. They added camera movement as they photographed each element. Then they used a film scanner to convert the images to digital data and composited them on a computer screen by simply laying one element on top of another. Even though it was called digital compositing, the process itself was really almost the same as optical compositing. The only difference was that they did not need to make masks.

Q: In typical optical compositing—one example being the compositing of a human figure on a background—you use two types of masks: a male mask, which is a cut out of the human figure, and a female mask, which is the part remaining after the cutout has been removed. First, you lay the male mask, which is transparent save for the black cutout of the character, on the background and photograph it once. Second, you wind the film back, lay the drawing of the human figure on the female mask, which is black save where the character portion has been removed, and photograph it again, from the same angle. You now have a composite image, with the human figure inserted into the area from which the background has been removed.

Many composite scenes in animated and science-fiction films are made using masks in this way, by layering elements and taking multiple exposures.

Okui: This process is basically the same in both animated and live-action films. With compositing, the job of the Camera Department is to photograph the animated background and character drawings together with the masks that link them.

Q: With digital compositing, however, you photograph an element with a single color background and convert it to digital data. Next you make a mask on the computer. By using this process, you are able to avoid mistakes that are common to optical compositing, such as slipping masks (in which part of the composited image is exposed and another part of the image is cut off), and are able to produce high-quality composite images. There are a number of other advantages. Elements that have been converted into digital data can be used again and again because the colors don't change and the picture quality doesn't deteriorate. Also, it's easy to add various effects later.

Okui: This was the first time we were able to composite on our own computers. Compared with before, it's become a lot easier to check the colors and otherwise work with the various elements. When we convert analog data—that is, things like cels and backgrounds that we can see with the naked eye—to digital, we're not going to have any problems as long as we pay attention to what we're doing. In *Princess Mononoke* most of the footage was photographed with conventional film, just as it has always been. Because we were integrating digitalized images into that footage, we couldn't allow them to stand out from the rest of the film—they had to blend in. For that reason, color blending became an extremely important issue.

Q: Before you began production you ran tests again and again, calculated the color blending data backward and forward and, based on the results, gave the go sign for the introduction of digital technology. The main technical theme for this film—the creation of digital images that wouldn't clash with cel animation—was reflected in this testing process as well.

Okui: The biggest change in the production process was that we were better able to integrate the work of the Studio Ghibli CG Department into the work of the rest of the studio. When we needed to do image processing that couldn't be done with existing animation software, we could consult with an in-house programmer about developing the type of program we wanted. Before we commissioned this kind of work outside, and after we had made the elements and handed them over, we were more or less at the mercy of our subcontractors. Now we have all the responsibility ourselves, down to the final stages of production. We can keep working on a scene until we are satisfied with it. Being able to do that makes us feel happy and motivated.

Q: You also have to give priority to your production schedule. With computer graphics you can spend more time creating the various elements of the film than you could before. On the other hand, the overall amount of production work has increased.

Okui: During the production of *Princess Mononoke,* Mr. Miyazaki kept asking us whether we could do this or that kind of processing, so we ended up developing new methods. One example was the black smoke that hangs over the fire and battle scenes. Film reacts to bright colors in the developing process, so you can't add multiple exposures of black smoke to the background once it's already been photographed. The only alternatives we had were to use brush elements or postproduction cels. In *Princess Mononoke* we filmed white smoke and then composited it on the computer using a reverse negative. I think we were able to make black smoke with a level of realism that we'd never had before.

Q: The introduction of computers seems to offer various possibilities not only technically, in terms of saving effort and achieving greater efficiency, but artistically, in terms of making possible a wider range of expression. How do you feel about that?

Okui: Sometimes there is something incongruous about digital images, but we can also use digital technology to create the feeling of analog film. Today there are so many computer-generated images everywhere, in games and TV commercials, so I think it's also all right to go into the other direction and use techniques that disguise an image's digital qualities, as we did in this film. But if digitalization keeps progressing the way it is, eventually the job of the cameraman for animated films may disappear. I feel that *Princess Mononoke* may be the last animation that we photograph with conventional film, so we've tried to put all of the know-how that we have accumulated into this film. We wanted to make it a compilation of noncomputerized animation techniques.

Multilayer Composite

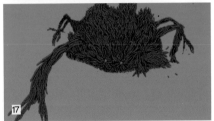

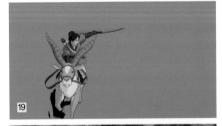

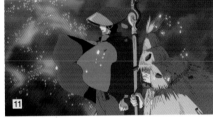

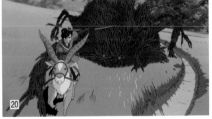

An example of multilayer compositing in cut 1181A. The image in Fig. 12 is a composite made on the computer using all the elements in Figs. 1 to 10, including human figures, smoke, and sparks.

San invades the ironworks (cut 525). The image in Fig. 14 is simply a composite of the foreground cel of San and the background drawing, but it has a more natural finish than images made using optical compositing.

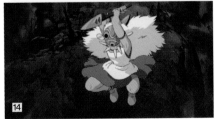

Ashitaka being pursued by the Demon God (cut 68). The image in Fig. 20 is a composite of five images, (Fig. 15) the background, in which the forest can be seen in the distance, (Fig. 16) the cel showing the track made by the Demon God through the grass, (Fig. 17) the B cel of the Demon God's body, (Fig. 18) the brush element showing the shadows and contours of the Demon God's body, (Fig. 19) and the C cel of Ashitaka and Yakkuru. A comparison of these images with the finished image in Fig. 20 shows the process of compositing various layers of cels.

III A First Attempt at Digital Painting

Using Digital Technology to Eliminate the Digital Look

Digital painting is, as the term implies, the process of applying color to animated images on a computer. At present, the production of animation paint and cels is declining, while the talent pool of animation painters continue to shrink. In animation production in the United States, most of the painting work has been turned over to digital painters. Given the changes in the animation workplace and the advantages of this technology, it seems likely that digital painting will become the industry standard in Japan as well. In making *Princess Mononoke,* Studio Ghibli used digital painting, particularly in the CG scenes. The chief digital painter for the film was Hiroaki Ishii.

Ishii: I originally joined Studio Ghibli as a member of the painting staff, so this was the first time for me to use a computer for my work. But the basic concepts behind digital painting are almost the same as those for painting animation cels.

Q: Painting is a general term for applying color to cels that have been traced for animation. Digital painting is the same as conventional animation up to the picture production stage.

Ishii: Ordinarily that's when we send out work to the postproduction staff, but when digital image processing is needed, we run the finished image through the scanner, convert it to digital data, and then color the digitalized image. This process is called digital painting. After we're done with that, we perform additional photographic processes such as compositing and then output the final image on film.

Q: The advantage of digital painting is that you can create as many as 16.77 million colors on the computer. Broadly speaking, there's almost no limit to the variations. You can freely produce special colors, colors that you can't find in paints.

Ishii: That's true, but actually there's no need for so many colors. At Studio Ghibli we try to create a total color image for each of our productions. For *Princess Mononoke* as well, Michiya Yasuda, who is in charge of color design, made a color chart. We input that chart into the computer and used it to paint.

Q: Another big advantage of digital painting is its efficiency.

Ishii: One example of that is the drawings of grass that appear in the beginning of the film, in the cut of the Demon God running through the field. Working with digitalized backgrounds, we selected colors according to Mr. Yasuda's chart and used them to paint the grass in the cel drawings. We could smoothly coordinate the background and drawings without going to the time and trouble of doing test paintings.

Q: As we mentioned in the discussion on digital compositing, when you composite with computer graphics, you can automatically generate mask elements, which makes it easier to achieve good compatibility between the different layers. Also, you don't have to worry about masks slipping, no matter how many layers of drawings you use.

In *Princess Mononoke,* you used digital painting in nearly all the CG scenes, scenes that required detailed masks, and scenes with a large number of elements, such as crowd scenes (see page. 183).

Also, unlike conventional cel painting, with digital painting you don't have to worry about errors caused by differences in the skills of individual painters. You can cut and paste elements right on the screen. Because the process requires only moving the mouse and pentablet while watching the monitor, painters can learn it relatively easily. There are many ways in which digital technology is superior, but have you discovered any negatives about digital painting?

Ishii: In a scene where the human figure is at rest and only the hands and face move, we have to composite a number of separate drawings. With conventional postproduction, we first put one drawing of the body and a number of drawings with facial and other movements in the trace machine. Because we have to attach a face to the body cel, we put the face cels, together with the body cel, in the trace machine again. In this way we composite the body and the face cels on one cel. Using one drawing of the body we can make a number of composite cels, but not all of them are going to be exactly alike. But those discrepancies add a human flavor.

With digital technology, we only have to make one drawing of the body. We can make it look truly motionless, with no jittering at all. But when we put that drawing together with a series of face and hand drawings, each with a different motion, it is not going to look natural. You no longer feel that the human being up there on the screen is alive. So we process the body lines to deliberately add some jitter and get rid of the unnaturalness. In short, we use the same digital technology that creates "digital stiffness" to make the image softer, more lifelike. Of course, there are also composite scenes involving tools and other motionless objects in which digital technology's consistency becomes a plus.

Q: It's often said that digital painting reduces or eliminates the time and manpower required when using cels, paints, and coloring tools, but despite these advantages, it's really not so simple.

Ishii: Digital painting is truly convenient and has given rise to new forms of expression, but as we become able to do everything with digital technology, I feel that if we don't place any limits on it, we are going to get further and further away from cel animation. For example, you can expand the number of colors indefinitely, but if you don't paint according to the usual color models for animation, you're going to end up with a wishy-washy mess. In short, it all depends on how you use the technology.

Q: We have looked at the digital technology used in *Princess Mononoke* from the three main categories of 3D animation, multilayer compositing, and digital painting, but I'd like to talk once again with CG Department chief, Mr. Sugano. Mr. Sugano, how far do you think the digitalization of animation will progress in the future?

Sugano: This film had a total of 1,600 cuts, of which we used digital image processing on about 100. This is a large number for our first time. In the not-too-distant future I think that we'll be using digital technology for the entire film. By making extensive use of computer graphics, we can arrive at a form of visual expression different from that of cel animation. *Princess Mononoke* is in some senses an experimental work for us. It's important for us to use what we have learned in this experiment in our next project. The digital challenge for Studio Ghibli has only just begun.

(Writer and coordinator Shinsuke Nakajima)

Digital Ink & Painting

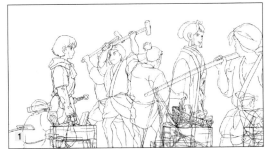

1

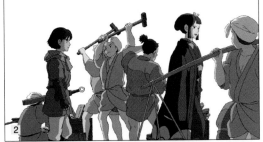

2

3

Cut 432 is another example of digital compositing. With digital painting it is possible to easily color even this kind of complex drawing. Fig. #1 is the drawing to be painted. In Fig. 2, color has been applied. Fig. 3 is the finished image, with the background composited. The entire process was completed on the computer monitor.

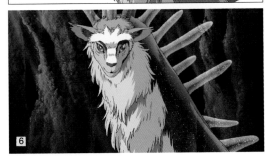

7

A digital paint computer screen. The thickness and darkness of the lines on the screen can be adjusted with a scanner.

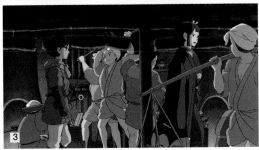

4

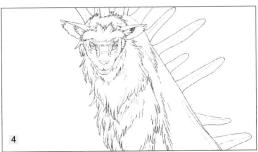

5

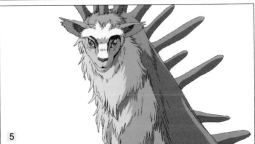

6

As in Figs. 1 to 3, Figs. 4 to 6 demonstrate the digital painting process. After various steps, which include making the horns look transparent, the finished drawing (Fig. 6) is ready.

8

9

10

Fig 8. is the palette edit screen for digital painting. Once the colors are recorded in the palette on the lower part of the screen, according to the color chart, they can be used in any number of other scenes. Fig. 9 shows color being applied to the drawing, in coordination with the character's movements. Fig. 10 is a screen on which the finished drawing is being processed in conformity with a time sheet.

Hayao Miyazaki's Layout Drawings

The following is a collection of layout drawings from the film's last scene, drawn by Hayao Miyazaki. They were intended as blueprints indicating Miyazaki's instructions for image processing and composition. Layouts are usually drawn for use in picture continuity by the layout artist, but all the drawings in this collection were made by the director. Miyazaki also made some changes in the story, as noted in the drawings.

Note: In some cases two drawings with the same cut number are grouped together. This indicates that one is a background and one is a character drawing. In some cases, the layout artist has made character drawings to go with the layout.

CUT 1562

Left: cut 1563 (background drawing), *right:* cut 1563 (character drawing)

CUT1564

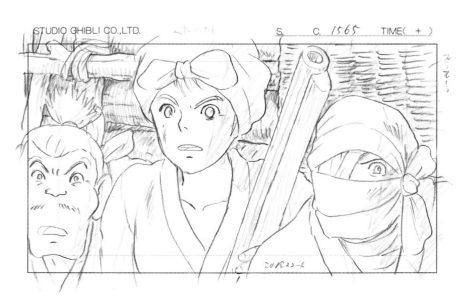

CUT1565

STUDIO GHIBLI CO.,LTD. S. C. 1566 TIME(3 + 12)

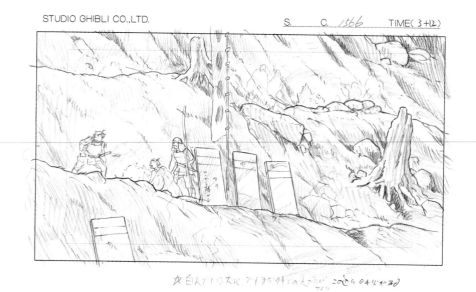

CUT1566

STUDIO GHIBLI CO.,LTD. S. C. 1567 TIME(5 + 0)

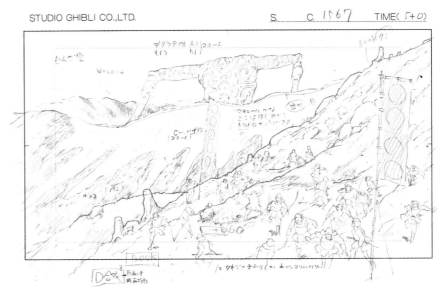

CUT1567

STUDIO GHIBLI CO.,LTD. S. C. 1567B TIME(2 + 12)

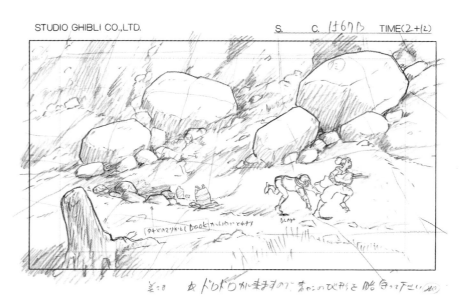

CUT1567B

186

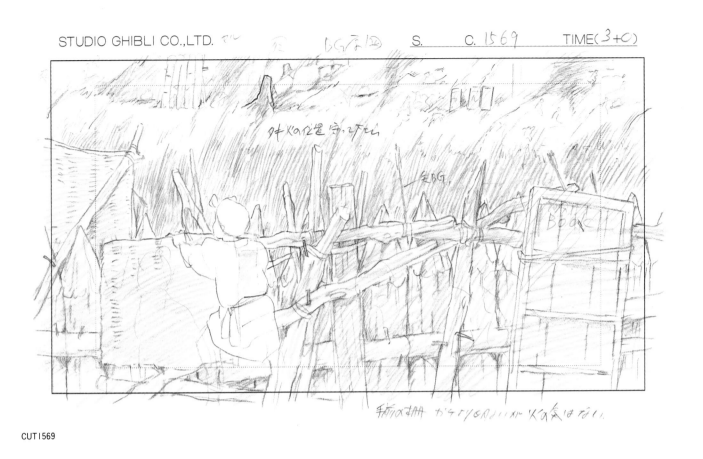

CUT1569

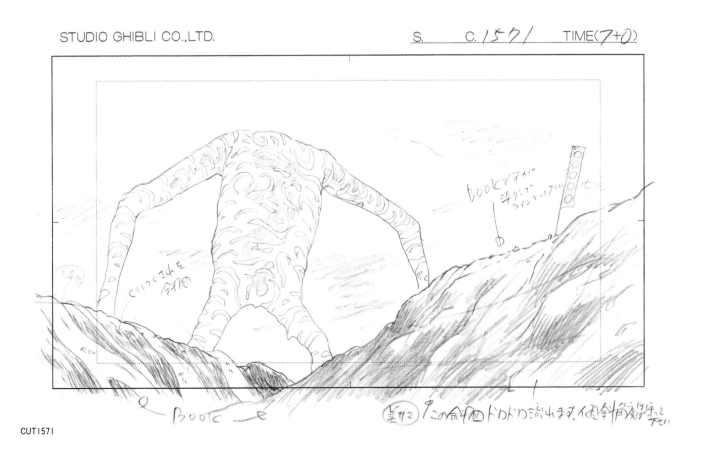

CUT1571

　　　　　　　S.　　C.　1573　　TIME(2+2)

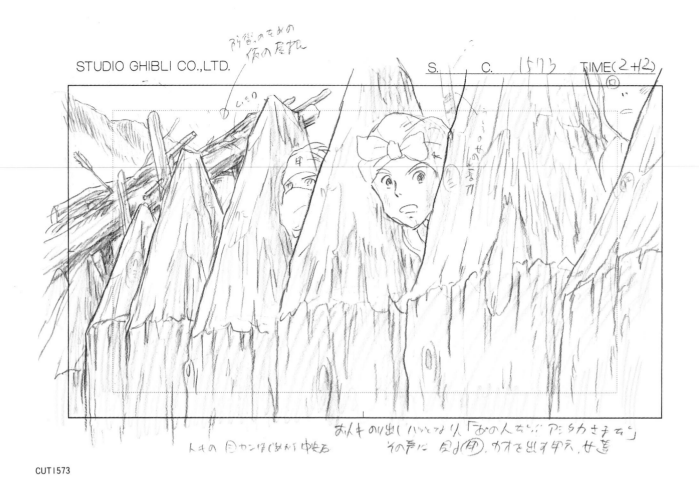

CUT1573

　　　　　　　S.　　C.　1574　　TIME(2+2)

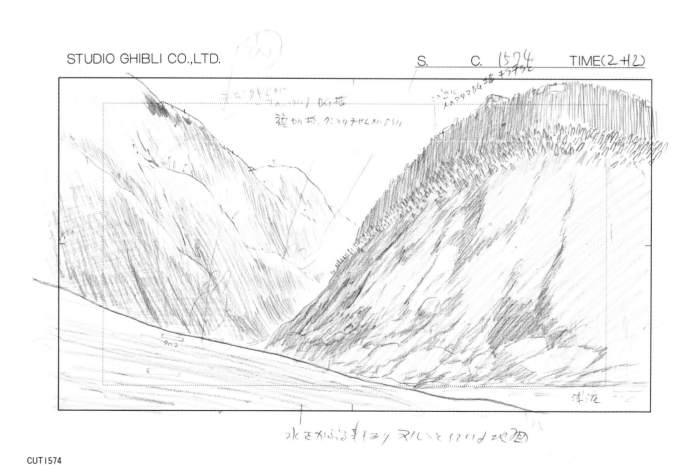

CUT1574

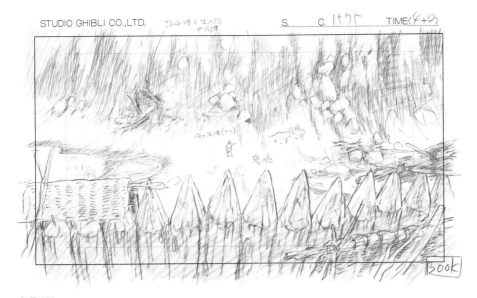

CUT1575

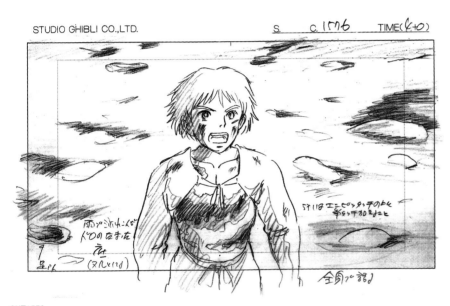

CUT1576

CUT1577

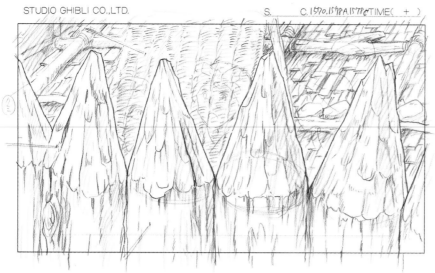

Left: cut 1570, 1578A, 1578C (background drawing), *right:* cut 1578A (character drawing)

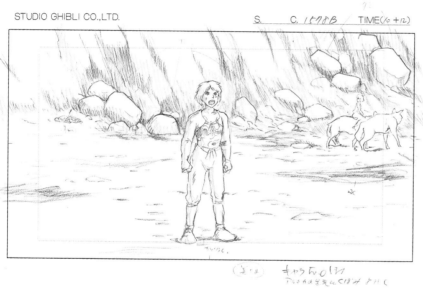

CUT 1578B

cut E-1 ("e" is a contraction of "extra cut")

CUT E-2

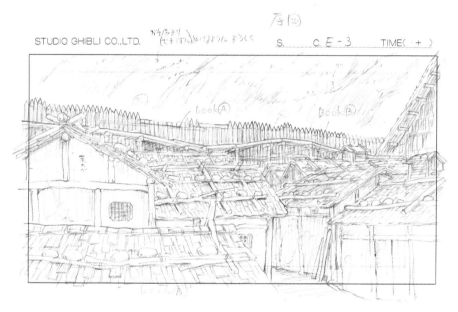

CUT E-3

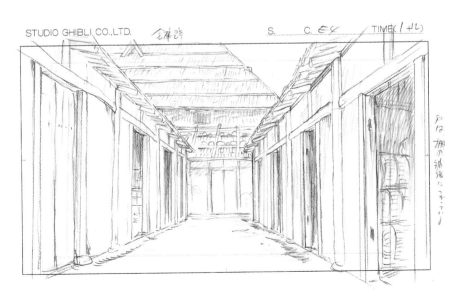

CUT E-4

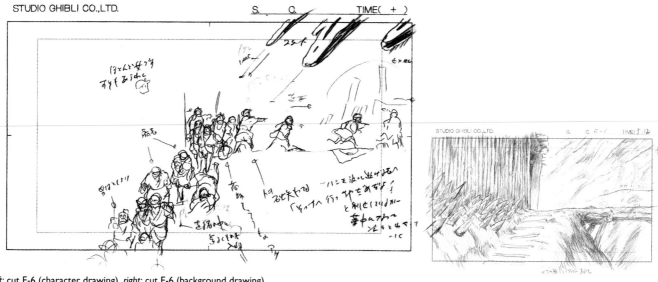

Left: cut E-6 (character drawing), *right:* cut E-6 (background drawing)

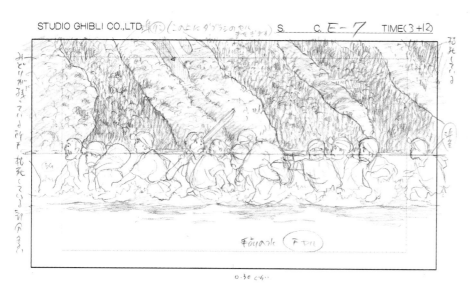

CUT E-7

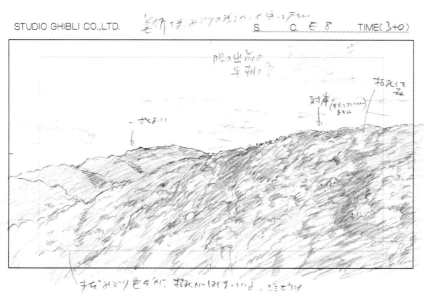

CUT E-8

192

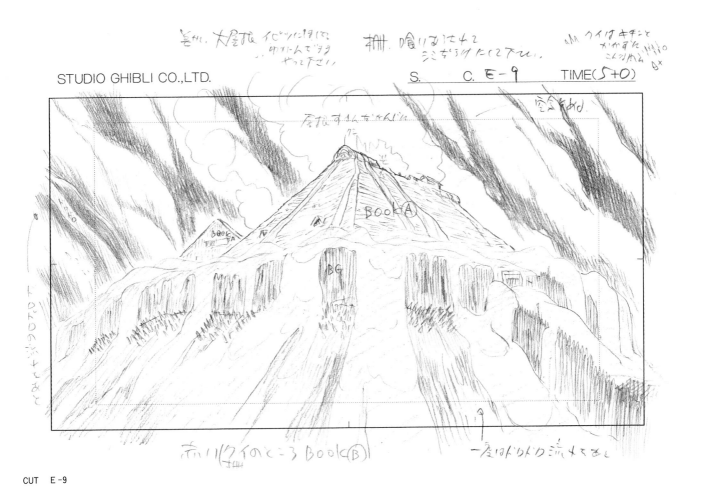

CUT　E-9

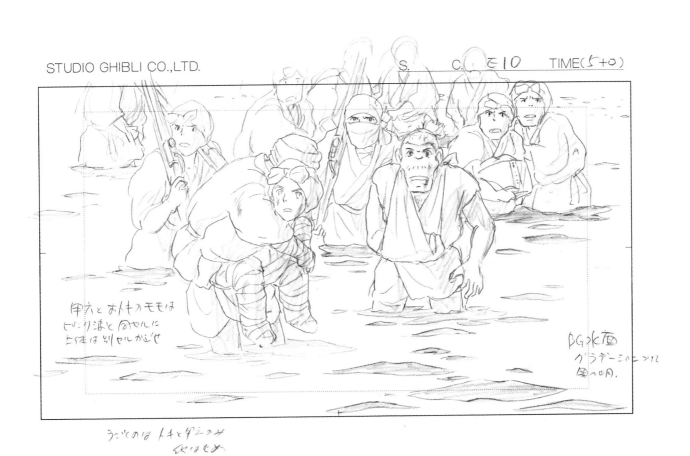

CUT　E-10

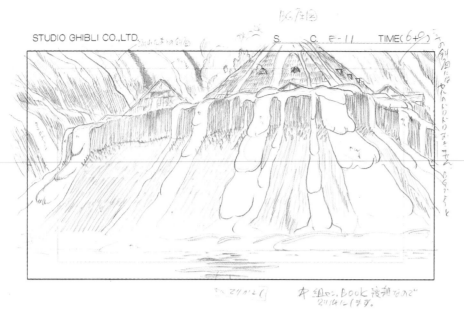

CUT E-11

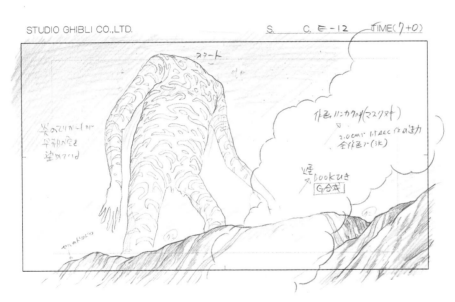

CUT E-12

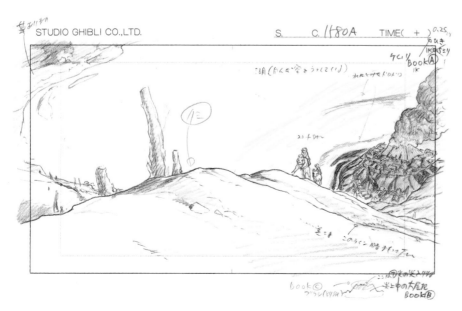

CUT I580A

C1579

CUT1579

STUDIO GHIBLI CO.,LTD.　　　　S.　C.1580B　TIME(3+0)

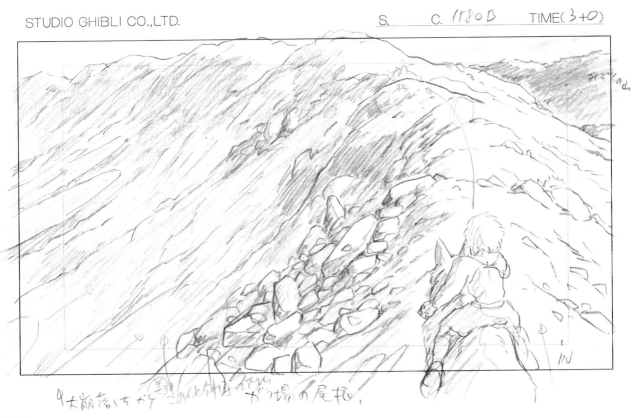

CUT1580B

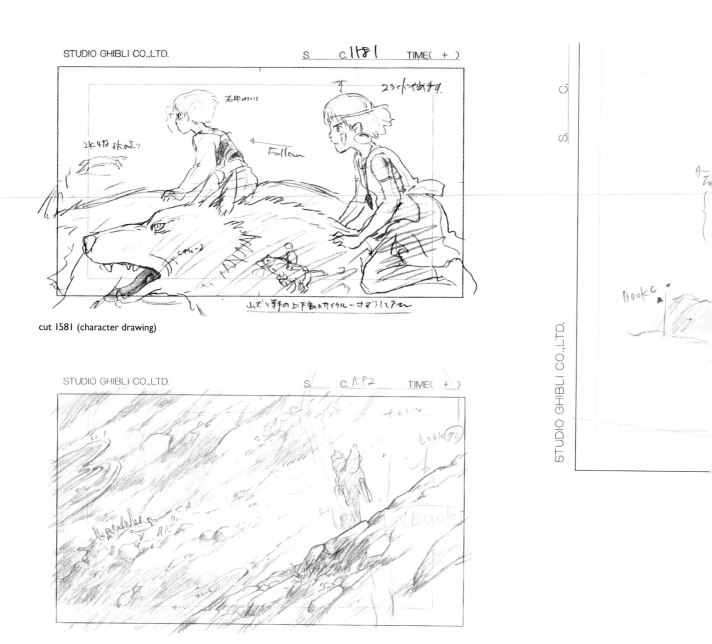

cut 1581 (character drawing)

CUT 1582

CUT 1583

cut 1581 (background drawing)

CUT 1584

STUDIO GHIBLI CO.,LTD. S. C. 1585 TIME(+)

CUT 1585

STUDIO GHIBLI CO.,LTD. S. C. 1586 TIME(3 + 0)

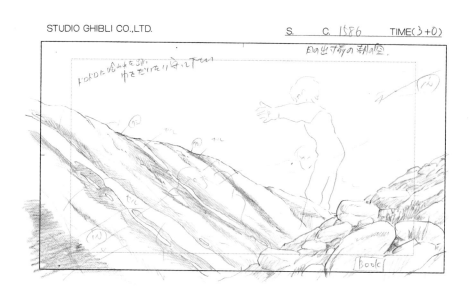

CUT 1586

STUDIO GHIBLI CO.,LTD. S. C. 1587 TIME(4 + 0)

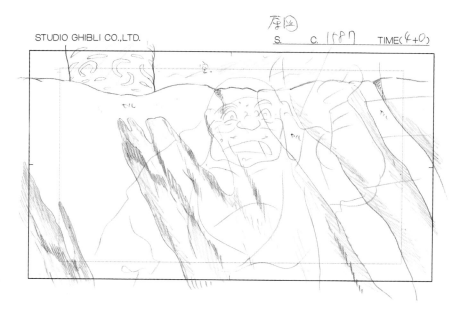

CUT 1587

198

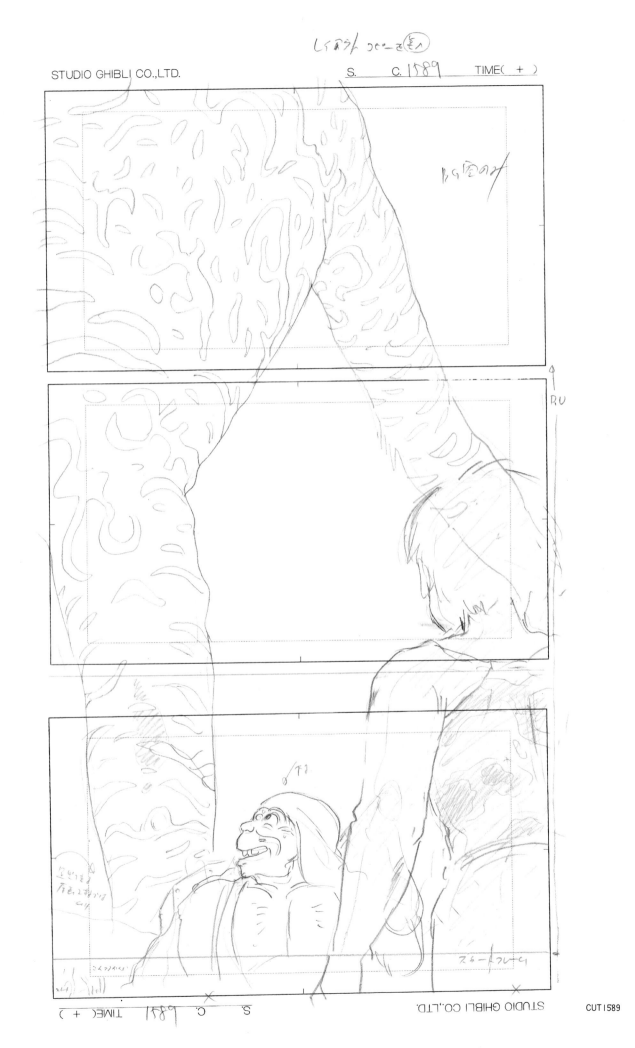

STUDIO GHIBLI CO.,LTD.　　　　　　　　　　S.　　C. 1588　　TIME(4+0)

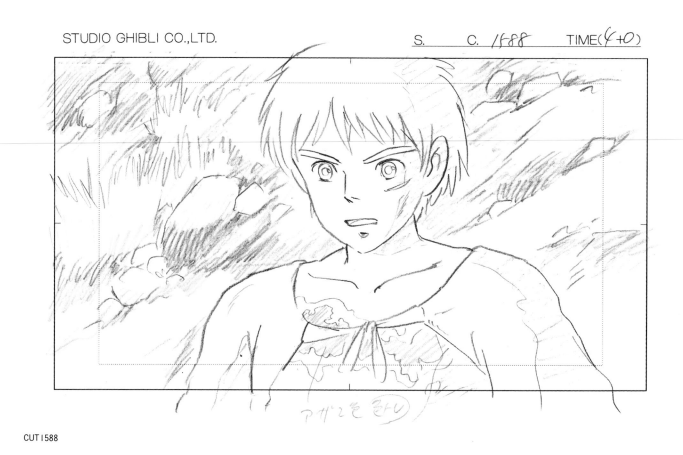

CUT 1588

STUDIO GHIBLI CO.,LTD.　　　　　　　　　　S.　　C. 1590　　TIME(+)

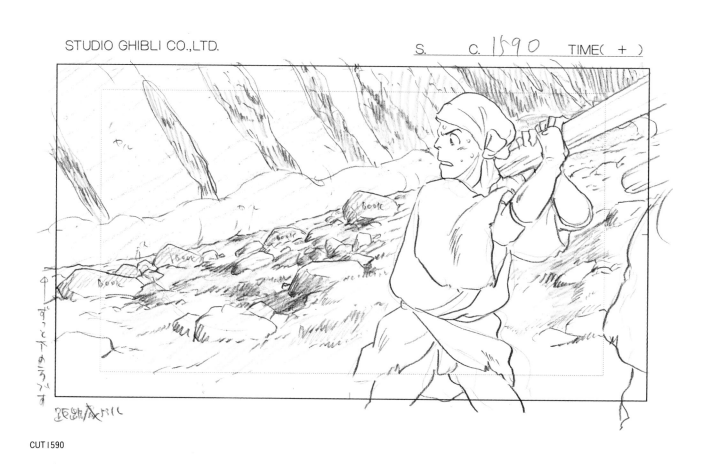

CUT 1590

200

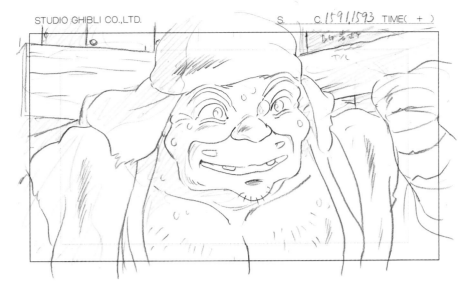

CUT1591、1593

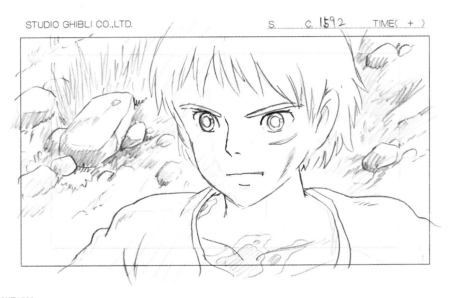

CUT1592

CUT1594

S. C. 1596 TIME(1 +2)

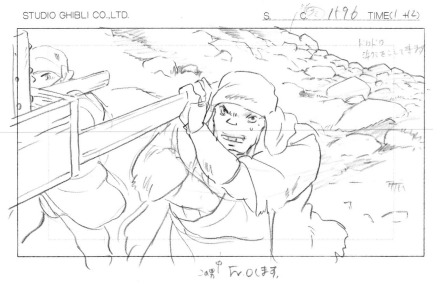

CUT 1596

S. C. 1597 TIME(+)

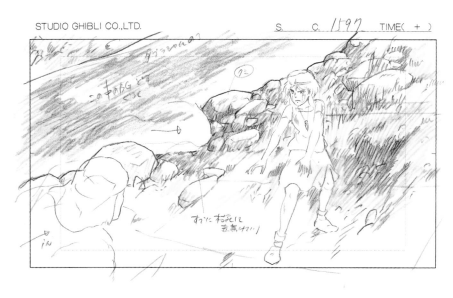

CUT 1597

S. C. 1598 TIME(+)

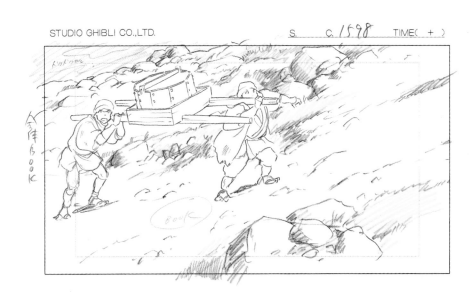

CUT 1598

202

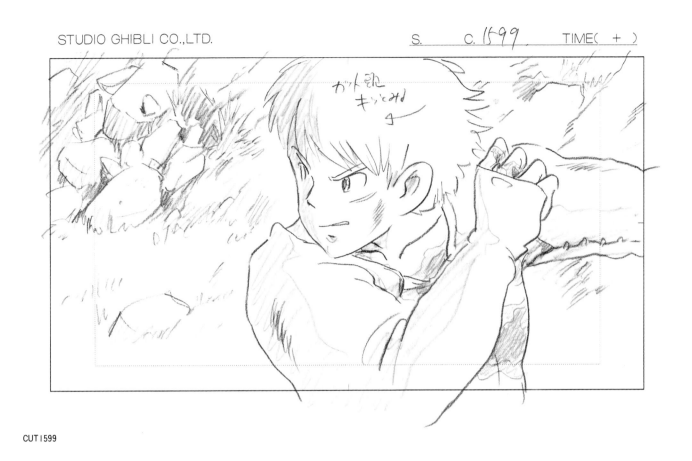

CUT1599

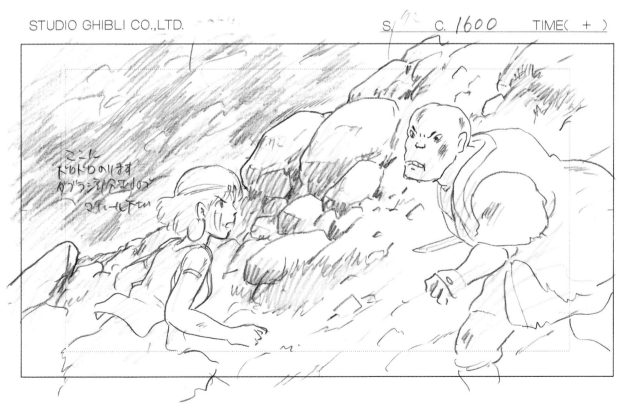

CUT1600

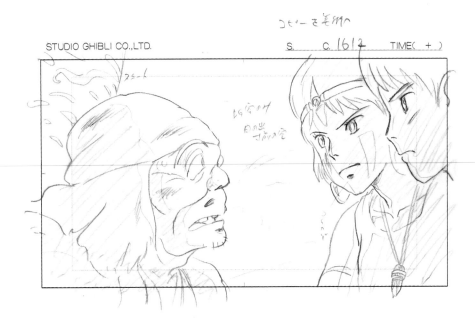

CUT1612

CUT1613

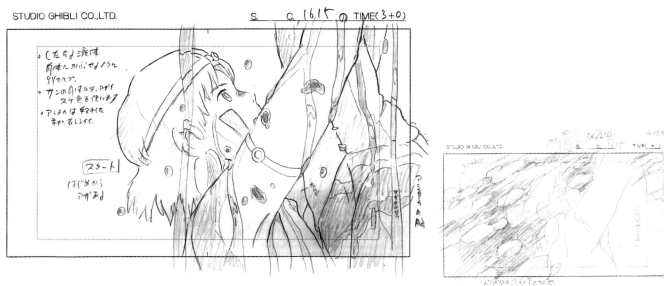

Left: cut 1615 (character drawing), *right:* cut 1615 (background drawing)

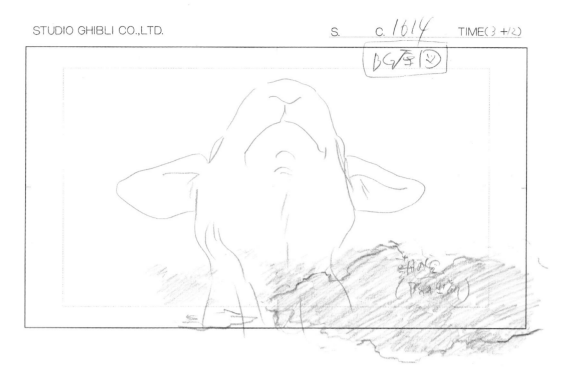

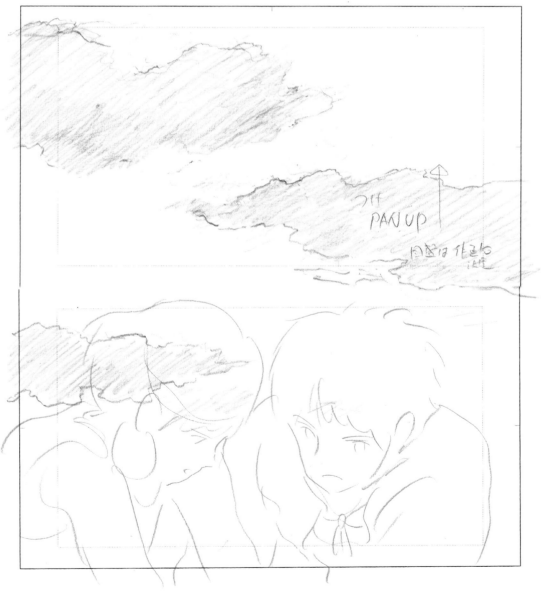

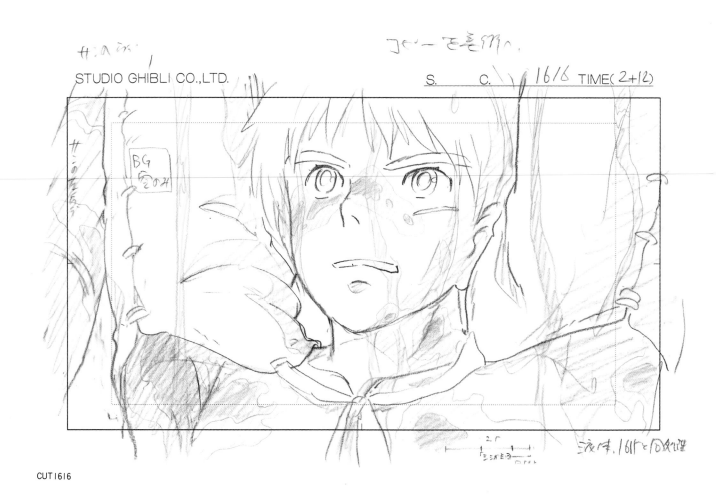

STUDIO GHIBLI CO.,LTD.　　　　　　　　　S.　　C.　1616　TIME(2+12)

CUT1616

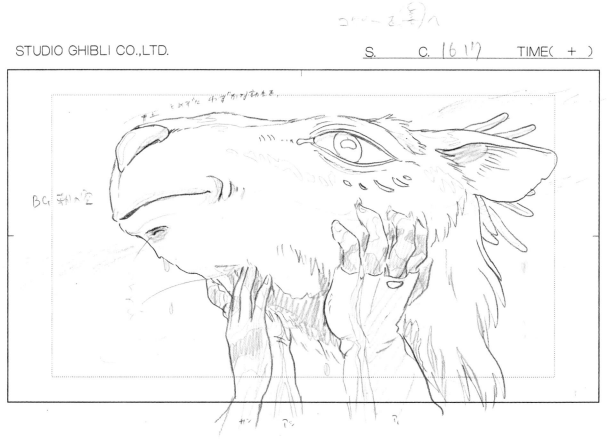

STUDIO GHIBLI CO.,LTD.　　　　　　　　　S.　　C. 1617　　TIME(+)

CUT1617

206

BG/原図

S.　C. 1619　TIME(+)

こすかし

②
P.U

Fix 1.5
P.U 6.0
Fix 5.0
12/frac.

CUT 1619

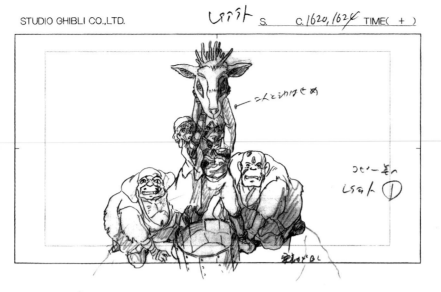

Left: cut 1620, 1624 (character drawing), *right:* cut 1620, 1624 (background drawing)

CUT 1621

cut 1622 (background drawing)

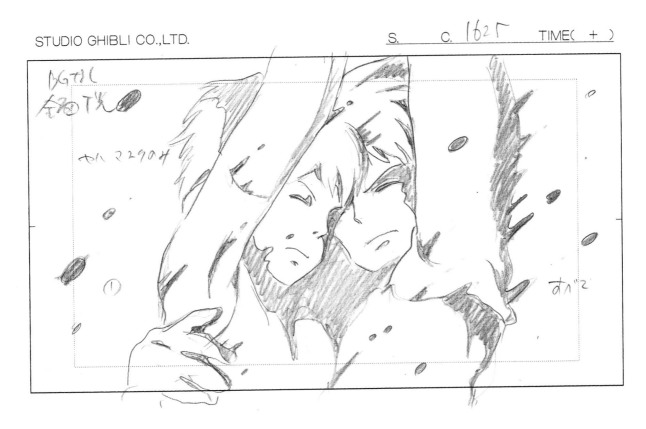

CUT 1625

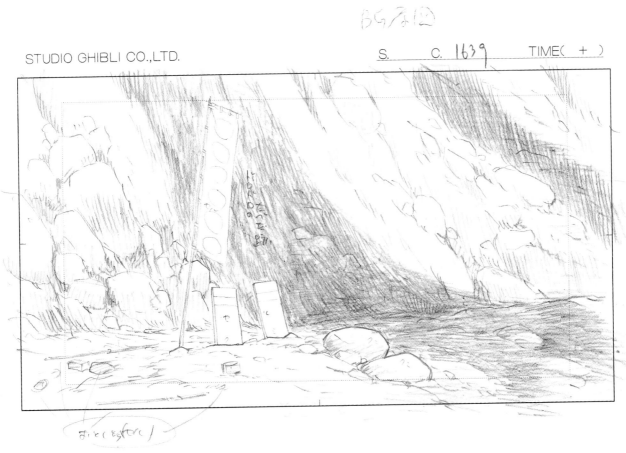

CUT 1639

STUDIO GHIBLI CO.,LTD.　　　　　S.　　C.1643　　TIME(+)

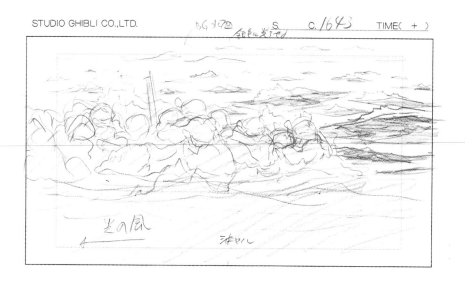

CUT1643

STUDIO GHIBLI CO.,LTD.　　　　S.　　C.1640　　TIME(+)

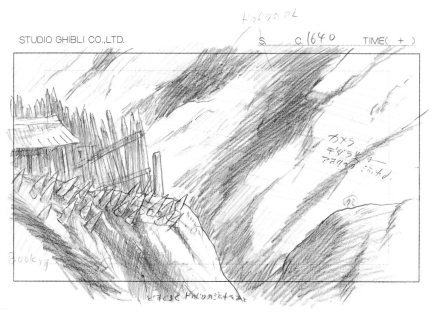

CUT1640

STUDIO GHIBLI CO.,LTD.　　　　S.　　C.1641　　TIME(2+2)

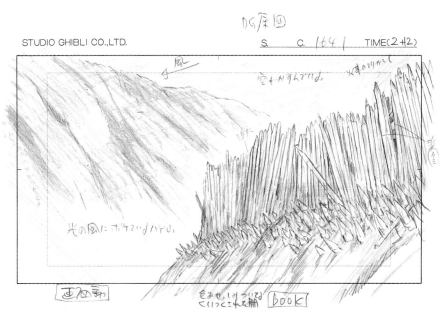

CUT1641

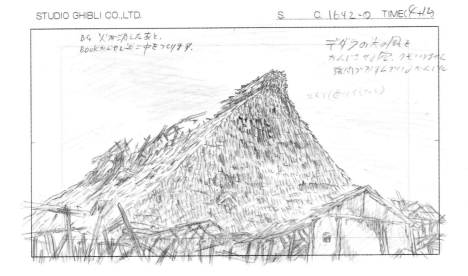

Left: cut 1642-①, *right:* cut 1642-②

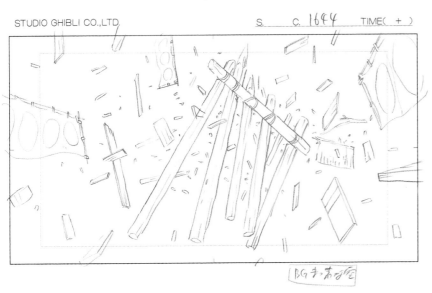

CUT 1644

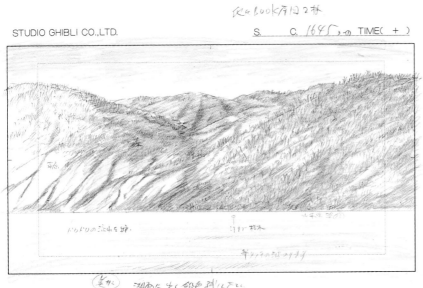

CUT 1645

BG ONLY

S.　C. 1646(8-①) TIME(8+②)

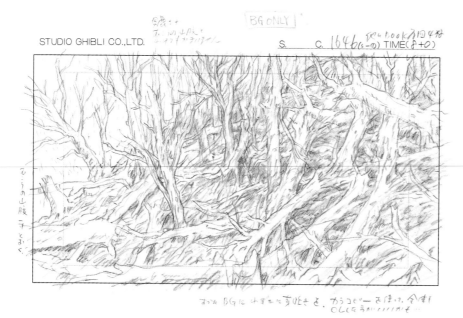

CUT 1646

CG OL　S.　C. 1647(8-①) TIME(+)

CUT 1647 (⑧-1)

CG OL　S.　C. 1647(8-②) TIME(+)

CUT 1647 (⑧-2)

BGONLY

STUDIO GHIBLI CO.,LTD.　CGOL 2枚目A　S.　C.1648　TIME(5+2)

CUT1648-①

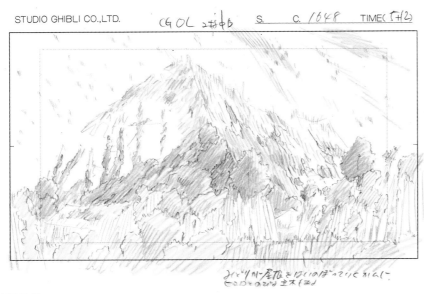

STUDIO GHIBLI CO.,LTD.　CGOL 2枚目B　S.　C.1648　TIME(5+2)

CUT1648-②

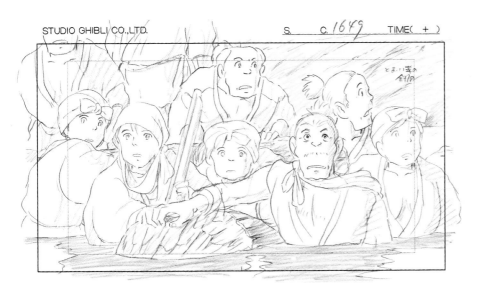

STUDIO GHIBLI CO.,LTD.　S.　C.1649　TIME(+)

CUT1649

STUDIO GHIBLI CO.,LTD.　　　　　　　S.　　C. 1661, 1665　TIME(⁴₆ + ⁰₀)

CUT1661、1665

STUDIO GHIBLI CO.,LTD.　　　　　　　S.　　C. 1662　TIME(8+0)

CUT1662

214

STUDIO GHIBLI CO.,LTD.　4834　　　　　S.　　c. 1663　　TIME(2+0)

CUT1663

STUDIO GHIBLI CO.,LTD.　　　　　　　S.　　c. 1664　　TIME(6+2)

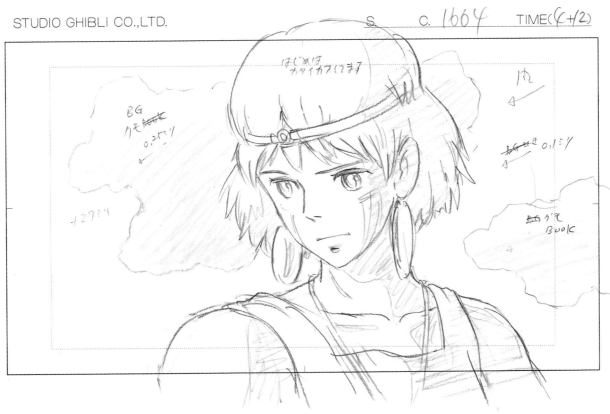

CUT1664

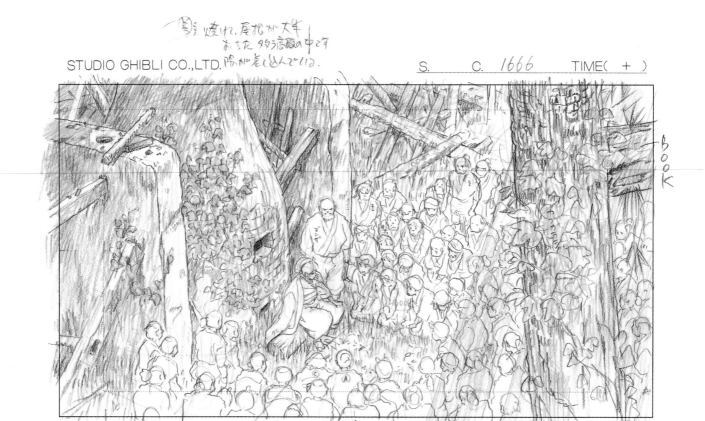

CUT1666

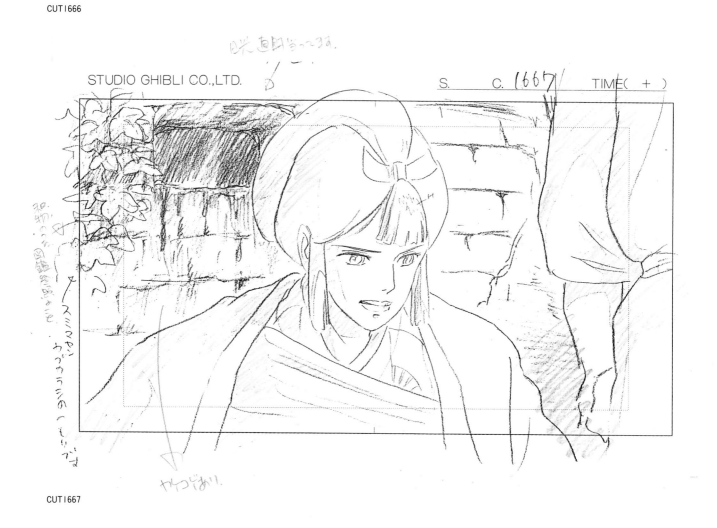

CUT1667

STAFF and CAST

Presented by Tokuma Shoten, Nippon Television Network, Dentus & Studio Ghibli

PRODUCTION STAFF

CHIEF EXECUTIVE PRODUCER Yasuyoshi Tokuma
EXECUTIVE PRODUCERS Seiichiro Ujiie Yutaka Narita

ORIGINAL STORY & SCREENPLAY Hayao Miyazaki

MUSIC Joe Hisaishi
THEME SONG "Mononoke-Hime"
LYRICS Hayao Miyazaki
COMPOSITION Joe Hisaishi
MUSIC ARRANGEMENT Joe Hisaishi
PERFORMANCE Yoshikazu Mera
(Tokuma Japan Communications)

SUPERVISING ANIMATORS Masashi Ando

Kitaro Kosaka Yoshifumi Kondo
KEY ANIMATION
Shinji Otsuka Masako Shinohara Noriko Moritomo Megumi Kagawa
Kenichi Konishi Masaaki Endo Hiroshi Shimizu Tsutomu Awada
Hiroko Minowa Michio Mihara Atsuko Otani Takeshi Inamura
Hideaki Yoshio Makiko Futaki Kenichi Yamada Shinsaku Sasaki
Eiji Yamamori Kenichi Yoshida Masaru Matsuse Ikuo Kuwana
Mariko Matsuo Toshio Kawaguchi Takehiro Noda Sachiko Sugino
Katsuya Kondo Yoshinori Kanada
Telecom Animation Film
Atsuko Tanaka

ANIMATION CHECK Hitomi Tateno

Katsutoshi Nakamura Masaya Saito
Rie Nakagome Kazuyoshi Onoda
INBETWEEN / CLEAN-UP ANIMATION
Akiko Teshima Mayumi Omura Yumiko Kitajima Reiko Mano
Masako Sakano Kazuko Shibata Misuzu Kurata Kuri Sawa
Makiko Suzuki Mariko Suzuki Hana Kikuchi Kojiro Turuoka
Atsushi Tamura Minori Noguchi Kaori Fujii Hiromasa Yonebayashi
Hisako Yaji Tamami Yamada Manabu Kawada Yukie Sako
Alexandra Weihrauch David Encinas

Seiko Azuma Yukari Yamaura Sumie Nishido Kiyoko Makita
Keiko Tomizawa Komasa Yayoi Toki Eriko Shibata
Yoko Nagashima Ritsuko Shiina Emiko Iwayanagi Maya Fujimori
Rie Kondo Shinobu Tuneki Hiromi Nishikawa Keiko Watanabe
Kumiko Tanihira Morihiko Yano Hiromi Furuya Akihiko Adachi
Mayumi Yamamoto Daisuke Nakayama Masae Tanabe Rie Niidome
Atsuko Matsushita Kumiko Ota Rie Shimizu Yoshie Hayashi
Sachiko Kobayashi Hiroko Tetsuka Chiharu Haraguchi

Telecom Animation Film
Natsuko Iimori Natsuko Watanabe Mayu Yazawa Yoko Toju
Keiko Nakaji Shinobu Mori Noriko Odaka Mineko Ueda
Shin Itagaki Hiroko Yasutome Masae Tomino Miyoko Shikibu
Keiko Yozawa Kazuko Hirai Masayo Fujikura Akihiko Uda

SUPPORTING ANIMATION STUDIOS
Anime Torotoro Oh production Studio Cockpit
Studio Takuranke Group Donguri

ART DIRECTION Nizo Yamamoto Naoya Tanaka
Yoji Takeshige Satoshi Kuroda

Kazuo Oga
BACKGROUND
Noboru Yoshida Naomi Kasugai Kyoko Naganawa Hisae Saito
Ryoko Ina Sayaka Hirahara Sadayuki Arai Kiyomi Ota
Junichi Taniguchi Masako Osada Hiroaki Sasaki Seiki Tamura

SPECIAL ART EFFECTS Yoshikazu Fukutome

SPECIAL EFFECTS Kaoru Tanifuji

Tomoji Hashizume Masahiro Murakami
Toyohiko Sakakibara Kumiko Taniguchi

COLOR DESIGN Michiyo Yasuda

COLOR KEY Masayo Iseki Naomi Mori Kanako Moriya
INK AND PAINT
Akiko Ono Naomi Atsuta Fumiko Oda Yukie Nomura
Kazuko Yamada Eiichi Suzuki Yuriko Katayama

Studio Killy
Toshiko Iwakiri Naomi Takahashi Chiemi Miyamoto Mariko Shimizu
Chiyomi Morisawa Nobuko Watanabe Kazuhiro Hirabayashi Kaori Yajima
Kaori Ishikawa Hiromi Tsuchiya Yuriko Kudo Chie Harai
Atsushi Kodama Kazue Urayama Fumiko Taira Kimiko Hatano
Shizuka Ishiguro Miyoko Yoshida Sayuri Takagi Keiko Goto
Masako Osumi Keiko Sasaki Kazuko Tsunoda Kaoru Nakagama
TRACE-MACHINE Tatsumi Yukiwaki

IM Studio
Michiyo Iseda Mito Ozaki Hisashi Nabetani Yoriko Asai
Toyomi Nishimura Kaoru Morita Kaori Anmi Kazumi Ouchi
Yumiko Kimura Tomomi Tenma Keiko Sato Sigeko Akanuma
Kinuyo Maehara Sachiko Funasaki Tae Tochihara Kazuo Kobayashi

Trace Studio M
Naomi Anzai Akiko Aihara Wakako Sugiyama Junko Kanauchi
Reiko Daigo Emiko Motohashi Megumi Matsuo Hiroko Otsuk
Toei Animation
Kazuko Kurosawa Kimiyo Okunishi Sonoe Sakano Mihoko Irie
Yoshiko Igarashi Sumiko Furuya Kiyomi Fujihashi Tomoko Totsuka

Telecom Animation Film
Tomoko Yamamoto Mari Hitokurai Sayuri Nagashima Makiko Ota
Eriko Ishikawa Yoshimi Nishiwaki Junko Miyakawa Junko Nagaoka

Studio OM Aomori Works Anime House Hadashi Pro
Peacock Monsieur Onion Studio OZ Studio Ad

TECHNICAL COOPERATION
Mamoru Murao Stac Yoshiro Saito Naigai Carbon Ink
Taiyo Shikisai Shigeharu Kitamura Chromacholour International Ltd. Roy Evans

DIGITAL INK AND PAINT
Hiroaki Ishii Makiko Sato Akira Sugino Keiichiro Hattori
Takahashi Production/T2 Studio
KanakoTakahashi Megumi Ishido Yuki Murata Yumiko Shimoe
Yukiko Kakita
D.R Movie T & V

COMPUTER GRAPHICS
Yoshinori Sugano Yoshiyuki Momose Mitsunori Kataama Masafumi Inoue

CAMERA SUPERVISOR Atsushi Okui
CAMERA OPERATORS Junji Yabuta Wataru Takahashi Tamaki Kojo

AUDIO RECORDING Omnibus Promotion
AUDIO DIRECTOR Kazuhiro Wakabayashi
ASSISTANT AUDIO DIRECTOR Kei Mayama
RECORDING & SOUND MIXING Shuji Inoue
RECORDING ASSISTANT Masahiro Fukuhara
SOUND MIXING ASSISTANTS Tsutomu Asakura Tsukuru Takagi (Tokyo T.V. Center)
Makoto Uchida (Omnibus Promotion)
SOUND EFFECTS PRODUCTION Sound Ring
SOUND EFFECTS Michihiro Ito
SOUND EFFECTS ASSISTANT Takahisa Ishino
SOUND EFFECTS PRODUCTION SUPPORT VOX
Kazuhiko Ikai Motoi Watanabe Shigeru Tokida

SOUND EFFECTS COMPILATION SUPPORT
Aichi-ken Horai-cho Takao Kato Tokyo Kita-ku Archery League
Masamune Kogei Tsunahiro Yamamura

MUSIC PRODUCTION Wonder City
Yukio Yamashita Toru Takigawa
Studio Ghibli
Kazumi Inaki
MUSIC MIXING Masayoshi Okawa Makoto Morimoto
MUSIC PERFORMANCE Tokyo City Philharmonic Orchestra
PIANO PLAYER Joe Hisaishi
CONDUCTOR Hiroshi Kumagai
SOUNDTRACK CD PRODUCTION Tokuma Japan Communications
Tomoko Okada

RECORDING STUDIOS
MUSIC RECORDING Wonder Station
Hiroya Ishihara
Avaco Creative Studio
Kenji Furukawa
DIALOGUE RECORDING MIT Studio
Tatsuya Ikeba Rie Nishijima Yuki Yasoshima
Avaco Creative Studio
Mitsuharu Kanei Nobutaka Hirooka
RECORDING & MIXING Tokyo T.V. Center
OPTICAL RECORDING Futoshi Ueda
DIGITAL OPTICAL RECORDING Noboru Nishio

TITLES Kaoru Mano Yukari Yoshida (Malin Post)

EDITING Takeshi Seyama
EDITING ASSISTANTS Kyoko Mizuta Megumi Uchida Mako Tamura

ASSISTANT TO THE DIRECTOR Hiroyuki Ito
ADDITIONAL ASSISTANTS TO THE DIRECTOR Koji Aritomi Masakatsu Ishizone

PRODUCTION MANAGER Toshiyuki Kawabata
PRODUCTION DESK Kazuyoshi Tanaka Tomoaki Nishigiri
PRODUCTION ASSISTANTS Koji Otsuka Kenji Imura Kenichiro Suzuki
PRODUCTION ADMINISTRATION Shinsuke Nonaka Yuichiro Mochizuki
PUBLIC RELATIONS Tamami Yamamoto Minako Nagasawa
MERCHANDISING DEVELOPMENT Tomomi Imai Koichi Asano
INTERNET COORDINATOR Noriko Ishimitsu
ASSISTANT TO THE PRODUCER Takahiro Yonezawa
PUBLISHING DEVELOPMENT Yukari Tai

ADVERTISING PRODUCER Masaru Yabe
 Toho Shigeto Arai Yusuke Tomoda
 Major Morikazu Wakizaka Naoto Okamura Masaru Tsuchiya
 Michiyo Koyanagi Fumiyo Sasada Chihiro Tsukue
 Nozomi Fukuda Mariko Kato

 Mieko Hara Mika Watanabe
SPECIAL MEDIA ADVISOR／Masaya Tokuyama

FILM PREVIEW PRODUCTION
 Gal Enterprise
 Keiichi Itagaki Hiroko Hanamoto

OVERSEAS PROMOTION
 Stephen M. Alpert Haruyo Moriyoshi Keiji Hamada

PRINCESS MONONOKE PRODUCTION COMMITTEE
 Tokuma Shoten
 Tsutomu Otsuka Minoru Muroi Noboru Tsukahara
 Junko Ito
 Nippon Television Network
 Seiji Urushido Nobuhisa Sakata Hidehiko Takei
 Kazuaki Ito Yoshiko Nagasaki Sue Fujimoto
 Kako Nomoto Daisuke Kadoya Tomoko Kamiya
 Dentsu
 Mitsuyoshi Katsurada Takaya Noda Shozo Katsuta
 Noritoshi Aoyagi Ryoichi Fukuyama Yushin Soga
 Studio Ghibli
 Shigeru Kobayashi Shokichi Arai Akio Ichimura
 Tomoki Horaguchi Shogo Komagata Eiko Fujitsu

ASSOCIATE PRODUCER Seiji Okuda

SPECIAL MEDIA SUPPORT The Yomiuri Shimbun

FILM DEVELOPING Imagica
 TIMING Hiroaki Hirabayashi
 OPTICAL Masaharu Sekiguchi
 DIGITAL FILM I/O Hideo Tsuji
 DOLBY(LOGO) TECHNICAL COOPERATION Mikio Mori
 in selected theaters Continental Far East Inc

PRODUCTION Studio Ghibli
PRODUCER Toshio Suzuki

DIRECTOR Hayao Miyazaki

V O I C E S

Ashitaka: Yoji Matsuda
San: Yuriko Ishida

Lady Eboshi: Yuko Tanaka
Jiko: Kaoru Kobayashi

Koroku: Masahiko Nishimura
Gonza: Tsunehiko Kamijo
Toki: Sumi Shimamoto
Wolf: Tetsu Watanabe
Tatari-gami: Makoto Sato
Ushikai: Akira Nagoya

Moro: Akihiro Miwa

Oracle: Mitsuko Mori

Okkoto: Hisaya Morishige

Kei Iinuma Akira Sakamoto Kimihiro Reizei Michiko Yamamoto
Yoshimasa Kondo Daikichi Sugawara

Shiro Saito Keiko Tsukamoto Akio Nakamura Kazue Sugiura
Shinji Tokumaru Yayoi Kazuki Ikuko Yamamoto

Kiho Iinuma Takashi Matsuyama Shigeto Ho Shigenobu Miyake
Hiroki Ochi Katsutoshi Nagura Masahiko Seno Kenji Tashiro
Kota Fukazawa Kazuya Kobayashi Takehiro Matsuda Tomikazu Kuwabara
Fumio Ukibe Shinichi Watanabe Nobuhisa Okazaki Akihiko Tonosaki
Nobuyoshi Harada Daigo Fukunaga Yoshiaki Arai Ryota Ono
Eiji Kato Tetsuo Omi Yoshiaki Masuda Kinu Yoshimi
Fumi Kakuta Kazuyo Murata Akiko Yoshioka Shinobu Sakashita
Eriko Ando Saori Takatsuki Yuko Kashima Riri Tajima
Miyuki Nikaido Takako Fuji Kazuyo Uekusa Naoya Fujimaki

STUDIO GHIBLI - Its Past and Present

by Toshio Suzuki

Studio GHIBLI President

(from his speech at the ANNECY International Animated Film Festival, 1995)

GHIBLI - ITS BEGINNINGS

"Nausicaa of the Valley of Wind" was a successful film, both in terms of box-office performance and critical acclaim. This success triggered the creation of Studio GHIBLI in 1985. Tokuma Shoten (Tokuma Shoten Publishing Co., Ltd), the company that produced "Nausicaa," founded the studio together with animated film directors Hayao Miyazaki and Isao Takahata. In the same year, the Studio produced a feature film called "Laputa: Castle in the Sky."

"GHIBLI" is the name given to one of the hot desert winds blowing out of the Sahara by Italian pilots in Northern Africa during World War II, and was also the name they used for their own scouting planes. Hayao Miyazaki, who has a passion for vintage aircraft, knew this, and decided to use this word, GHIBLI, as the new studio's name. "Let's blow a hot wind into the Japanese world of animation!" was, I remember, the intention behind the naming of GHIBLI.

This studio, I believe, is quite unique not only in the Japanese animation industry, but internationally as well, in that the studio produces only feature-length theatrical animation ("feature animation"). Because the production of theatrical films is a relatively risky undertaking, in that there is no guarantee of box-office success, it is common for most animation studios to work mainly on TV animation. In Japan the existing animation studios mainly make animation for television, producing theatrical films only from time to time, and many of these are theatrical versions of already popular animated TV series.

GHIBLI became the kind of studio it is today through a series of stages. It probably began a little more than 30 years ago when Isao Takahata and Hayao Miyazaki first met. Both were working at Toei-Doga, a production studio which at that time was producing only animated feature films. But for various reasons, the studio began making only animation for television. One of the TV series they produced was "Heidi," aired in 1974. Animated by Miyazaki and directed by Takahata it was very highly regarded in the world of TV animation.

Miyazaki and Takahata, however, were not satisfied with the limitations inherent in the television animation medium. They were looking to achieve something more with their animated films. They wanted to create animation of the highest possible quality, something that probed to the depths of the human mind, and that illustrated the joys and sorrows of human life and emotions. If the existing studio structure of the time would not allow them to make this kind of film, they realized they had no choice but to start their own studio.

But their original conception of their studio was not necessarily of a long-enduring entity. When they began their first film outside of the studio system, "Nausicaa of the Valley of Wind," their idea was to dedicate their full efforts and energy to the work at hand, with sufficient budget and time, never compromising on the quality or content of the piece. The directors, Miyazaki and Takahata, and not the studio's backers and business managers, would be in charge. Perhaps, Studio GHIBLI's history up to the present is one that has managed to overcome the difficulties in maintaining this posture and still achieving a measure of commercial success.

In the beginning, none of the creative founders and staff of the studio really thought that Studio GHIBLI would survive for very long. "Make one film. If that succeeds, make another. If that flops, that ends it." This was the philosophy. So to keep the risk to a minimum, no full-time employees were hired. About 70 persons were hired on a temporary basis to complete one film, and when the film was completed, the team was disbanded. The studio's space was one rented floor in a building in Kichijoji, a suburb of Tokyo.

Takahata originated and implemented all of the new studio's policies. He was the one who produced "Nausicaa of the Valley of Wind," and it was his ability as a business manager that contributed so much to the start of the new studio. "Laputa: The Castle in the Sky," the studio's next film, was also produced by him and directed by Miyazaki. "Nausicaa," was released in 1984, and drew close to one million people to the theaters. "Laputa" was released in 1986 and sold about 800,000 tickets. Both films were very well received by critics and film reviewers.

GHIBLI ATTRACTS THE ATTENTION OF THE JAPANESE FILM INDUSTRY

The next two films that Studio GHIBLI produced were "My Neighbor Totoro" and "Grave of the Fireflies," directed by Miyazaki ("Totoro") and Takahata ("Fireflies"). The simultaneous release of two films by Japan's two most talented directors was quite an event. It would turn out to be the first and the last time this was attempted.

The process of making these films at the same time in a single studio was sheer chaos. The studio's philosophy of not sacrificing quality was to be strictly maintained, so the task at hand seemed almost impossible. At the same time, nobody in the studio wanted to pass up the chance to make both of these films. Who knew when, or even if, such a chance would come again.

Once the decision was made to produce the two films, no one ever looked back, and no one thought about anything other than successfully completing the two films. The reason the studio was established in the first place was to produce films of the highest possible quality. The management and growth of the studio as a company, as a business, always came a distant second. This policy is probably something that has distinguished Studio GHIBLI from other studios, and without it, the undertaking of these two films would not have been possible.

One person who figures very prominently in the history of Studio GHIBLI is Yasuyoshi Tokuma, the president of Tokuma Shoten. Besides looking after the main publishing business of Tokuma Shoten, Mr. Tokuma has always been closely involved in the development of

other businesses as well. He is also the owner of the Daiei film studio, famous for its production of films directed by Kenji Mizoguchi and Akira Kurosawa, Shintaro Katsu's "Zatoichi" series, and most recently the films of Masayuki Suo, including "Shall We Dance?"

Mr. Tokuma very rarely visited the Studio, not for lack of interest, but because he firmly believed that the creative decision-making should be left up to the filmmakers, in whom he had absolute faith. He supported the filmmakers when his support was needed most. It was he who made the decision that allowed Miyazaki's original manga series, "Nausicaa," to be made into a feature-length theatrical film, and it was he who provided the financial support needed to establish Studio GHIBLI.

Arranging for the release of "Totoro" and "Fireflies" was not as easy as it might now seem in retrospect. Both films seemed rather quiet compared to GHIBLI's previous two films, and distributors were initially not eager to take a chance on the new films. Mr. Tokuma himself visited the distributors in person and campaigned for the two films to be released. Thanks to a combination of his forceful personality and his personal contacts, he was able to secure an agreement with the distributors. Had he not been successful, Studio GHIBLI would probably not exist now.

The box office performance of "Totoro" and "Fireflies" was not as good as it might have been, because they were not released during the summer season when a great many Japanese go to the theater. Yet the critical acclaim for both films was high, and "Totoro" won most of the film awards in Japan for that year, including best photography. "Fireflies" was highly praised as a true work of cinematic art. Studio GHIBLI became widely known in the Japanese film industry, if not yet to the Japanese public at large.

"Totoro" brought an unexpected gain. The "stuffed animal" (or "plush") version of the film's namesake, Totoro, became a huge hit in Japan's toy stores. The stuffed toys were marketed nearly two years after the release of the film, and they were not intentionally created to promote the film's box office performance. A certain manufacturer of stuffed toys felt so passionately that Totoro was a character that deserved to be made into a stuffed toy, and was so persistent in pleading with Studio GHIBLI for its permission, that the studio finally allowed him to go ahead.

Ironically, thanks to the sale of Totoro merchandise, it became possible for Studio GHIBLI to cover any deficit in the production costs of its other films. Totoro has even been adopted as the studio's logo. Although GHIBLI has now set up an internal division to promote the sale of character goods, the studio's policy that film production comes first and merchandising of its characters comes only after the film has been released, has not changed. Ghibli has never decided on, and never will decide on, or change any part of, one of its films based on the expected merchandising value.

STUDIO GHIBLI - THE BEGINNING OF PHASE 2

The first GHIBLI film to be a serious box office hit was "Kiki's Delivery Service," directed by Hayao Miyazaki and released in 1989. About two and three-quarters of a million people went to the theater to see the film, and it became the number one Japanese hit film of that year. In fact, the film's box office performance exceeded all of GHIBLI's previous films combined.

But the success of "Kiki's" created a completely different kind of problem for Studio GHIBLI: what to do with the studio as a company and how to run it. In particular, now that it was fairly clear that GHIBLI would probably be around as a studio for a while yet, the studio needed to come to terms with the issue of recruiting, hiring and developing permanent staff.

In the Japanese animated film industry, it was common to pay according to the number of pieces drawn or painted. This is how GHIBLI had been paying its staff. As a result, the staff working on "Kiki's" generally received roughly half of the average hourly Japanese wage rate. Miyazaki made two suggestions:

1. Introduce full-time employment at a fixed salary, effectively doubling staff salaries.
2. Recruit staff on a regular basis and provide a training program.

While the conditions at GHIBLI were improving, the conditions in the overall animation industry in Japan were declining. To make quality films in such an environment, Miyazaki judged that it was important to maintain a fixed physical base of operations, to establish a solid organization, to actualize full-time employment and to implement a training & development program. It was the beginning of the second phase of GHIBLI. This position was also supported by the studio's backer, Mr. Tokuma.

In November of 1990, during GHIBLI's production of its next film, "Only Yesterday," directed by Takahata, full-time employment, an animation training program and regular annual recruitment were all implemented.

When "Only Yesterday" was released in 1991 it became another box-office hit and was also the number one film of that year. This was fortunate, because the realization of Miyazaki's goals of doubling salaries and recruiting and training new staff had now created yet another new problem for GHIBLI. As a general rule, 80% of an animated film's production costs come from the cost of labor. Now the cost of making a film at GHIBLI had suddenly doubled.

For the first time, GHIBLI was forced to pay more attention to the advertising and promotion of its films, with an eye to increasing box-office revenues. If massive increases in production costs were unavoidable, then the only choice was to conscientiously and strategically plan for an increase in box office performance. Although GHIBLI began to focus on its advertising as one of its filmmaking tasks with the release of "Only Yesterday," the policy of not allowing commercial decisions to influence the filmmaking process was still studiously maintained.

Toru Hara, Studio GHIBLI's General Manager at that time, often described GHIBLI as having the 3Hs: High Cost, High Risk, and High Return. To produce top quality work required high production costs, and to be sure, there was a great deal of risk to committing the resources to the production of a film whose reception at the box office could never be taken for granted. But while this is still true even today, even if the returns from a film are high, they will always be needed by the next production, and still they may not be enough. There will always be the latest computer-controlled camera system, the newest audio recording technology, or lately, the computers and software upgrades that will be needed to allow the animators to take their art to a new level of excellence not previously thought possible.

But at that stage in GHIBLI's history, it was the pressure of employing a full-time staff and having to pay a monthly payroll that created a situation where GHIBLI needed to be constantly in production mode. GHIBLI went ahead with its next film, "Porco Rosso," before finishing "Only Yesterday."

Since "Only Yesterday" was in the final, most hectic stages, just before completion and release in the theaters, every single helping hand in the studio was needed, and none of the staff could be called on to start working on a new film. The result was that Miyazaki had to work alone on "Porco Rosso" at first. Of course Miyazaki was not happy to learn that he would need to produce, direct and assist all on his own, but he realized that there was no choice but to do it.

BUILDING THE NEW STUDIO

To some extent, it may have been an attempt to channel off some of the stress of having to function as a one-man animation production unit. One day, out of the blue, Miyazaki came up with a proposal to build a new studio. When facing a seemingly insoluble problem, Miyazaki often tried to find a way through it by creating an even greater problem. But the reasons he gave were convincing. When trying to get the best people, a rented office is not impressive enough. Without space people cannot gather to share ideas, and without the proper environment, people will not develop. The space GHIBLI was using was already full—approximately 90 people were working in a 300-square meter space. But GHIBLI did not have the money to build a new studio.

Hara, the studio's manager, was a man of common sense and was opposed to this idea. While the idea of building a new studio did seem fanciful at that point in time, most of the studio's staff had a rather optimistic view of the proposed project. Mr. Tokuma was totally for it. "Give it a try. There are times when a man must carry heavy loads on his back," he would say. "Suzuki, there is plenty of money in the bank." In the end, when GHIBLI decided to go ahead, Hara felt he could no longer follow, and left the studio.

During this particular year, Miyazaki showed that he was truly a many-faceted genius. While working on "Porco Rosso," he drew up the blueprints for the new studio himself, held meetings with the builders to bring the completed building as close to his image of it as possible, drew concept drawings for the completed studio, gathered, checked, and chose the construction materials, and made all final decisions on construction. One year later, both the film "Porco Rosso" and the new studio were completed. Immediately after the release of the film, GHIBLI moved to its new studio in the Tokyo suburb of Koganei.

The site of the studio is approximately 1,100 square meters and the total floor space pretty much occupies the entire site. The building has a basement and 3 floors above ground. The third floor was originally occupied by the art department, the second by the drawing and production departments, and the first floor by the tracing/painting departments. The basement housed the photography department.

On the first floor there is a space called the "BAR," which is used as a common space for all staff. Most of the time it is used as a conference room or as a lunchroom. The ladies' rest room on the first floor is double the size of men's, even though the number of men and women are about the same. The studio has quite a lot of greenery and a rooftop break area overlooking a tree farm, and the parking area was intentionally made small.

"Porco Rosso" became the number one box-office hit of the year 1992, surpassing all films released in that year, including Spielberg's "Hook" and Disney's "Beauty and the Beast."

STUDIO GHIBLI'S UNIQUENESS

In 1993, GHIBLI purchased two large computerized cameras, and a new photography department was set up. With this addition, GHIBLI now had all the resources needed to complete an animated film in-house. The rest of the animation industry in Japan at this time was moving in exactly the opposite direction, emphasizing studio specialization and sub-contracting of the various component pieces of the animation process. The reason GHIBLI took the direction that it did was the belief that working closely under one roof with a common objective and governing philosophy was important in achieving high quality work.

In 1993, GHIBLI produced its first made-for-television animated feature, "the Ocean Waves." The director was Tomomitsu Mochizuki, who was 34 years of age at that time. It was the first time anyone other than Miyazaki or Takahata had directed a GHIBLI film. The production staff was young, consisting mostly of artists in their 20s and 30s. Their motto was to produce "quickly, cheaply and with quality."

The 70-minute TV special achieved at least one of its targeted goals. It did not meet its target in terms of budget and time schedule. TV may be an area of future development for GHIBLI.

The 1994 film directed by Takahata, "Pom Poco," also became the year's number one Japanese film. For this film, most of the animation was done by GHIBLI staff who were recruited and trained after the completion of "Only Yesterday." In "Pom Poco" GHIBLI made use of CG animation, computer-generated graphics, for the first time in its history. There were only 3 cuts using CG, but it was the beginning of a trend that will continue in all animation worldwide.

THE END OF THE SECOND PHASE

"Whisper of the Heart," which was released in the summer of 1995, was directed by Yoshifumi Kondo, who was the animation director in "Fireflies," "Kiki's" and "Only Yesterday." Miyazaki was the producer, wrote the screenplay and storyboarded the film. Various departments continued their experimentation with CG and other digital techniques, many of which were further expanded in the studio's tenth picture, "Princess Mononoke."

For this new challenge, a group specializing in CG has been set up and several of the departments at the studio we rearranged to allow

for the installation of new computers. At the same time, a CG director from Nippon Television Network, who had worked with GHIBLI on "Pom Poco," was invited to join the production team. Over 100 million yen was invested in computer systems before work on "Princess Mononoke" was even begun.

In April of 1995, GHIBLI started the "East Koganei Village School of Animation" under the guidance of Takahata in an effort to discover and develop new animated film directors to follow the late Yoshifumi Kondo.

There is no guarantee that Studio GHIBLI will continue to do as well as it has until now. No one at the studio has ever lost sight of the fact that each picture comes as a new challenge. To continue to be innovative in terms of the quality of work, technology, and development of personnel are the most important factors in maintaining the essence of Studio GHIBLI.

Both Takahata and Miyazaki continue to believe that for a studio to be truly successful, in the way that they define success, it is necessary to risk the life of the studio on each and every film. Everyone involved in the project must understand that if the film fails, the studio itself may close its doors. It is this willingness to take risks, regardless of the consequences, that they believe keeps its films fresh and vital, and gives them the kind of integrity that is a tremendous source of pride to everyone involved with filmmaking at Studio GHIBLI.

Studio Ghibli Filmography (including date of first release in Japan)

Nausicaa of the Valley of the Wind (Kaze no Tani no Nausicaa)
Original story and screenplay by Hayao Miyazaki
Music by Joe Hisaishi
Produced by Isao Takahata
Directed by Hayao Miyazaki
117 minutes
Released March 11, 1984

Laputa: Castle in the Sky (Tenku no Shiro Laputa)
Original story and screenplay by Hayao Miyazaki
Music by Joe Hisaishi
Produced by Isao Takahata
Directed by Hayao Miyazaki
124 minutes
Released August 2, 1986

My Neighbor Totoro (Tonari no Totoro)
Original story and screenplay by Hayao Miyazaki
Music by Joe Hisaishi
Directed by Hayao Miyazaki
87 minutes
Released April 16, 1988

Grave of Fireflies (Hotaru no Haka)
Original story by Akihiko Nosaka
Music by Michio Mamiya
Directed by Isao Takahata
88 minutes
Released April 16, 1988

Kiki's Delivery Service (Majo no Takkyubin)
Original story by Eiko Kadono
Screenplay by Hayao Miyazaki
Music by Joe Hisaishi
Theme songs by Yumi Arai
Produced and directed by Hayao Miyazaki
102 minutes
Released July 29, 1989

Only Yesterday (Omoide Poroporo)
Original manga by Hotaru Okamoto and Yuko Tone
Screenplay by Isao Takahata
Music by Masarui Hoshii
Produced by Toshio Suzuki
Directed by Isao Takahata
119 minutes
Released July 20, 1991

Porco Rosso (Kurenai no Buta)
Original story and screenplay by Hayao Miyazaki
Music by Joe Hisaishi
Theme song performed by Tokiko Kato
Produced by Toshio Suzuki
Directed by Hayao Miyazaki
102 minutes
Released July 20, 1992

Pom Poko (Heisei Tanuki Gassen Pompoko)
Original story and screenplay by Isao Takahata
Music by Shang Shang Typhoon
Produced by Toshio Suzuki
Directed by Isao Takahata
119 minutes
Released July 16, 1994

Whisper of the Heart (Mimi wo Sumaseba)
Original story and screenplay by Hayao Miyazaki
Music by Yuji Nomi
Produced by Toshio Suzuki
Directed by Yoshifumi Kondo
119 minutes
Released July 15, 1995

Princess Mononoke (Mononoke Hime)
Original story and screenplay by Hayao Miyazaki
Music by Joe Hisaishi
Produced by Toshio Suzuki
Directed by Hayao Miyazaki
135 minutes
Released July 12, 1997